SPLAT BOOM POW!

D1373388

SPLAT BOOM POW!

The Influence of Cartoons in Contemporary Art

Valerie Cassel

Essays by

Roger Sabin

Bernard Welt

A Cartoon Timeline

Jamie Coville

contemporary**arts**museum▾houston

This catalogue has been published to accompany the exhibition *Splat Boom Pow! The Influence of Cartoons in Contemporary Art*, organized by Valerie Cassel, Associate Curator, for the Contemporary Arts Museum Houston and subsequent tour.

Contemporary Arts Museum Houston
April 12–June 29, 2003

Institute of Contemporary Art, Boston
September 17, 2003–January 4, 2004

Wexner Center for the Arts, Columbus, Ohio
January 31–April 30, 2004

Henie Onstad Kunstsenter, Høvikodden, Norway
June 3–September 19, 2004

Library of Congress Control Number:
2002096353

ISBN 0-936080-78-7

Printed and bound in Germany.

Cover illustration: Sonny Windstrup
Frontispiece: Roger Shimomura, *Jap's a Jap: #6,*
 2000. Acrylic on canvas, 36 x 48 inches.
 Courtesy Greg Kucera Gallery, Seattle
Opposite: George Herriman, *Krazy Kat,* 1918.
 © Int'l Features Service, Inc.

Contemporary Arts Museum Houston
5216 Montrose Boulevard
Houston, Texas 77006-6598
Phone: 713/284-8250
Fax: 713/284-8275
www.camh.org

This exhibition has been made possible by The Andy Warhol Foundation for the Visual Arts and Union Pacific.

Additional support is provided by the patrons, benefactors, and donors to the Museum's Major Exhibition Fund:

Major Patron
Fayez Sarofim & Co.

Patron
Eddie and Chinhui Allen
Mr. and Mrs. A. L. Ballard
Mr. and Mrs. I. H. Kempner III
Mr. and Mrs. Michael Zilkha

Benefactors
Robert J. Card, M.D./Karol Kreymer
George and Mary Josephine Hamman Foundation
Max and Isabell Smith Herzstein
Rob and Louise Jamail
Susan Vaughan Foundation
Stephen and Ellen Susman

Donors
Baker Botts L.L.P.
James A. Elkins, Jr.
KPMG LLP
Ransom and Isabel Lummis
Lester Marks
Karen and Eric Pulaski
David and Suzanne Saperstein
Jeff Shankman
Shell Oil Company Foundation
Leigh and Reggie Smith
Mr. and Mrs. Wallace S. Wilson

The exhibition catalogue is supported by The Brown Foundation, Inc.

Official airline of the
Contemporary Arts Museum Houston

Distributed by:
Distributed Art Publishers, Inc. (D.A.P.)
155 Sixth Avenue
New York, New York 10013
212/627-1999
www.artbook.com

Contents

Lenders to the Exhibition

George Adams Gallery, New York

American Folk Art Museum, New York

Paule Anglim Gallery, San Francisco

Austin Museum of Art, Austin, Texas

Gayle and Charles Atkins, New York

Blum & Poe, Santa Monica, California

Rena Bransten Gallery, San Francisco

The Roger Brown Study Collection,
The School of the Art Institute of Chicago

Cat Chow, Chicago

Catherine Clark Gallery, San Francisco

James Cohan Gallery, New York

Dr. Nitin Dilawri, Toronto

Dunn and Brown Contemporary, Dallas

Electronic Arts Intermix (EAI), New York

Ronald Feldman Fine Arts, New York

Stephen Friedman Gallery, London

Estate of Keith Haring, New York

Michael Galbincea, Chicago

Carl Hammer Gallery, Chicago

Jeanne and Michael Klein, Houston

Greg Kucera Gallery, Seattle

Luhring Augustine Gallery, New York

Mattel, Inc., El Segundo, California

Robert Miller Gallery, New York

Modern Art Museum of Fort Worth

Museum of Contemporary Art, Chicago

PaceWildenstein, New York

Private Collection, Chicago

Private Collections, Houston

Private Collections, New York

Robert Pruitt, Austin

Skot Ramos, San Francisco

Rose Art Museum, Brandeis University,
Waltham, Massachusetts

David Sandlin, Brooklyn

Tony Shafrazi Gallery, New York

Jack Shainman Gallery, New York

John A. Smith and Vicky Hughes,
Raymond, Surrey, U. K.

Reggie and Leigh Smith, Houston

Bernice Steinbaum Gallery, Miami

Texas Gallery, Houston

Stanley and Mikki Weithorn, New York

Jennifer Zackin, New York/Connecticut

Foreword

For the past five decades, the Contemporary Arts Museum Houston has enjoyed a reputation for the presentation of important thematic exhibitions centered around significant issues in recent art. Exhibitions such as *New Directions in Domestic Architecture* (1952); *Totems Not Taboo: An Exhibition of Primitive Art* (1959); *Pop! Goes the Easel* (1963), in which three artists in the present show first appeared; *Dále Gas: An Exhibition of Contemporary Chicano Art* (1977); *American Narrative/Story Art: 1967–1977* (1977); *Other Realities: Installations for Performance* (1981); *American Still Life: 1945–1983* (1983); and *Outbound: Passages from the 90s* (2000) have documented significant moments in contemporary art. *Splat Boom Pow! The Influence of Cartoons in Contemporary Art,* and its accompanying publication, continues this distinguished tradition.

Splat Boom Pow! traces the influence of cartoon drawings and animation in the mass media—comic books, cartoons, newspapers, movies, television—on the fine arts over a period of time almost synonymous with the Museum's history. The exhibition examines the roots of the present-day fascination with these works, which serve as an effective measure of the confluence of art and everyday life. Vast, critical changes in American society have taken place over the last half of the twentieth century. Every significant social, political, and cultural change of the last fifty years has been chronicled and documented both in cartoons and in the work of the artists who have appropriated its iconography, techniques, or methods of production. The exhibition not only is an examination of the history and present state of this appropriation, but is as well a review of the myriad changing attitudes and actions surrounding these fundamental alterations in society.

The exhibition is supported by significant grants from The Andy Warhol Foundation for the Visual Arts and Union Pacific. We are grateful to both for helping make the exhibition a reality. Contributors to the Museum's Major Exhibition Fund, which supports exhibitions mounted in The Brown Foundation Gallery, are listed on page 4 of this catalogue. These generous individuals, foundations, and corporations are committed to the Museum's mission—the exhibition and documentation of contemporary art—and to education programs that make it accessible to all audiences. The loyalty of these donors through both prosperity and more challenging economic times is crucial to the Museum's ability to serve its audiences.

Recognizing the importance of scholarship in contemporary art and the imperative to document this research in a form more permanent than exhibitions, The Brown Foundation, Inc. has provided resources to support all Museum-published catalogues, including this one.

After its presentation in Houston, *Splat Boom Pow!* will travel to Boston and to Columbus. We deeply appreciate the support of our colleagues Jill Medvedow, director, The Institute of Contemporary Art, Boston; and Sherri Geldin, director, and Helen Molesworth, chief curator of exhibitions, Wexner Center for the Arts, Ohio State University, Columbus.

Finally, we all owe a debt of gratitude to Valerie Cassel, associate curator and organizer of the present exhibition. She has conceived and executed this project with great commitment and imagination, and we will all benefit from her vision and dedication.

—Marti Mayo
Director

Acknowledgments

Undertaking a project of this magnitude at the Contemporary Arts Museum Houston dictates that many are responsible for the development of the eventual exhibition. I am deeply indebted to each of my colleagues at the Museum, all of whom proved to be an extraordinary pillar of support. I am especially grateful for my wonderful constellation of colleagues, including Senior Curator Lynn Herbert, who helped to secure key loans, Associate Curator Paola Morsiani, who asked the probing questions, and Director of Education Paula Newton, who never turned me away from her door, as well as Director Marti Mayo for believing in this project from the very start. Many, many thank-you's go to Director of Communications and Marketing Megan Conley, and Director of Development Ellen Efsic for their efforts in developing further resources for this exhibition. Cheryl Blissitte provided invaluable support in securing loans and with the initial editing and correspondence. Registrar Tim Barkley made the challenging task of tracking, securing, and transporting a significant assemblage of artworks look easy. The entire Education Department at the Museum developed and implemented interpretive programs related to this exhibition, and the Museum's Teen Council embraced this exhibition with enthusiasm.

Outside of the Museum, other colleagues who offered pivotal moments of insight, generous assurances, and incalculable support include George Adams, George Adams Gallery, New York; Andrea Barnwell, director, Spelman College Museum of Fine Art, Atlanta; Kim Davenport, director, Rice University Art Gallery, Houston; Hugh Davies, director, Museum of Contemporary Art, San Diego; Jane Farver, director, MIT List Visual Arts Center, Cambridge, Massachusetts; Andrea Grover, my collaborative partner in the development of the exhibition's cinematic program; Fredericka Hunter, Texas Gallery, Houston; Hiroko Onoda, Tony Shafrazi Gallery, New York; Franklin Sirmans, independent curator and critic; and Hamza Walker, director of education, The Renaissance Society at the University of Chicago. My many conversations with the artists in this exhibition also provided inspiration. Among those who deserve special recognition are Candida Alvarez, Enrique Chagoya, Michael Ray Charles, George Condo, Rachel Hecker, Kerry James Marshall, Kenny Scharf, and Roger Shimomura.

For the development of this publication, I am extremely grateful to the authors and contributors—Jamie Coville, Roger Sabin, and Bernard Welt—whose thoughts on myth, language, and the historical relationship between cartoons and contemporary art served to broaden the parameters of this investigation. Thanks also go to Don Quaintance, who contributed more to this catalogue than just its design, and his assistant, Elizabeth Frizzell, whose knowledge of comics and cartoon history proved invaluable in securing key images for the catalogue's timeline. Clare Elliott undertook the monumental task of compiling and assuring the accuracy of the artists' biographies and bibliographies. University of Houston intern Julie Firth provided initial research for this project, and Debbie Simon, intern, helped with copyright waivers. Polly Koch offered an unwavering and experienced eye for consistency in editing all aspects of the catalogue, as well as the magic in further shaping my thoughts. For their efforts in securing permissions to reproduce images in this publication, I am grateful to Jack N. Albert and Wendy Bucci, EC Comics; Ruth Begell, director, Charles M. Schulz Museum, Santa Rosa, California, and Heather Orosco, Special Projects Coordinator, Charles Schulz Productions; Stephen R. Bissette, Spiderbaby Grafix and Publications; George Condo; Jamie Coville; Chantal Crousel, Galerie Chantal Crousel, Paris; Charlie Degliomini, Gemstone Productions; Scott Dickens, Linda Jones Enterprises, Inc.; Ronald Feldman and Laura Muggeo, Ronald Feldman Fine Arts, New York; Janie Fire, American Folk Art Museum, New York; Fox Television Network; Gagosian Gallery, New York; Rich Goldwater and Halley Konig, Association of American Comics; Larry Gonick; Janet Hicks, The Artists Rights Society; Joan Hilty and Thomas King, DC Comics; Howard Jurofsky, Heavy Metal Magazine; Timo Julku, Classic Media; Peter Laird; Shelly Lee, Estate of

Roy Lichtenstein; Frank Miller, Dark Horse Comics; Alan Moore; graphic artist Harvey Pekar; the staff of Phyllis Kind Gallery, New York; Joe Quesada and Carol Platt, Marvel Comics; Gary Richardson, Mirage Licensing, Inc.; Kenny Scharf; Art Spiegelman and Deborah Karl; Kim Thompson, Fantagraphics; Tiffany Ward, managing director, Ward Productions; and Valentina Zaldana, manager, Cartoon Network.

I also extend my sincere appreciation to the artists' gallery representatives and studio assistants, as well as to institutional colleagues who not only helped to make the huge task of assembling the works of art in this exhibition possible, but also provided detailed documentation about the artists and their work. The efforts of the following individuals were essential to the realization of this exhibition: Brooke Davis Andersen, director and curator of the Contemporary Center, American Folk Art Museum, New York; Roland Augustine, Luhring Augustine, New York; Michael Auping, curator, Modern Art Museum of Fort Worth; Diane Barber, visual arts director, DiverseWorks Artspace, Houston; Martina Batan, Ronald Feldman Fine Arts, New York; Douglas Baxter, PaceWildenstein, New York; Tim Blum and Gabriel Ritter, Blum & Poe, Santa Monica, California; Trish Bransten. Rena Bransten Gallery, San Francisco; Annette Carlozzi, curator of Contemporary Art, and Kelly Baum, Jack S. Blanton Museum of Art, Austin; Catherine Clark Gallery, San Francisco; Rebecca Cleman and John Thompson, Electronic Arts Intermix, New York; Lisa Corrin, deputy director, Seattle Art Museum; Jeffery Deitch, Trinity Parker, and Elizabeth Schwartz, Deitch Projects, New York; Matthew Drutt, chief curator, and Mary Kadish, registrar, The Menil Collection, Houston; Talley Dunn, Dunn and Brown Contemporary, Dallas; Yolanda Farias, Carl Hammer Gallery, Chicago; Brian Ferriso, senior director of curatorial affairs, and Leigh Albritton, registrar, Milwaukee Art Museum, Milwaukee; Ria Freydl and Michelle Einkauf, Mattel, Inc.; George Adams Gallery, New York; Ian Glennie and Fredericka Hunter, Texas Gallery, Houston; Robert Grosman and Leta Grzyn, Mitchell-Innes & Nash, New York; Dana Friis-Hansen, director, Austin Museum of Art; Christian Hayes, Lori Salmon, and Melissa Montgomery, The Project, New York; David Hubbard, Stephen Friedman Gallery, London; Michael Jenkins, director, Brent Sikkema, New York; Joseph Ketner, director, and Janice Sorkow, registrar, Rose Art Museum, Brandeis University, Waltham, Massachusetts; Greg Kucera, Greg Kucera Gallery, Seattle; Anja Lenze, Galerie Hans Mayer, Dusseldorf, Germany; Shana Lutker and Jordan Gutcher, D'Amelio Terras, New York; Joel Mallen; Susanne Tatum McCurry; David Morgan; Katherine Nagler, curator of Forefront Exhibitions of Contemporary Art, Indianapolis Museum of Art; Hiroko Onoda, Tony Shafrazi Gallery, New York; Anna O'Sullivan, former sales representative, and Michele Heinrici, registrar, Robert Miller Gallery, New York; Skot Ramos; Annelise Ream, Estate of Keith Haring; Jack Shainman and Judy Sagal, Jack Shainman Gallery, New York; Elizabeth Smith, Museum of Contemporary Art, Chicago; Lisa Stone, curator, The Roger Brown Study Collection, Chicago; Olga M. Viso, curator of contemporary art, and Ned Rifkin, director, Hirshhorn Museum and Sculpture Garden, Smithsonian Institution, Washington, D.C.; and Michael and Nina Zilkha and assistant Robyn Pilkinton.

My sincere thanks to those artists whose special efforts helped to secure work for the exhibition: Cat Chow, Jason Dunda, Michael Galbincea, Art Jones, Liza Lou, Kara Maria, Kerry James Marshall, Robert Pruitt, Mel Ramos, David Sandlin, Kenny Scharf, Roger Shimomura, and Jennifer Zackin.

And I am forever grateful for the overwhelming generosity of the lenders to this exhibition —who are listed on page 6—the art collectors, galleries, and artists who without a second thought offered to lend their work to this exhibition so that a wider audience could both enjoy and benefit. Finally, I am indebted to the artists—both those included and those not included in this exhibition—who through their talent, courage, and insight have helped shape my understanding and appreciation of how art becomes so essential to rendering sight and voice to many.

—Valerie Cassel
Associate Curator

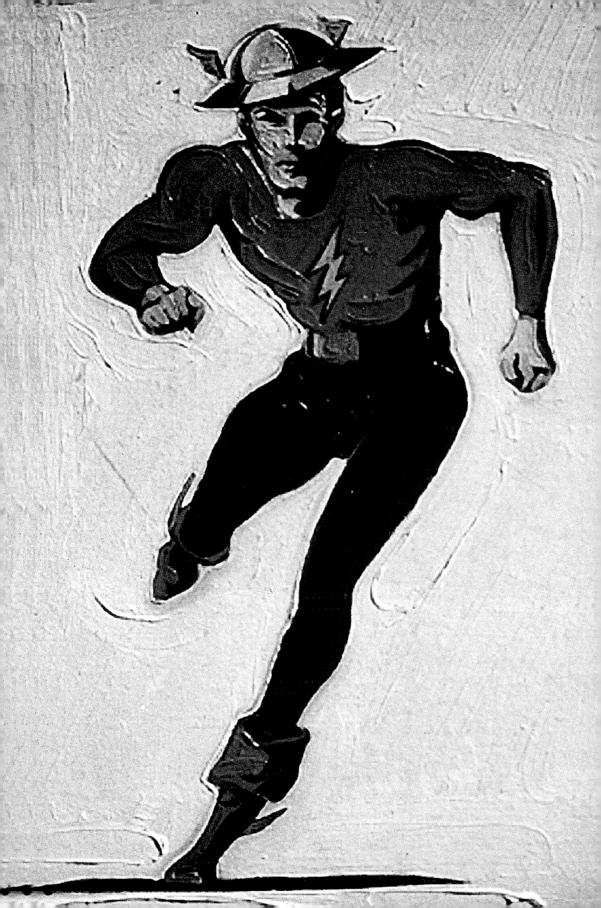

Quote and Be Damned...? *Roger* SABIN

Comics and fine art have always been uneasy bedfellows, despite the fact that the two art forms are closer than many commentators have allowed. In fact, their relationship is often symbiotic, as many of the artworks in *Splat Boom Pow!* attest, and this has been true since the beginning of mass market comics in the United States. Check out the critical rediscovery of the influence of comic strips such as *Krazy Kat* and *The Katzenjammer Kids* on Pablo Picasso. (The best contemporaneous example of reverse traffic would probably be the influence of the Bauhaus on Lyonel Feininger's *The Kin-der-Kids*.) And yet controversies remain about who wins and who loses from the relationship, because these two worlds, though locked in a creative embrace, have never been on an equal footing.

While fine art traditionally has been feted by the arbiters of taste, comics remain at the bottom of the cultural heap. Despite a contemporary public increasingly aware of what comics are capable of, the predominant perception is that comics are vulgar commercial artifacts, satisfying the lowest common denominator demands of the market. Although a comic occasionally will stick its head above the low-art parapet—Chris Ware's graphic novel *Jimmy Corrigan: The Smartest Kid on Earth* (2000) was a surprise winner of literary prizes—such sightings are rare. In general things are much the same as they were back in the days of *Krazy Kat*, and respectability for comics—at least this kind of respectability—remains unlikely.

The subsequent tension between fine art and comics has to do with appropriation—in this case, the "borrowing" of material for high art from the low-culture comics industry. Although the fine art world has since become a very different place, the Pop Art period featured in parts of *Splat Boom Pow!* is where many of the most electrically charged arguments over the use of comics imagery originated. Roy Lichtenstein was the obvious lightning conductor. Were his huge canvas images blown up from comic book panels an exercise in making us see popular culture afresh? Were they a revolutionary attempt to lay bare the plastic politics of consumer society? Or were they theft, pure and simple?

Many in the comics industry thought the worst at the time and applauded when cartoonists made plans to sue. Dave Gibbons, one of contemporary comics' best-known artists (*Watchmen, Give Me Liberty*, etc.), told a graphic design journal in 1999, "I detest the arrogant notion that commercial work just happens to exist and is therefore devoid of creativity or intellectual process. Roy Lichtenstein's copies of the work of Irv Novick and Russ Heath are flat, uncomprehending tracings of quite sophisticated images."[1]

Others in the comics world have made their feelings known in less direct ways. The organizers of the annual Angoulême comics festival in France, the largest and most prestigious event of its kind, have pointedly used the device of either projecting the work of cartoonists onto

fig. 1 Mel Ramos, The Flash, *1962. Oil on canvas, 34 x 18 inches. Collection of Skot Ramos, San Francisco*

walls, thereby magnifying it to Lichtensteinian pro-
portions, or simply enlarging panels to similar effect.
(The summer 2002 comics exhibition at the Yerba
Buena Center in San Francisco followed suit with
spectacular results.) Others incorporated a critique
in the work itself. One famous edition of the super-
hero title *Miracleman* by Neil Gaiman and Mark
Buckingham features repeated images of Andy
Warhol caught in "strip limbo" with characters like
Popeye, Nancy, and of course Dick Tracy (fig. 1).[2]
Likewise, the 1989 Batman movie directed by comics
aficionado Tim Burton showed a scene in which the
Joker's henchmen gleefully destroy a Gotham City art
gallery. Was there ever a better expression of the rage
of the comics-loving community?

fig. 1 Neil Gaiman and Mark Buckingham, page
from Miracleman *(1993). © Eclipse Comics*

The Lichtenstein-style "take it and magnify it"
method of appropriation persists today, if more
rarely. Artist Glenn Brown acquired a reputation in
the 1990s for painting huge, detailed canvases copied
line-for-line from popular, low-culture images that
included fantasy book covers. Greeted with ecstatic
critical acclaim and nominated for Britain's prestigious Turner Prize, he claimed to be trying to
elevate the images to the status of "high art" (thereby doing the original artists a favor). But the
originators of his source material were not happy and, in terms that echoed Gibbons's condem-
nations of Lichtenstein, attacked Brown in the bitterest terms for breach of copyright.

By the end of the 1970s, as the fine art world moved on from Pop, a new aesthetic of bor-
rowing began taking over, a phenomenon eventually labeled "postmodernism." In its early
days, postmodernism went hand in hand with the subculture of the moment: punk. In the
U.K., punk was more a scream of outrage than a coherent philosophy, clearly distinguished
from the hippie counterculture that preceded it. If there were unifying themes, they included
an emphasis on negationism (rather than nihilism), a consciousness of class-based politics
(often given an anarchist slant with a stress on "working class credibility"), and a belief in spon-
taneity and "doing it yourself." In the United States, these attitudes were supplemented by the
artistic interests of some of the American punk prime movers. The Patti Smiths, Tom Verlaines,
and Richard Hells saw themselves as much as poets and bohemians as rock stars, and there was
a tangible "art rock" aspect to what they did. This was important because it opened up a bridge
to other performers and artists in different fields.

The links between punk music and the fine art world, for example, can be traced in the biog-
raphies of several of the stars of *Splat Boom Pow!* Jean-Michel Basquiat was in a punk/noise band
in the late 1970s and starred in the underground "new wave" semidocumentary *Downtown 81*
in 1981. Raymond Pettibon was much involved with the West Coast hard-core punk scene of
the early 1980s, producing flyers and record sleeves for the seminal band Black Flag in which his
brother played guitar. Other artists experimented with cut-and-paste techniques that often
mimicked punk fanzines, becoming known in some critical circles as "neo-Dadaists" (a label al-
most as abhorrent and un-punk as "postmodernist").

Significantly, punk was influenced by Situationism, a philosophy that held plagiarism to

be a potentially liberating act—a way to empower people to see through the sham of "spectacular" late capitalism.[3] Because of punk's supposedly "lower class" credentials, any appropriation of pop culture sources could be read—rightly or wrongly—as a political statement, meaning the use of a "culturally debased" art form such as comics could now be seen as allying the artist with the "forlorn and forgotten" in society. Comics thus became the inevitable fodder for this new cut-and-paste eclecticism. As the catalogue to the Whitney Biennial of 1993 said about Pettibon and his ilk: "[They] deliberately renounce success and power in favor of the degraded and dysfunctional, transforming deficiencies into something positive in true Warholian fashion."[4]

But no sooner had punk taken a grip on the collective artistic imagination than a new force arrived on the scene: hip-hop. As rap acts began to replace punk bands in the alternative music charts, hip-hop spawned a new kind of street art based on graffiti. The links with punk were strong: again there was an emphasis on doing it yourself, on "street credibility," and on anti-establishment stances. Given the added fact that hip-hop was a black scene, at least at the beginning, it is unsurprising that former punk Basquiat was drawn to it like a moth to a flame. Meanwhile, Basquiat's (white) friend Keith Haring began using graffiti as a way to experiment with a comics-influenced graphic language.[5] Once sampling emerged as an integral part of the hip-hop aesthetic (ranging from the remixing of songs from the same or different eras, to the quoting of sounds, vocals, or riffs), the art world returned to comics imagery, using comics characters in the manner of found objects that signified everything from a "screw commercialism" take on pop culture to an affection for the cartoon masters of the past (at the start of the hip-hop graffiti scene, the underground cartoonist Vaughn Bodé was a particular favorite for his cute, spraypaint-friendly characters and swooping, dynamic line). As the galleries caught on to Basquiat, Haring, and the rest, critics began to speak of this kind of collaging and pastiching in terms of a breaking down of the barriers between high and low culture. At the time, this seemed like a not unreasonable analysis. From today's vantage, we know better.

The old questions now took on a new spin. For example, when an artist sampled from the comics, could the audience be sure what the quotation referred to? Comics characters evolve over time and can mean radically different things according to their context. So, when Pettibon quotes Batman, it means something that his version has long, pointy ears. This is explicitly not the Batman of the 1960s television show, who was a paunchy comedy figure, but the Batman of the comics of the 1940s, which were closer to the horror genre than anything else, featuring a character who was a dark avenger out to take reprisal on the criminal underworld for the death of his parents.[6]

Similarly, when artists use Superman (as they often do, evidenced in the work of Warhol, Philip Pearlstein, Mel Ramos, Mike Bidlo, etc.), chances are they are saying something about the version of the character who came to represent "Truth, Justice, and the American Way"— essentially a right-wing vision. What is not widely realized is that at his inception in the 1930s, Superman represented a kind of New Deal figure who helped striking miners against pit owners and took army generals to the battlefront to show them the carnage. Mythic figures thus are never "fixed." Because it is rare for fine artists to be explicit about their intentions, they often prefer to use some kind of generic creation to make a point. As Chris Ofili said of his character Captain Shit, "[He] represents the superhero quality of the black male … rooted in the history of black superstars from George Clinton on stage to Nelson Mandela."[7]

Another question revisited was whether the appropriating artist owed the original creator a credit or even a royalty. In the music world, tales of hip-hop and rap acts being sued were

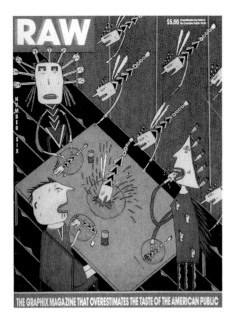

fig. 2 Mark Beyer, cover of RAW, no. 6, 1984.
© Raw Books

commonplace: as the much sampled James Brown put it, "Take me off your record, 'less you're paying me." In the fine art world, where one might have expected a similar attitude from cartoonists—or at least from the companies that own the comics characters—response so far has been muted. While this is surprising given the aggressive way in which publishers like DC Comics and Marvel Enterprises Inc. usually protect their copyrights, perhaps they see the long history of quoting in art—even the old masters were at it after all—as dooming a lawsuit to fail, as the suits failed against Lichtenstein. Perhaps they see any kind of fine art exposure as good publicity. Perhaps, indeed, peace has been declared.

By the early 1980s, a new crop of alternative comics titles was emerging that had, in the eyes of many critics, a "fine art sensibility." Foremost among these was *RAW* (1980), an anthology put together by Art Spiegelman and Françoise Mouly out of New York—home to much of the new wave in art. Contributors to *RAW*, like Mark Beyer (fig. 2) and Kaz, worked in an unusual abstract style that seemed to chime with what was going on in the galleries. The occasional fine artist also made an appearance, including Henry Darger, the outsider painter represented in both *RAW* and *Splat Boom Pow!* The *RAW* tagline, "High Art for Low Brows," seemed to sum up this fresh approach to the comics medium, at once pioneering and ironically self-conscious, and its high production values guaranteed it shelf space in gallery bookstores.

Other less upmarket comics also alluded to developments in the galleries. *Weirdo* (1981), another anthology, was the brainchild of underground comix hero Robert Crumb, who used it to enter into a kind of cartoon dialogue with painter and self-confessed Crumb fan Philip Guston.[8] *Weirdo* was more tuned in to a punk sensibility than *RAW*, and it was no surprise when Pettibon turned up in its pages. Elsewhere, art styles fed back into the comics: cartoonist Hendrik Dorgathen (*Space Dog*, etc.) took Haring's stylized animal and human figures and used them to tell graphic design-influenced stories. This kind of cross-pollination hadn't been seen since the heyday of Pop. Again, it led many to ask whether the two mediums were finally moving closer.

But the postmodern dream of a high-low blend remained a long way off. Hierarchies among the different art forms were still very much in evidence in the 1980s and 1990s, and the question of the relative respect accorded to comics persisted. *RAW* might elicit the occasional review in a quality newspaper, and Crumb might merit a corner of a room in the 1990 *High and Low: Modern Art and Popular Culture* show at The Museum of Modern Art in New York, but nobody bar a few culturally illiterate media commentators was fooled. It was always clear, for example, that the same leeway for freedom of expression did not exist in both mediums. In the fine art world of the 1990s, the Chapman Brothers could deal with subjects like pedophilia or mutilation and emerge with their reputations unscathed. In comics, when Mike Diana attempted to do the same, he was locked up for obscenity—the first cartoonist ever to be so punished in the United States.

In fact, there is only one part of the world where the issue of respect for the comics medium is not a problem, and that is Japan. Here, *manga* sell in numbers that dwarf comics sales in the United States and Europe, and the status of cartoonists is comparable to that of any fine artist, novelist, or filmmaker (*manga* artists have even been known to stand for political office). Creative individuals in Japan thus can achieve success across a range of mediums. At a 2002 conference on *manga* in London, "Manga and Art: Visual Culture in Contemporary Japan," guest artist Makoto Aida entertained attendees with a demonstration of his work both in comics and in fine art. Included in *Splat Boom Pow!*, Takashi Murakami, one of the country's biggest artists, refers to his art as "PoKu," a mix of Pop Art plus *otaku*—a term describing a demonized Japanese subculture of *manga* and *anime* fans.

Can the United States and Europe ever aspire to the same kind of balanced comics—art relationship as seemingly exists in Japan? It's unlikely. Fine artists in the West continue to see comics from the outside—as a communications phenomenon. To see them from the inside would require an unprecedented shift in consciousness. A huge gulf lies between quoting from comics and actually utilizing the comics medium—for example, using image-to-image transitions to progress a narrative. The artists in *Splat Boom Pow!* are clearly more interested in the former.

This is not necessarily a bad thing, so long as we accept that what they are doing is dealing in iconography. *Comic Iconoclasm*, a show with a similar theme that took place at London's Institute of Contemporary Arts in 1987, had as its core idea that quoted comics were somehow acting as iconoclasts in the fine art world. But any visitor to *Splat Boom Pow!* can see that sampling has manifold motivations and interpretations. Ultimately, as long as comics are capable of generating characters with iconic dimensions, we can be sure that painters, sculptors, video-makers, and the rest will use them to make statements across the political and emotional spectrum, perpetuating their iconic status. We can also be sure that the controversies about "quoting" versus "ripping off" will continue.

NOTES

1. Dave Gibbons, quoted in Rian Hughes, "Meanwhile in the weird world of art," *Eye*, vol. 10, no. 39, Spring 2001.
2. *Miracleman* was collected as a graphic novel by Harper Collins in 1993.
3. Strictly speaking, the Situationists' take on plagiarism, which is seen as an essential part of *detournement*, a method of artistic creation, is quite specific. Here, plagiarism subverts both the source and the meaning of the original work in order to create a new work. This use is distinct from "appropriation" or "rip-off," plagiarism that subverts only the source of the material, and from postmodern "iconic quotation," plagiarism that subverts only the meaning of the material (the source becomes the meaning). Whether or not critics (or artists) ever took these finer distinctions seriously is open to debate.
4. Lisa Phillips, "No Man's Land: At the Threshold of a New Millennium," in *1993 Biennial Exhibition*, exh. cat.

(New York: Whitney Museum of American Art and Harry N. Abrams, 1993), p. 54. See also Ralph Rugoff, *Just Pathetic*, exh. cat. (Los Angeles: Rosamund Felsen Gallery, 1990), and J. Bankowsky, "Slackers," *Artforum*, vol. 30, November 1991, pp. 96–100.
5. Haring was also responsible for organizing one of the earliest graffiti shows in New York at the Mudd Club, now home to the thriving hip-hop dance scene but formerly a center of punkdom.
6. This vigilante-style interpretation was revived in the 1960s by Neal Adams (probably the version encountered by the young Pettibon), again featuring a cowl with long, threatening ears.
7. Chris Ofili, quoted in *The Turner Prize*, exh. cat. (London: Tate Gallery, 1998).
8. One Crumb cover featured a Guston-like figure with the words, "It's a Fine Art Thing!"

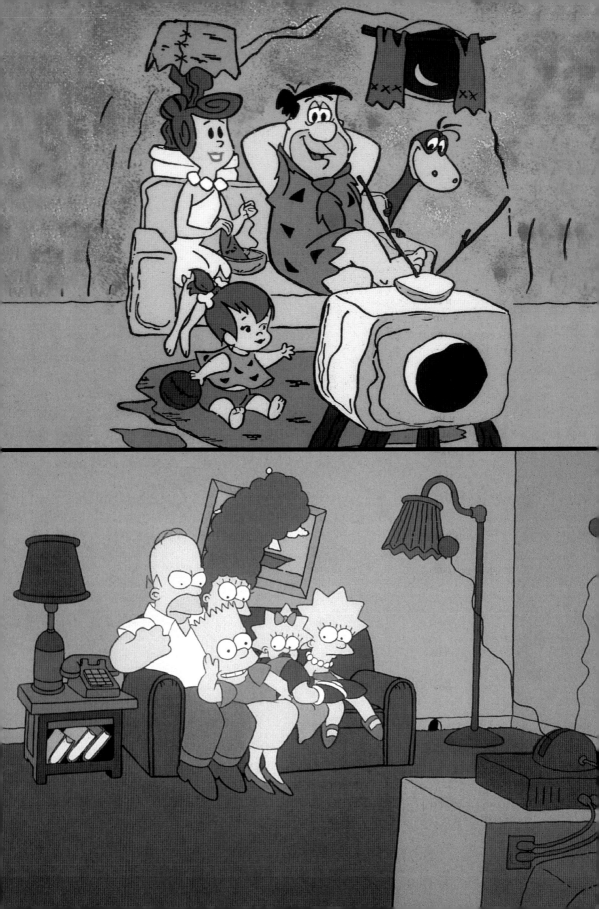

Between a Bedrock and a Nuclear Power Plant

Valerie CASSEL

I n September 1960, *The Flintstones* premiered on ABC—the first prime-time animation series.[1] Produced by Hanna-Barbera Productions, the thirty-minute show set in the prehistoric town of Bedrock replicated a domestic life familiar to television viewers, with all the modern conveniences, including telephones (albeit as ram's horns), stone-framed television sets, and even automobiles fueled by foot power (fig. 4). Running for six years, *The Flintstones* was an instant cultural phenomenon, one not to be repeated until thirty years later.

In January 1990, *The Simpsons* premiered on Fox Television.[2] While similar in its formula to *The Flintstones* (working-class family man negotiating domestic life), *The Simpsons* entertains a much greater dysfunction: life is far more complicated in Springfield (where Homer Simpson works at the city's nuclear power plant) than in the Stone Age city of Bedrock, and its ethnic and cultural stereotypes—from a hemp-stoned school bus driver to the East Indian convenience store clerk—reflect a social and economic stratification unacknowledged in the 1960s.

The juxtaposition of *The Flintstones* and *The Simpsons* offers a snapshot of the cultural changes that society has undergone in thirty years. But cartoons had already proved themselves as bellwethers of popular culture. American comics in the decades preceding television and animation visually communicated a communal ethos as well as a social and political critique. For that reason, it is not surprising that cartoons should have profoundly influenced the artistic practice of contemporary artists. The exhibition *Splat Boom Pow! The Influence of Cartoons in Contemporary Art* investigates this influence across three generations, from Pop Art to the present. The forty artists in this exhibition have been loosely grouped into three distinct areas: *Splat*, the use of existing iconography drawn from both cartoons and popular culture; *Boom*, the appropriation of the techniques of the comics genre; and *Pow*, the melding of form and technique to construct new mythologies and alter egos. But to understand how artists have absorbed cartoons in their practice, one must embrace the history of the comics genre itself.

Sowing the Seeds of an American Cultural Phenomenon

T he comic strip first appeared in American newspapers in the late nineteenth century. R. F. Outcaut's *Yellow Kid,* published in the *New York World* in 1896, portrayed the meanderings of a young child through New York's immigrant ghettos. Rudolf Dirk's *The Katzenjammer Kids,* which debuted in the Hearst *New York Journal's* Sunday supplement on December 12, 1897, also focused on the burgeoning immigrant community.[3] The *Katzies,* written in broken English with a smattering of German words, chronicled the mischievous behavior of Hans and Fritz, two young boys adjusting to their new life in the United States.[4] While both comic strips offered entertainment to readers across the economic

fig. 4 The Flintstones, c. 1965. Photofest/trademark and © 2003 Warner Bros.
The Simpsons, 1998. Photofest/trademark and © 2003 Twentieth-Century Fox Film Corporation

divide, they mainly allowed those less fortunate to laugh at the insurmountable odds of their survival in America's urban centers. Many émigrés also felt that the characters portrayed in these comic strips, particularly *Yellow Kid,* could provide a strategy to help them rise above the economic mire.[5]

During the Great Depression, the comics industry flourished. Popular among both youth and adults, comic strips eventually moved from the pages of newspapers and into books. Traditional newspaper comics like *Little Nemo in Slumberland* and *Mutt and Jeff,* among others, were compiled into small volumes. However, it was not until 1935 that the comics solidified into a distinct literary genre. That year Detective Comics, Inc. (later known as DC Comics) published the first-ever book of all new comic material: *The Big Comic Magazine.* Published under the direction of Major Malcolm Wheeler-Nicholson, a former officer in the American cavalry, the magazine featured the adventures of soldiers who had fought both in the American West and in the recent World War. The magazine went on to capture the dark mayhem of urban life through its spy, detective, and mystery stories.

Among the characters introduced by *The Big Comic Magazine* and its companion compilation *New Adventure Comics* was Superman (1938), created by Jerry Siegel and Joe Shuster, two Jewish-American men. Originally a science fiction pulp, *Superman* developed into a politicized response to Adolf Hitler's calls for a "super race of men."[6] Siegel and Shuster's *Superman* serial even integrated events such as the 1935 enactment of the Nuremberg Laws and 1938's *Kristallnacht* into episode storylines.[7] The public's embrace of *Superman* was in part due to the deep psychological need that Americans had to see an ordinary person, albeit through supernatural powers, battle the evil that seemed to be consuming Europe.

Superman became an instant patriotic icon, shown fighting crime all over the world while also defeating the homegrown evildoers behind American child labor, government corruption, lynching, and even domestic violence.[8] *Superman's* success spawned a number of new superhero comic characters including Batman (DC Comics, 1939); Wonder Man (Wonder Comic, 1939); Green Lantern and The Flash (All American Comics, 1940); Wonder Woman (All American Comics, 1941); Captain America (Marvel Comics, 1941); Black Hawk and Plastic Man (Quality Comics, 1941); and Captain Marvel (Whiz Comics, 1942), among others.[9] All these characters were in some sense fueled by the impending war, and unsurprisingly the readership of action comics tripled between 1940 and 1945. Superheroes were used for propaganda purposes, selling wartime bonds and stamps that financially fueled the war effort.[10] In 1940, Siegel and Shuster were even commissioned by *Look* magazine to depict *Superman* bringing an end to World War II by capturing and subjecting both Hitler and Stalin to an international tribunal.[11]

If cartoons served to boost morale during the Second World War, they fed upon the public's paranoia in its aftermath. By the early 1950s, the comic industry was taking on issues from the Red Scare to fear

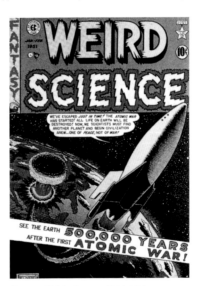

fig. 5 *Wally Wood, cover of* Weird Science, *EC Comics (January 1951).* © *William M. Gaines, Agent, Inc.*

of nuclear annihilation (fig. 5). The war had irreparably changed the American landscape, both introducing the atom bomb and bringing up a generation of American kids whose parents were largely absent due to either enlistment or wartime factory work.[12] The changing values of the nation's youth were perceived in the 1950s as an epidemic of eroding morals that had permeated all facets of popular culture.

In the comics industry, the grim mystery, horror, and detective stories were increasingly joined by serials specifically geared toward the burgeoning teen market, spearheaded by *Archie Comics (1941)*, a spin-off of *Pep Comics*. *Archie Comics* was based on the adolescent memories of Bob Montana, who confessed that Archie "was in fact his alter ego."[13] As this new generation embraced the uniqueness of their adolescence, the relatively new concept of being a "teenager" emerged as a phenomenon in American culture.[14] Along with *Archie Comics* came a new industry serial, *Young Romance*, specifically marketed to teenage girls. While the early romance comics instructed girls on the etiquette of becoming a lady, later comics concentrated on tales of disappointments in love, the awkwardness of sexual desire, and the harrowing fate of "fallen" women.[15]

As the nation's youth became more and more resistant to the rigid conventions of the day, authorities pointed to comics, at that time estimated to be selling 70 to 150 million copies per month, as a culprit in juvenile delinquency, citing the "chronic stimulation, temptation, and seduction" found in their pages.[16] In *Seduction of the Innocent* (1954), psychologist Dr. Fredric Wertham placed crime and horror comics at the foundation of youth delinquency.[17] In 1955–56, a Senate Judiciary Committee Hearing determined that not only did the violence found in this genre of comics create emotional pathology, but that the actual techniques used to commit violent crimes could be learned from its pages. It concluded that "the welfare of this Nation's young makes it mandatory that all concerned unite in supporting sincere efforts of the industry to raise the standards of its products and in demanding adequate standards of decency and good taste."[18]

The comic book industry responded quickly to the Senate hearings, forming the Comics Magazine Association of America, which placed The Comics Code Authority Stamp on books before they reached the newsstand. But the damage was done. Even with the return of the action comic genre and the introduction of new characters, the industry could not rally, and it experienced further decline once television made its ubiquitous intrusion into the American household. Early television programming, presented as an alternative to the "disturbing" effects of comics, consisted of comedy programs, television theatre, quiz shows, and variety programs with an emphasis on family values and good clean fun.[19]

However, while the fifties is considered the "last age of morality, patriotism, law and order, [and] popular culture which was pleasing, not shocking," the social and political events that occurred over the decade set the stage for the cultural revolution to come.[20] The Civil Rights Movement went into full swing with the 1954 Supreme Court decision *Brown v. Topeka Board of Education;* America's military, having entered and exited the Korean Conflict, was now poised for action in Vietnam; and the secure framework of morality, authority, and discipline was disintegrating under the weight of social and political change.[21] By the early 1960s, the transition taking place in the sociopolitical and economic landscape had left the nation in a state of flux. And cartoons, which for over half a century had given voice to the voiceless, advocated for political and social reform, provided hope at moments of national despair, taught morality and social etiquette, and reflected a nation's hysteria and paranoia, found a resurgence in American Pop Art.

Pop

From the end of the Second World War to the late 1950s, the Abstract Expressionist movement ruled the art world.[22] Rejecting figuration as an albatross of European tradition, the movement considered its "raw" and "process" paintings as a way to project from a pool of nothingness the deep and most visceral utterances of the American spirit. This bold embrace of America and the shift away from figuration were due in part to a desire for a "conscious break from Europe and the European past, something distinctly American with a raw newness rather than tradition."[23] Having matured in the wake of the Great Depression, with some even serving in the Second World War, these painters wanted to create a *heroic art*.

In the late 1950s, artists began to break away from the movement and returned to an unabashed figuration, incorporating the techniques and iconography of an earlier illustrative heroic genre, the comics. Philip Guston was the first to reintegrate the visual formula of flatness and figuration into the Abstract Expressionist vocabulary in a direct challenge to that aesthetic. Returning to his earlier use of figuration in his 1930s protest paintings, Guston eventually took up the iconography and simplified form of the comic strip, drawing on such comic sources as *Mutt and Jeff, The Grumps,* and *Krazy Kat*.[24] Historian Ronald Paulson has speculated that Willem de Kooning and Arshile Gorky, rather than Guston, were the first Abstract Expressionists to use the iconography of comics.[25] But Guston's desire to capture the confluence of this prevalent visual language and the more conceptual and ideal practice of abstraction left an indelible mark.

It was left to Roy Lichtenstein, who also integrated images of popular culture into his abstract paintings, to wholly embrace a public idiom steeped in figuration. His arrival at a Pop sensibility that sought to appropriate images from popular culture, mass media, comics, and advertising was part of a prolific synergism. The moment of Pop Art's crystallization as a recognized phenomenon came in New York when Ivan Karp, then with Leo Castelli Gallery, noticed that both Lichtenstein and Andy Warhol were using comics in their work. At that time, Warhol was working as a commercial artist when he approached the prominent New York art gallery with his work. As curator Henry Geldzahler later said to Warhol, "It was like a science-fiction movie—you Pop artists in different parts of the city, unknown to each other, rising up and out of the muck and staggering with your paintings in front of you."[26] Although Warhol initially showed his cartoon-referenced paintings in his store window displays at Bonwit Teller, a New York department store, they later appeared in art museums featuring his work. Warhol and Lichtenstein served as the frontrunners to this new brand of artistic expression, which quickly brought under its rubric artists from around the United States.

The radical commentary of depicting a banal subject matter complete with the flatness of its original context within the hallowed realm of the fine arts was significant in its lack of reverence for the lofty ideals expressed in earlier decades. This push against the "authority of aesthetics" came to a nation overrun with a commercialism brought on by the marvels of modernization and rapid technological advances. While many early critics of Pop Art dismissed the movement as vulgar, the movement would prove redemptive in its ability to provide new "legibility" to the fine arts.[27]

In fact, early paintings by Lichtenstein and Warhol that used popular icons found in comic strips and Walt Disney films were rendered by hand and with a pronounced distinction that spoke to the artists' individual approach toward painting. Warhol's 1961 paintings included *Dick Tracy, Batman, Superman, Nancy,* and *Saturday Popeye.* Two years later, Lichtenstein took *Forget It, Forget Me!* (1962, pl. 13), one of his earliest paintings, directly from Tony Abruzzo's

illustrations in *Girl's Romance* comic book, with minimal editing of composition and text.[28] Warhol soon moved away from the iconography of the comics for subject matter he knew best from his work as a commercial illustrator, and he took up silkscreen technology that more closely replicated the techniques of mass media. Yet while Lichtenstein also turned to mass production techniques, his subject matter changed little over the course of the decade. His initial Pop paintings, featuring characters from Mickey Mouse and Donald Duck to Popeye, are notable for their Benday dots (the residual dots of an industrial printing process), which Lichtenstein reproduced by hand. For Pop artists, the image was "genuinely democratic in its accessibility," functioning as "a mirror to the culture in which it originated."[29]

The use of popular culture iconography specifically appropriated from the comics and even its techniques was also prevalent among other Pop artists, including John Wesley, Claes Oldenburg, Ed Ruscha, Mel Ramos, and Peter Saul. Ramos's early sixties paintings feature comic book action heroes including Batman, Superman, The Flash (fig. 1), Captain Midnight, and Wonder Woman, among many others. Works like *Captain Midnight* (1962, pl. 1) celebrate not only the readability of comics images, but the mythology they suggest. Ramos's impasto painted portraits of action heroes are not about "their status as printed images but as symbols of heroism in a contemporary mythology in which good always triumphs over evil."[30] Lawrence Alloway has argued that "Pop Art is essentially an art that addresses signs and sign systems by using visual material from popular culture that is inherently pre-coded."[31] So, using images of mass media in fine art "involves the confounding of an art of communication with an art of contemplation."[32] Within this context, Ramos was using coded images to speak to the contemplative mythologies lurking beneath the comics themselves.

Pop Goes Splat!

Almost as soon as Pop Art congealed, it began to dissolve in a sea of social unrest and shifting sentiment. By 1963, the American public was in mourning—the assassination of President John F. Kennedy, the increasingly violent resistance to racial integration in the South, and the impending war with Vietnam had left people fractured and anxious. It was at this point that Peter Saul broke the "silence" imposed on social commentary by the Pop Art movement with his perversely altered iconographic images, intentionally constructed to critique the political and social events of the day. His *Superman's Punishment* (1963, not in the exhibition), conceivably a direct response to the assassination of President Kennedy, draws from the action comic strip not only to reference the fall of a superhero, but also to point to the cause of his demise, American greed. Although his strongest images, darkly commenting on the Vietnam War, emerged in the mid 1960s, Saul's *Americans vs. Japanese* (1964, pl. 3) was pivotal in that his use of Donald Duck, a Disney character, did not show the icon as heroic or positive, but rather as a war-loving soldier.

This intentional shift of the mythology of this popular culture icon underlies the present exhibition, which focuses on artists who use the legibility of existing iconography to enter into the debate of social change. *Splat, Boom, Pow!'s* premise is that the system of visual language enabled by the idiom of comics has provided artists with not only a permission to speak, but a means to do so. Even so, this is not an exhibition of social politics, but rather an exploration of the malleable and pervasive language that emerges from the comics—not only the idioms of its iconography and form but also its mythology.

Splat

The appropriation or borrowing of existing popular iconography was an inherent characteristic of Pop Art. Although Andy Warhol's use of iconography drawn from comic books prevailed for only one year, imagery from the comics resurfaced in one of his final print series. The *Myths* portfolio (1981) features archetypes of popular culture including *Superman, Uncle Sam, Santa Claus, Howdy Doody, Dracula, Mickey Mouse* (pl. 2), and Warhol himself as the Shadow, a character from a popular 1940s radio mystery show. Warhol's use of this subject matter in the early 1980s was part of his ongoing effort to mine the most pervasive imagery of the American psyche. His insertion of his own self-portrait, *The Shadow*, implicating himself in that psychological spectrum, though perhaps more as a voyeur of history than one of its icons.

Whereas Warhol presented existing iconography without much alteration, save for the morphing of the Shadow, David Sandlin's work delves into the deconstruction of popular culture icons. Sandlin's suite of Plexiglas-mounted, backlit silkscreen images is drawn from the Disney films *Snow White* and *Pinocchio*. In a way similar to Saul's transformation of Donald Duck, Sandlin distorted the imagery of these icons into satirical, content-driven narratives. *Seven Sips of Sin* (1996), *So-White, So-Pure* (1995), and *Sin-occhio* (1995, pl. 4) suggest darker, seedier alter egos of Disney's well-known icons, based loosely upon Sandlin's own mythology formed around the fictional character of Bill Grimm and his puritanical war against hyperconsumerism, capitalism, and the hypocrisy of modern morality.[33]

Other social conventions are challenged within the work of Enrique Chagoya, a veteran of the identity politics of 1980s multiculturalism who incorporates the existing iconography of comics and animation films in his work to counter social imperialism and the simplified politics of identity. Chagoya's *Les Aventures des Cannibales* (2000) follows the artist's practice of creating a contemporary codex that portrays the history of Aztec culture through the use of ancient mythology and personages mixed with contemporary iconography, thus reevaluating the residual imprint of the past upon the present. Included within this codex are such iconographic images as Wonder Woman, the Cuban revolutionary leader Ché Guevera, neo-Nazis, Aztec gods, and ancient cartography. The codex stands in stark contrast to the more recent paintings like *General Merchandise* (2000, pl. 7), which unabashedly and unapologetically re-presents the derogatory ethnic and gender stereotypes of 1930s and 1940s animations.

Dara Birnbaum and Jennifer Zackin have taken on the iconography of DC Comics' first female superheroine, Wonder Woman. In referencing this icon, both artists underscored the inherent debate between feminists and the character's creator, William Marston, a psychologist who felt that Wonder Woman's feminine supremacy lay in her ability to submit to male domination.[34] Birnbaum's source is the Wonder Woman television series that aired in weekly episodes on ABC in 1976.[35] In *Technology/Transformation* (1978–79, pl. 5), the momentary transformation of the show's protagonist, Lynda Carter, from her alter ego of Diana Prince to Amazon beauty and crime-fighter is captured and repeated over and over in an effort to offer viewers a glimpse into the mystical transmutation of form and being. Zackin's *Wonder Woman Cosmos* (2002, pl. 12) also uses the imagery of Wonder Woman, but Zackin subjects the icon to the Buddhist mandala *Kalachakra*. While the *Kalachakra* is a male deity, the artist uses the pattern for its philosophical underpinning—wisdom and compassion in chaos—creating a new dimension in the preexistent mythology of Wonder Woman.[36]

Cat Chow's *Power Ranger Kimono* (2000, pl. 11) also takes on a debate in feminism. Her use of trading cards depicting a female Power Ranger, a contemporary superheroine of television animation, to construct a kimono, an artifact fraught with the history of female servitude,

is notable. The lenticular images on the cards allow the viewer to see *Yellow Ranger's* transformation. The visually coded transformation of the Power Ranger evokes Birnbaum's maniacally repetitive moment of mystical transformation, both works tracking the shift from ordinary woman into extraordinary being.

Watch My Back (2000, pl. 8), Candida Alvarez's "fabric drawing" of Babar, a children's story character, lures viewers into the double-entendre of Alvarez's aesthetic. The elusive representation of the icon through the artist's obsessive hand-stitched pencil transforms the innocent character into an ethereal mythical being that seemingly appears and disappears into the void. The drawing's title suggests a multitude of meanings, none of which are inherent in the narrative from which the character has been excised. Alvarez's work conveys a narrative that is more reminiscent of urban youth than of the pristine fairy-book world in which Babar resides, thus transforming the icon into a more accessible, contemporary persona.

The narrative force of iconography is deflected into abstraction in the works of Polly Apfelbaum and Arturo Herrera. Apfelbaum's *Townsville* (2000, pl. 9) is one of four works she has created inspired by the Cartoon Network animation series *The PowerPuff Girls*. Holding true to her aesthetic practice of sculptured painting, Apfelbaum uses pieces of dyed velvet to construct abstract portraits of each of the color-determined PowerPuff characters, as well as the town in which they reside. Herrera's *Night Before Last, 5R* (2002, pl. 10) is also taken from a series of large-scale graphic works. This projection of fragments of Disney's *Snow White* underneath myriad markings that all but obscure the image is part of Herrera's ongoing investigation that began with his earlier collage work that incorporated used children's coloring books. Herrera's process emphasizes the readability of an image, exploring how much information is needed before the viewer can legibly read not only the image, but its implied narrative as well. His work makes clear that the imagery of Disney's films is so deeply etched upon the American consciousness that the partial dissolution of its iconography can never truly accomplish its complete anonymity.

Boom

One significant aspect of the Pop Art movement, beyond its integration of images drawn from popular culture, was its appropriation of the visual methods of mass communication. The comic strip built within its visual language a vocabulary of idioms, a formulation of movement and gesture, narrative, dialogue and thought boxes, as well as a methodology to indicate the passage of time. With their flatness of form and use of color making them inherently germane to Pop Art, the absorption of the comics' techniques and formal structure naturally followed, a practice that contemporary artists would continue to embrace.

Although closely aligned to Lichtenstein's unflinching appropriation of techniques from the comic strip because of his use of Benday dots, German painter Sigmar Polke was never a part of Pop Art in the 1960s. His photo-based paintings, however, embrace commercial production to criticize social consumption. His earlier works taken from magazines and newspapers served to critique the commercialism of 1960s Germany by reflecting its banality. While Polke's subject matter and technique have shifted over the decades, his use of Benday dots has been a recurring element in his oeuvre. In *Untitled* (1994, pl. 14), the artist integrates abstract washes of color with Benday dots.

Liza Lou's *Business Barbie* (1999, pl. 6) provides a contemporary twist on Lichtenstein's and Polke's adoption of the Benday dots. Using glass beads, Lou "pixelates" a popular culture icon, Barbie, herself derived in part from the popular German cartoon character Lilli.[37] However,

unlike her predecessors' later practice of incorporating commercial processes in the creation of work, Lou's digital-referenced production involves the obsessive process of threading and sewing each bead, one at a time, onto the image's frame.

While Ida Applebroog's early use of multiple cells presented sequentially in her paintings is perhaps a consequence of her training in advertising, they are an equally strong element of the comic strip. Applebroog's *Face It, Chaos is Useless* (1980) and *I Hear You're a Terrorist* (1986, pl. 15B) are narrative paintings composed in sequential frames. Applebroog uses the formal aspects of painting and the storyboard format to render the passage of time, allowing the narrative to unfold with each frame. The edited information rendered as fractured narrative can never be recovered, leaving the viewer to resolve each scenario.

Owing her aesthetic direction to the early work of Applebroog, Laylah Ali reasserts the sequential narrative, but not toward the same end as Applebroog. Drawing more from the structure of the comic book than that of the storyboard, Ali allows her viewers to become the direct witnesses of cultures in conflict. Her characters—simplistic, androgynous forms with bulbous heads—would be indistinguishable from one another were it not for the marked difference of their clothing, masks, or weaponry. The flat images (see *Untitled*, 2000, pl. 23), which she has placed under the simple rubric of *The Greenheads*, makes the violent clash of difference ever more disconcerting.

In *Sarajevo, the Serbian Way* (1993, pl 16), Roger Brown also brings the flatness of the image into alignment with sequential narrative. Brown was a member of the Chicago Imagist Movement of the late 1960s, but his work over its history has shown more concern with readability than that of his colleagues. Brown once said, "I'm very interested in simplifying and making a painting easy to read."[38] Brown's social commentary on the war in Sarajevo gains an emotional charge through his creation of many sequential narratives that can be read either across or up and down. Instead of using his usual architectural composition, Brown places the narrative within the frame of a menacing robotic figure, reminiscent of the Transformer toys of the mid-1980s.

Primarily known for his large-scale paintings, Kerry James Marshall has admitted to a childhood love of Marvel Comics. *Another Great Migration* (2002, pl. 22) is his second within a series that uses the actual format of the newspaper comic strip. His first work to adopt this mode, *Rhym Mastr* (1999). Unlike that work, which formed an ongoing narrative, *Another Great Migration* is more of a commentary on the displacement of thousands of Chicagoans living in the Robert Taylor Home Section-8 housing system. Marshall limits the running commentary to only the bottom-eighth of each page, rendering the abbreviated narrative primarily through slang-filled dialogue bubbles delivered by his characters, who denounce their displacement as a grim consequence of capitalistic profit-seeking and commercial greed.

Whereas Marshall's works begin with the creation of a narrative that is then inserted into the format of the comic strip, Michael Galbincea has drawn his *Vectorized Heroes* (2002, pl. 20) from the music of DJ and rapper Kool Keith. Galbincea sees himself as a respectful albeit unauthorized collaborator with the musician, creating images to accompany the lyrics of the rapper's songs. Galbincea's blown-up, single-image panels can be placed within the trajectory leading from Lichtenstein's single-frame works to the freeze frame in current music video production. While Galbincea aspires to visually translate the recordings, he does so in a stop-and-start format, editing out vast amounts of narrative each time before beginning again.

Michael Ray Charles uses the historical framework of the political lampoon in his painting *Re-action Jackson* (2001, pl. 21). The image is steeped in Charles's aesthetic practice, which draws from advertising, comics, and the nineteenth-century illustrations of Currier and Ives. In

this work, however, Charles's intonation of caricature suggests a political critique of the Reverend Jesse Jackson as more of an opportunist than a negotiator. Yet the flatness of the painting and its exaggeration of form suggest a visual corollary to both historical and present-day political cartoons.

The use of exaggerated forms and color makes Elizabeth Murray's surreal abstracted forms leap from their canvases in daydreaming play. Indeed, Murray has long experimented with imagery, color, and form, bringing elements of both Constructivism and Surrealism to her work. In *Cloud 9* (2002, pl. 24), the frame is literally unhinged by cartoon-like forms and objects. Murray has said that her use of color and figurative exaggeration was inspired by cartoons: "Cartoons were the first art I saw. I loved them. I had comic-books for the pictures more than for the little stories. So the images, the shapes, the movement . . . are all there from the beginning."[39]

Jason Dunda also draws his works from the well of cartoon iconography. His small paintings are minimalist renderings of comic book idioms that convey a sense of nostalgic melancholy. In *Supergirl's Bedroom* (2000, pl. 19), Dunda has altered an existing comic strip panel from the series to create a stark and bare refuge for the young superheroine. The punctuated gesture of a lone, wind-blown curtain infuses a sense of life, occupying the space and suggesting clues to an otherwise elusive narrative. As with Herrera, Dunda provides minimal information, hoping instead that through form and color, the image will be instantly recognizable.

The use of the comic genre's lexicon to convey war and conflict is prevalent in Julie Mehretu's *Bombing Babylon* (2001, pl. 18). Mehretu is best known for her deliberately pristine architectural paintings that depict the mass migrations of civilizations from one realm to another. Her laboriously painted works incorporate architectural drawings overlaid with markings to denote the changing histories of civilizations and the displacement of people due to war and conflict. The subtlety of the warfare portrayed in the gestural idioms taken from cartoons extends the tension of Mehretu's "history maps," showing a world in transition.[40]

The work of Kara Maria is equally concerned with the self-annihilation of humanity. Her abstract compositions virtually vibrate with a futuristic *anime* quality, due in part to Maria's love of comic books and in part to her interest in the Japanese wood-block prints that she copies, dissects, and integrates into her paintings. Maria uses rich color saturation in both *L'Éclair* (2000, pl. 17) and *Boom* (1999). Where *L'Éclair* suggests an extension of depth through its composition and color, *Boom* radiates with a flatness more reminiscent of the painting in California in the 1950s and Pop Art in the 1960s.

Pow

By the late 1960s, a multitude of subcultures had evolved in America. The buzz of multiculturalism that emerged in the 1980s was reflective of a generation that had experienced integration and in having done so, felt the acute need to be seen as unique within the mainstream. Many artists, however, understood that racial or ethnic identity could not be entirely monolithic and began to insert more complex narratives into their work, pointing to a cultural allegiance by choice rather than from socioeconomic determinants. Living on the multicultural fringe allowed many artists to disengage from the usual cultural imagery and create new iconographies for themselves. This self-created iconography, liberated from conventional traditions, could then more sincerely reflect the ethos of a given subculture through the evolution of both alter egos and personal mythologies.

Perhaps one of the most remarkable of the artists examined within this section is Henry Darger, a self-taught artist whose 15,000-page mythological epic *The Story of the Vivian Girls, in what is Known as the Realms of the Unreal, of the Glandeco-Angelinnian War Storm, Caused by*

the *Child Slave Rebellion* (1957–67) is included in this exhibition. In this work, a narrative text accompanies a visual explosion of imagery taken from all facets of popular culture, including cartoons, paper dolls, mail order catalogues, stamps, and of course Darger's vivid imagination, which rendered his child subjects as nude, transsexual, sadistic, and violent.[41] A reclusive and religious man, Darger's exhaustive mythmaking astounds his viewers. The three double-sided images that appear in the exhibition (see pls. 25A & B), are excerpts taken from Darger's epic that chronicles the *Vivian Girls* as hostages of war and later as liberated children.

Keith Haring and Jean-Michel Basquiat would become equally famous purveyors of mythology as it related to the East Village scene in New York, first honing their practice on the streets with their graffiti work. Haring's amorphous images of humans devoid of identity became his trademark as both a graffiti writer and a contemporary artist. In his series *Subway Drawings* (1980–83), his spontaneous one-take drawings were as forward-looking in their political and social commentary as was his methodology in the arena of street art. He paid homage to the 1980s counterculture in an untitled 1986 series that features three skateboards celebrating skateboard culture (see pl. 26); the power of the individual over the establishment; and the presence of homosexuality in American life.

Basquiat's consciously crude and schematic images were as much an anomaly in art galleries as they were on the street. Alongside his scrawled messages and intuitive drawings, Basquiat would place his street "tag" or signature, accompanied by a copyright insignia. Historian Allen Schwartzman has described this "copyright protected" tag as an irreverent self-accreditation formulated to criticize standard corporate ownership.[42] The death of SAMO (same old shit), Basquiat's tag and street alter ego whose celebrated messages of anti-materialism had amassed a cult following, sent reverberations throughout the streets of Manhattan. However, Basquiat had merely retreated from the streets to transform and reassert his alter ego on canvas, blending graffiti with Afrocentric themes into a personal language. In Basquiat's *Untitled* (1985, pl. 28), the artist inserted himself as a silhouette, unusual in that the artist had historically used symbols like a crown to signal his presence. Basquiat's shadowy presence here mirrors Warhol's insertion of his self-portrait in the 1981 *Myths* portfolio, but it is perhaps also influenced by the work of street artist, Richard Hambleton, whose series of silhouettes appeared throughout New York City's five boroughs in 1982.

Kenny Scharf met Haring while both were students at New York University. The two became roommates, but their practices would remain vastly different. Scharf began by painting from the existing iconography of televised animation series including *The Flintstones* and *The Jetsons*. His manipulation of these icons as well as his re-presentation of their environs gave him a voice on many social issues. However, it was not until 1983 that Scharf began to create and experiment with his own creations. *Fun's Inside* (1983) marks the artist's shift to the creation of his own character, loosely based upon Felix the Cat and accompanied by an expansive narrative. Scharf's mythology later evolved to include new characters, among them the angular and rigid figure in *Power Happy* (1986, pl. 27).

Like Haring, Basquiat, and Scharf, George Condo belonged to the 1980s New York East Village scene. Condo's experimentation in merging the figuration of cartoons and television imagery with the more reverent figuration of Pablo Picasso, Diego Velázquez, and the old Dutch masters enabled the artist to create a new iconic character that reflected his own schisms in art making. Condo developed this imagery in Warhol's Factory, where he executed multiple silkscreen paintings for the artist. Condo's adeptness in silkscreen technology as well as in traditional oil painting let him move fluidly between these two worlds. The tension of this continuous

shifting creates a psychological profile of the artist's alter ego. A recent work, *The Stockbroker* (2002, pl. 38) is a continuation of this iconic figure.

The lone surfer is the subject of a series of untitled drawings that Raymond Pettibon created from 1990 to 2001. Pettibon's drawings in this exhibition (see pl. 29) reveal both the artist's personal relationship with the character of the surfer as well as his desire to represent the ethos of that community.[43] The surfer, one of a series of alter egos for Pettibon, parallels other recurring characters such as Superman, Vavoom, and Charles Manson. Pettibon's ink-washed figures, coupled with his enigmatic phrasing and texts, have served both mainstream and underground culture, but none more profoundly than the underground music scene of the early 1980s, when Pettibon produced album covers and flyers for the band Black Flag.

A common element in the work of many of these artists is the complexity of identity. For Roger Shimomura, Renee Cox, John Bankston, Trenton Doyle Hancock, and Robert Pruitt, the notion of identity no longer resides in the understanding or acceptance of a monolithic whole, but rather in the multidimensionality of each individual.

Roger Shimomura's painting *Jap's a Jap: #6* (2000, page 2) draws on the imagery of ethnic stereotypes rampant in 1940s animation. The duality of the painting's protagonist, a hybrid image of stereotype and icon, becomes itself a reverberation of two histories that are now inextricably linked, an expression of how diversity manifests as an act of uneasy coexistence. In *Jap's a Jap: #2* and *Frat Rats*, both created in 2000, Shimomura more explicitly embraced the derogatory Japanese stereotype as a direct persona. In *Jap's a Jap: #2* (pl. 31), the artist has reproduced actor Mickey Rooney's dance scene in the movie *Breakfast at Tiffany's*.

Whereas Shimomura embraces an existing iconography with regards to race, Renee Cox does the opposite. Through her works, she creates a stage for "Rajé," the nation's first Afrocentric superheroine outside of the Blaxploitation films of the 1970s. Cox's unapologetic use of radical political thought, performance theater, and self-portraiture gives the series its mythical realization. Moreover, by blending her work as an international fashion photographer with her more conceptual practice, Cox succeeds in ushering forth the many narratives and iconographic characters embodied in the collective culture. Three works from this series appear in this exhibition: *Taxi, Chillin' with Liberty*, and *Lost in Space* (pl. 30), all from 1998.

Trenton Doyle Hancock has literally created a world of myth to which he is inextricably linked. By centering the character of the "mound" within an inexhaustible narrative, Hancock embraces the mound as an alter ego in a way that has enabled him to mine its deeper complexity. In previous work, Hancock established both the mound's origins and the events shaping its fictional home, as well as introducing the primordial spirits that affect its well-being. But Hancock's large and expansive assemblage paintings depicting epic moments in the mound's history have now given way to more intimate portraits. The works in this exhibition, such as *Esther* (2000, pl. 40), are from Hancock's most recent body of work in which he sheds the largesse of the epic for a personal narrative of his multifaceted self.

John Bankston's large-scale paintings are also about mythology, but his images are more reminiscent of fairy tales or children's coloring books depicting Brothers Grimm-like narratives. Through the narrative's protagonist "Donkey Boy," a black man dressed in seventeenth-century costume with rather large donkey ears, Bankston explores questions about the structure of power in both racial and personal relationships. His paintings *Riding Desire* (pl. 36) and *Taken By Desire* (both 2001) are excerpts from Donkey Boy's adventures.

In contrast to the world of heroic myth, Kojo Griffin's paintings are explorations in the psychology of urban existence. While Griffin's works of 1998 and 1999 were deeply linked to

the emotional and psychological survival of victims of domestic abuse, his most recent work focuses more on urban violence. By using stuffed animals as his characters that behave and apparently feel as humans do, Griffin pulls the viewer into an identification process. His *Untitled (Man with gun, man on knees, man looking at watch)* (2001, pl. 37) evokes a visceral response from viewers by placing them within the context of the unfolding narrative.

Takashi Murakami and Yoshimoto Nara are both known as *shinjinui* (members of the Japanese postwar generation), and both work to conflate the boundaries between commercialism and fine art production. As leaders of the recent Japanese artistic explosion, Murakami and Nara are emblematic of the wide influence of Japanese popular culture both at home and abroad. These two young artists have delved into graphic design and embraced digital technology, taking advantage of the revival of Japanese *anime* and *manga*. But however closely related they may seem to be, their expressions are distinct.

Murakami is a prolific artist due in part to his Hiropon Factory, which roughly translates in English as "hero bang!" As Warhol did in his Factory, Murakami conceptualizes and creates work that is in turn executed by a team of assistants. Within these works, "Mr. DOB" is Murakami's most pervasive icon. Depicted as a peculiar mouse-like creature, DOB is often found amid surreal landscapes. Murakami's *Untitled* (2002), a DVD projection, follows the adventures of Mr. DOB's alter ego i-DOB, a laconic critique of Apple's I-Mac computers. Murakami's *Dream of Opposite World* (1999, pl. 32) that also features i-DOB, serves as a forerunner to the untitled projection. Nara's work, conversely, is unmistakably about childhood—its imagery, innocence, and cruelty. Nara's blending of children's books, graffiti, and punk rock evokes a "push me/pull you" tension in the work. The mood of Nara's images shifts greatly as the artist moves from his sculptures to paintings and works on paper. While the artist's sculptures such as *Quiet, Quiet* (1999, pl. 33) and works from his Little Heads series featured in this exhibition exude blissful serenity, his paintings and drawings denote the awkward angst and dark moments of youth.

The work of Robert Pruitt and David Shrigley share the quirkiness of youthful irreverence. Both artists are firmly positioned under the rubric of Conceptualism with works that have taken form as sculpture, works on paper, and in the case of Pruitt, video. In this exhibition, Pruitt's *Black Stuntman* (2002, pl. 39A–D) is a low-budget animation short that follows the mishaps of the ultimate black antihero. The wry voice-over narration by the artist of the Stuntman's adventures serves to further expand Pruitt's humorous critique of identity politics. Shrigley's work also celebrates the ordinary. His witty one-liners are double-signified through both image and the accompanying text. Shrigley's titles for his works, as evident in *Untitled (Tom Thumb)* (2000, pl. 35), are also tied conceptually to a larger communal language derived from the visual vernacular of his offbeat humor.

It's a Wrap!

The impact of cartoons upon American society has been extraordinary. For over a hundred dred years, cartoons have provided a means of visual communication adept at rendering the ethos of America. For that reason, the absorption of cartoons within the fine arts was inevitable. From the Abstract Expressionism of the 1950s to today, cartoon imagery and techniques have provided a means for artists to both mirror the changing social landscape and assert their own understanding of its evolution. *Splat Boom Pow!* has attempted to replicate this practice by providing a context that chronicles both the development of the cartoon genre as well as its absorption and permutation into the fine arts.

The role of the cartoon genre within contemporary art spans a forty-year period and extends

over three generations of artists. This bridge between the artistic production of Pop Art and the current practice of today, offers viewers a means to see and understand cartoon-influenced work within a broader context. Ultimately the work of these artists is about the pervasive desire for myth and the development of a collective visual language built upon the prevailing structure of cartoons, that amassed an indelible repository of idioms throughout the century. Through their systematic integration of the cartoon genre—its iconography and techniques—the forty artists in this exhibition have created work whose resilience derives from its legibility and serves to extend the dialogue between art and the greater social landscape.

NOTES

1. Ted Sennett, *The Art of* Hanna-Barbera: *Fifty Years of Creativity* (New York: Viking Studio, 1989), p. 79.
2. Matt Groening and Jesse Leon McCann, *The Simpsons Beyond Forever!: A Complete Guide to our Favorite Family . . . Still Continues* (New York: Harper Perennial, 2002) p.10
3. Maurice Horn, *100 Years of American Newspaper Comics* (New York: Random House, 1996), p. 163.
4. Ibid., p.12.
5. Winthrop D. Jordan, Miriam Greenblatt, and John Bowes, *The Americans: The History of a People and a Nation* (Evanston, Ill.: McDougal, Littell, 1985), pp. 415–24.
6. In the book, *Mein Kampf [My Struggle]*, Hitler cites the theory of the "master race" as blond and blue-eyed Germans. He denounces several "races" such as Jews, Slavs, and other non-whites as an "inferior" element that only promotes a contamination of society. These inferior races, Hitler goes on to state should either be exterminated or subjected to servitude.
7. Winthrop, et al., p. 642.
8. For example,Superman saves a prisoner from a lynch mob, confronts domestic abuse, and unmasks a corrupt senator in *Action Comics #1* (1938) and reveals unsafe mining conditions in *Action Comics #3.*
9. Les Daniels, *Sixty Years of the World's Favorite Comic Book Heroes* (New York: DC Comics, 1995), pp. 46–49.
10. Ibid., pp. 64–65.
11. Ibid., p. 65.
12. Michael Barson and Steven Heller, *Teenage Confidential* (San Francisco: Chronicle, 1998), pp. 18–22.
13. Ibid., p. 30.
14. Ibid., jacket notes.
15. Ibid., p. 106.
16. Daniels, p. 114.
17. Ibid.
18. Harley M. Kilgore, quoted in Senate Judiciary Committee, *Comic Books and Juvenile Delinquency, Interim Report,* 84th Congress, 1955–56, pp. 1–17.
19. Michael Barson and Steven Helier, *Teenage Confidential* (San Francisco, Chronicle, 1998), p. 9.
20. Arthur Marwick, *The Sixties: Cultural Revolution in Britain, France, Italy, and the United States c1958–c1974* (New York: Oxford University Press, 1998), pp. 3–4.
21. Ibid., p. 3.
22. Mark Rosenthal, *Abstraction in the Twentieth Century: Total Risk, Freedom, Discipline* (New York: Guggenheim Museum Publications), pp. 93–96

23. Ronald Paulson, *Figure and Abstraction in Contemporary Painting* (New Brunswick and London: Rutgers University Press, 1990), p. 39.
24. Ibid., p. 109.
25. Ibid.
26. Carter Ratcliff, *Andy Warhol: Modern Masters* (New York: Abbeville, 1983), p. 21.
27. Pop artists were called the New Vulgarians in an article written by Max Kozloff for *Art International*'s February 1962 issue.
28. Lichtenstein's admiration for the work of Tony Abruzzo and Russ Heath's military comic strips may be linked to his connection with Irv Novick, who had been his superior officer during his tour of duty in 1947. See Les Daniels, *Sixty Years of the World's Favorite Comic Book Heroes* (New York: DC Comics, 1995)
29. Marco Livingstone, *Pop: An International Perspective* (New York: Rizzoli, 1991), p. 15.
30. Ibid., p.72.
31. Carol Anne Mahsun, *Pop Art and the Critics* (Ann Arbor, Mich., and London: University of Michigan Press, 1987), p. 17.
32. Ibid., p. 47.
33. David Sandlin, conversation with the author, March 2002
34. Daniels, p. 61.
35. Ibid., p. 171.
36. Jennifer Zackin, conversation with the author, March 2002.
37. M. G. Lord. *Barbie: The Unauthorized Biography of a Real Doll.* (New York: William Morrow and Company, 1994).
38. Roger Brown, quoted in Sydney Lawrence, *Roger Brown* (New York: George Braziller and Washington, D.C.: Hirshhorn Museum and Sculpture Garden, 1987), p. 13.
39. *Elizabeth Murray: Recent Paintings,* exh. cat. (New York: PaceWildenstein, 1997), p. 8.
40. Laura Hoptman, "Crosstown Traffic," *Frieze,* vol. 104, September–October 2000.
41. Michel Thévoz, *The Strange Hell of Beauty,* exh. cat. (New York: Abrams, 2001), p. 15.
42. Allen Schwartzman, *Street Art* (New York: Dial Press, 1985), p. 31.
43. Robert Storr, Dennis Cooper, and Ullrich Loock, *Raymond Pettibon* (New York: Phaidon, 2001), pp. 8–25.

Against Nature

Bernard **WELT**

(Cartoonish rendering of an archetypal Southwest desert scene. In the background, distant buttes and mesas, ochre sand, pale blue sky, cotton-ball clouds; in the foreground, a massive, flat red cliff face. A weary figure in a mangy gray coat occupies himself with the contents of an open cardboard box, emblazoned with a single word: "ACME.")

I know what you're thinking. Everyone wants to know the same thing: What would you do with him if you *did* catch him?

Well, in case you haven't noticed, there's not much else to eat around here. *(He produces from the box a round black bomb labeled "BOMB," tossing it from hand to hand before setting it down.)* This is what hunger drives a body to—running down the road, legs spinning in a cartwheel, my tongue hanging out, knife and fork in hand, a napkin tied around my neck, all ready to commence the feast, and I can't even *see* the creature I'm chasing. Can you beat it? What I'm running after is just a featureless dot that fades in the distance, lifting the ribbon of road up along with it as it zooms away—a cloud of dust, a blur of colors that forms and reforms before me, faster than life itself. Sometimes it occurs to me it isn't a meal I'm pursuing at all. It's my own hunger, abstracted from my body, always unsatisfied, uncatchable, unconquerable, forever leading me on.

(He hauls out of the box an enormous horseshoe-shaped magnet.) It's impossible to understand. I don't mean I'm trying to understand him. I don't want to understand him. What I want is to eat him.

Then he stops dead in his tracks like that, just staring at me, calm and curious. He's not afraid, he's not even angry at me for focusing the whole of my existence on ending his life, and he's close enough for me to reach out and throttle his scrawny neck, but I know that if I do, he'll be off in another incomprehensible blur, and the whole ... *atmosphere* around here will suddenly go all abstract....

Time stops.

You bet I'd eat him. I'd swallow him whole if I could, just so I'd know it was him I was eating and not that collection of random parts I see speeding by me, sticking out akimbo from a rumbling cloud of dust.

(He pulls a crossbow out of the box and checks its mechanism.) The thing is, the natural rules just don't seem to apply here. I mean—me, predator; him, prey. "Me" should knock him out of the running with one swipe of my paw; "him" should be one tasty, not very memorable meal. Then I'd sleep and wake to hunt another day. But no. Instead Nature says, "Just hang on a second there, partner." OK, OK, sometimes the hunt has to end in failure; sometimes the prey lives to run again. And OK, yes, usually that's when things start to get interesting. That's when you feel the joy of being a hunter, when things don't come easy, when you have to use more than muscle to get by, when you have to employ all your cunning to trap your foe. When you

fig. 6 Chuck Jones, I Think Therefore I Acme (Wile E. Coyote and Road Runner), *2000. Limited edition animation cell. Characters, names, and all related indicia are trademarks of Warner Bros. © 2001. Courtesy The Chuck Jones Studio Galleries, Laguna Beach, California*

see your quarry speed by and you know all his old tricks and he knows yours and you realize, with a flash of insight that surpasses mere poetry—because, you see, it's not just a rootless perception; it serves *hunger*—that it's you or him. And this plan you form, it's going to keep you alive another day by feeding your belly with fresh meat—this plan, *this* plan's going to work. . . . *(He regards the box dolefully.)* And it doesn't work, and I go hungry again.

(He draws a boomerang out of the box and contemplates it.)

Maybe there's a lesson in this I haven't learned.

(Through the following, he extracts from the box and briefly inspects in turn a large steel spring, a harpoon gun, a length of rope, a shotgun, a pogo stick, a couple of grappling hooks, a pressure cooker, an unfurled parachute, several red cylindrical sticks of dynamite labeled "TNT," a unicycle, a handful of eggbeaters, a toy piano, a mini-trampoline, a pair of skis, a gaily striped parasol, a jet-propulsion pack, a slingshot, a hand grenade, a miniature windup flying saucer, a bunch of bananas, a pair of roller skates, and a huge set of Leonardo da Vinci-looking canvas wings.)

Do I . . . overcomplicate things? It occurs to me that when life gets that complicated, you are trying to do something that's either absurdly simple or totally impossible. But you have no idea which it is.

I'll give you an example: I set a trap that doesn't depend on anything but gravity to work. Huge boulder leans on little rock. I knock little rock out of the way as fellow creature passes. Huge boulder falls. Fellow creature on this earth is crushed and broken—*tenderized*, you might say. Gravity. Good, old, dependable, ineluctable gravity. You might say it isn't even my doing—it's gravity that's responsible. Gravity's a *natural law*.

But what happens? Huge boulder teeters, sways, and falls back in wrong direction—*against* gravity. It can't be, you think. There's no mighty wind sweeping down the desert, no sudden shift in the earth's axis, nothing to explain this departure from the ground rules I have every right to expect will hold in every encounter between object and object on earth.

Is there something I've failed to observe? OK, try again. Huge boulder, little rock, *meep meep*, knock rock—boulder falls wrong way. OK, there are flukes in the web of this world. There are unexplainable deviations from the rules, so move on. Try again, try, try again. Boulder, rock, *meep*, rock knocked—boulder falls wrong way. OK, life's a mystery. Try again. Rock, knock, wrong way—again and again and again.

And it doesn't just fall the wrong way, understand. It falls *on me*. Somehow this gravity, which cannot be counted upon to act justly when it has every opportunity to push a boulder in the correct, predictable, indisputably sanctioned direction, seeks me out to bring the whole weight of the boulder down on me. Not once, but over and over.

It ought to be simple: I fire gun, bullet emerges at high speed, bullet strikes object in path, object falls—I eat object. But what happens? Bullet pursues object, object speeds on oblivious, bullet strains and strains to catch up, bullet sweats and pants, huffing and exclaiming, object outruns bullet—bullet gives up. The bullet . . . gives . . . UP!

(Finally he draws out of the box with evident effort an outrageously oversized anvil, nearly as large as himself, sets it on the ground beside him, and leans on it, panting.)

Of course, if you stood outside of it, just watching it all, you could almost see a kind of humor in it.

I have scaled the sides of cliffs, I've flown weightless through the clouds, I have been catapulted, springboarded, and shot out of a cannon, and only one law seems to apply: Whatever energy I expend on survival rushes back at me with murderous force, marshalling the whole environment against me. Every ascent ends in an opposite and unequally fatal descent. All paths lead downward, and as I fall, I grow smaller and smaller. I watch myself plummet, a tiny dot reaching dead center of my mind's eye.

Anyhow, they always say it's only that last inch or so that's the killer. Gravity would be no problem at all if it weren't for the earth entering into the picture at the last moment.

Things are different here. *(He gestures to the cartoonish backdrop.)* Speed and rest, breadth, depth, and extension are not physical characteristics of objects here. They are just means of measuring hunger and suffering. Nature is a collection of momentarily distracting illusions, as flat as roadkill. It's only the pain that's real.

(He produces a few cans of paint and some brushes. As he speaks, he paints a white line on the floor, ending at the backdrop. Then he begins to outline a large parabola in pitch black on the cliff face.)

There's a story everyone knows around here: The tortoise and the hare had a race. All the animals turned out for the fun—not that there was any question who would emerge as the winner, for the hare was by far the fastest among them. Now, you may have heard this tale, how the hare—delicious hare—was so confident that he diddled away his time while the tortoise, slow and steady, won the race. But that is not how I heard it.

The hare took off at a good pace and, looking back, saw the tortoise, who appeared to be standing still. No, the hare realized, he's just moving so slowly you can hardly perceive the motion. This is his life, the hare thought. Moving from one moment to the next so slowly that everything seems to stand still. And how does he tell one moment from another, the hare wondered.

(He paints, in gray, a road running up through the tunnel he's created, then the light at the end of the tunnel, with a tiny view of the horizon beyond.)

No, no, the hare decided, he *is* standing still. Then the hare stopped a moment, and after a bit, he looked again and thought the tortoise had indeed moved. So he stopped and stared, trying to reason it out for himself: Was the tortoise, in his essence, a series of stock-still moments, each to be considered separately for its separate quality, or was he one uninterrupted, unceasing flow? Somehow this was a very intimidating idea. And as he stared, paralyzed by thought, it seemed the tortoise zipped by him, faintly bleating … *meep meep.* And then the hare began to run, to run as fast as he could *(he pantomimes running)*, coming closer and closer to the speeding tortoise, but never quite catching up, till they were almost at the finish line. Yet it seemed to the hare, as in a dream, that he had to cover many times the distance the tortoise had to just in order to keep up.

It was that *laaaast* inch that was the killer.

(He draws the diminishing white line that connects his three-dimensional space to the painting of the tunnel in one unbroken perspective.)

Do you ever consider your own … unreality? How could you prove to a scientific tribunal that you have real existence beyond the dumb solidity of your body as an object, comprising a dumb collection of physical qualities: height, weight, boiling point? And what if they said, "What is this weight you speak of? What is height? What is depth?" Or do you feel you are a collection of incidents? Of episodes? Daredevil adventures, near misses, thrilling pursuits, hair-raising escapes?

What am I doing here? Am I here just as a force to give gravity some counterweight, to foil the natural order of things once in a while—always to my own disastrous disadvantage? To give gravity something to do?

I don't have any answers. I don't even have a point of view. I'm only asking you to think things over. To be a little more skeptical of the evidence of your senses and the ideas you usually resort to in interpreting that evidence. After all *(he admires his handiwork)*, I'm an artist, not a philosopher.

Anyway, no one could argue that I would make a trustworthy guide to life's deeper mysteries. It seems to be part of my character to carry on as if each day were my first on earth, relentlessly ignoring the lessons of experience. Painting a road on a wall, for instance, is one thing—but *choosing to take that road?*

(He steps back, runs up the white line on the ground headed for the tunnel, and slams into the wall, then crumples slowly to the ground. Stars and cuckoos circle his head, then fade. He grins ruefully.)

Back to the old drawing board. *(He pulls himself up.)*

This one may not work. The next one may not work. The one after that may not work. The one after that may not work. The one after that may not work. The one after that may not work.

But can I really go on losing forever?

I realize this has to stop somewhere—but, dammit, I keep *getting new ideas.*

(He falls back, exhausted, with the sound of a hammer striking an anvil.)

END

In memory of Chuck Jones, 1912-2002

1842

The Adventures of Mr. Obadiah Oldbuck by **Rodolphe Topffer**. First graphic novel published in the U.S., reprint of French original, *Histoires en estampes Monsieur Vieux-Bois* (1837). Humorous tale about a drunk man's suicide attempts after losing his lover.

1849

Journey to the Gold Diggins by Jeremiah Saddlebags by brothers **James A.** and **Donald F. Read**. First known original American graphic novel. Adventure story about the California Gold Rush.

1865

Max and Moritz by **Wilhelm Busch**. First modern comic strip, appearing weekly in European magazines. Was redone in 1897 for the U.S. as *The Katzenjammer Kids* by **Rudolph Dirks**.

1907

A. Mutt, later known as *Mutt and Jeff*, by **Harry Conway "Bud" Fisher**. Became the first highly successful daily comic strip. Fisher became the first millionaire cartoonist.

1910

First appearance of **Krazy Kat** by cartoonist **George Herriman**. Later became a popular and highly influential comic strip series.

1916

Out of the Inkwell by **Max** and **Dave Fleischer**. The **Fleischer Studio** would later create the popular **Betty Boop**, **Popeye**, and **Superman** cartoons.

1919

Felix the Cat debut by **Pat Sullivan**. First internationally successful cartoon character. The animated shorts were directed by **Otto Messmer**.

A Cartoon Timeline

Jamie COVILLE

1842

1905

THE FELIX ANNUAL

ADVENTURES OF THE FILM CAT

1919

FAMOUS FUNNIES

100 COMICS AND GAMES·PUZZLES·MAGIC

1934

1894

Hogan's Alley (with **The Yellow Kid**) by **Richard F. Outcault**. First comic strip to appear in newspapers rather than magazines. Ran in the *New York World*.

1905

Little Nemo in Slumberland by **Winsor McCay**. Imaginative and brightly colored Sunday comic strip by one of the early pioneers in animation. McCay later created animated cartoons featuring **Little Nemo** (1911) and other characters like **Gertie the Dinosaur** (1914) .

1906

First animated cartoon *Humorous Phases of Funny Faces* by American cartoonist and filmmaker **James Stuart Blackton**. Followed by *Phantasmagorie* (1908) by **Emile Cohl** of France.

1928

Mickey Mouse debut in the early sound cartoon *Steamboat Willie* by **Walt Disney** and animator **Ub Iwerks**. The hugely successful cartoon launched Disney's empire.

1929

Buck Rogers by **Philip Nowlan** (drawn by **Richard Calkins**) and *Tarzan* by **Edgar Rice Burroughs** (drawn by **Harold "Hal" Foster**). Also making its debut in *Thimble Theatre* was *Popeye* by **E. C. Segar**.

1934

Famous Funnies. First successful continuing newsstand comic book. Its 218 issues reprinted many successful comic strips until it ceased publication in 1955.

1935

Porky Pig debut in *I Haven't Got a Hat* directed by **Friz Freleng**. First major character from **Warner Brothers** studio. **Daffy Duck** followed in 1937.

1935

Little Lulu by **Marjorie Henderson Buell**. First appearance in *The Saturday Evening Post*. Her popularity led to comic books and cartoons.

1937

Snow White and the Seven Dwarfs by the **Walt Disney** studio. First full-color American animated feature. A box office smash making $8 million.

1938

Action Comics #1, with first appearance of **Superman** by **Jerry Siegel** and **Joe Shuster**. The first superhero, Superman would define the medium of comics for decades.

1940

The Spirit by **Will Eisner**, a sixteen-page weekly newspaper booklet designed to compete with comic books. Eisner's experiments with story-telling techniques influenced later artists.

1941

Classic Comics, later called **Classics Illustrated**. Adaptations of great novels into comic book form. Seen as having added prestige, *Classic Comics* garnered both praise and condemnation from educators.

Pogo debut in a story by **Walt Kelly** in the **Dell** comic book **Animal Comics**. **Albert the Alligator** was featured on the early covers. **Pogo** finally made the cover of issue #17 in 1946. The newspaper comic strip **Pogo** later became famous for attacking Senator Joseph McCarthy during his Communist witch hunts.

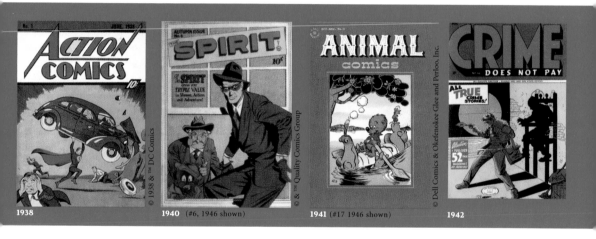

1938

1940 (#6, 1946 shown)

1941 (#17 1946 shown)

1942

© 1938 & ™ DC Comics

© & ™ Quality Comics Group

© Dell Comics & Okefenokee Glee and Perloo, Inc.

1939–41

Appearance of more superheroes: **Batman, Wonder Woman, Captain America, Captain Marvel, Plastic Man,** and others.

1940

Tom and Jerry debut in **Puss Gets the Boot** made by **William Hanna** and **Joseph Barbera** for **MGM** studios.

Bugs Bunny debut in **A Wild Hare** directed by **Tex Avery** for **Warner Bros.** Became one of the most popular animated characters in the world.

Woody Woodpecker debut in the Andy Panda cartoon **Knock Knock** by **Walter Lantz**. Most successful cartoon character from the Walter Lantz studio.

1941

Archie Andrews debut in backup story by **Bob Montana** in **Pep Comics #22**. The character and **Archie Comics** would become hugely popular.

Military Comics #1, featuring **Blackhawk**, the Polish leader of a specialized aviation team which fought the Axis powers. Created by **Will Eisner**, this was among the most successful non-superhero war features, remaining popular long after WWII ended.

1942

Crime Does Not Pay. Hugely successful comic book exploiting violent and uncensored tales of crime. It and its many imitators, including a new horror genre, came under fire by critics of the comics industry.

1942

Donald Duck's first appearance in comic books, as written and drawn by **Carl Barks**, in Walt Disney's *Four Color Comics #9*, vol. 2. Barks, who later created **Uncle Scrooge**, influenced several generations of comic storytellers with stories that are still popular today.

Supermouse, better known as **Mighty Mouse**, debut in *The Mouse of Tomorrow*. Very popular character from **Terrytoons** animation studio.

1944–46

Appearance of increasingly popular **Warner Brothers** cartoon characters: **Sylvester the Cat, Tweety Bird, Pepe Le Pew, Foghorn Leghorn,** and others.

1945

Casper, the Friendly Ghost debut in **Famous Studios**' cartoon *The Friendly Ghost*. Moving into comic books, Casper became one of **Harvey Comics**' most famous characters. **Famous Studios** was originally **Fleischer Studios**.

1947

Young Romance #1 by **Jack Kirby** and **Joe Simon**. Romance remained a major genre in comics from the late forties until the seventies.

1949

Mr. Magoo debut in **UPA Productions**' cartoon *Ragtime Bear*. Among the last of the cartoons to start in movies and move into television.

Road Runner and **Wile E. Coyote** debut in **Chuck Jones**' *Fast and Furry-ous* for **Warner Brothers**.

1942

© Terrytoons

1947

© 1947 DC Comics

1950

© & ™ United Features Syndicate

1950

© & ® William M. Gaines, Agent, Inc.

1945

Millie the Model by **Stan Lee** and **Ruth Atkinson**. Highly successful at tapping into a female audience, Lee and Atkinson later duplicated that success with *Patsy Walker*. Both titles endured almost twenty years.

1946

March of Comics series of giveaway books featuring popular cartoon and comic strip characters. Inside were advertisements and product coupons. Most successful free comic published, running through 1982.

Treasure Chest Comics, a precursor to other Christian comics. Most successful ongoing religious-themed comic series, lasting twenty-six years.

1950

Peanuts by **Charles Shultz** and *Beetle Bailey* by **Mort Walker**. Popular comic strips with great longevity.

The Adventures of Bob Hope, published by **DC Comics**. Followed by other movie star comics such as *Dean Martin and Jerry Lewis*, a successful genre lasting almost twenty years.

"New Trend" books of **EC Comics** in horror, sci-fi, war, and other genres. Controversial, highly innovative comics written for more mature readers. The EC horror comic *Tales from the Crypt* was later adapted for a popular cable television series which ran from 1989–1996.

1952

Tales Calculated to Drive You MAD by **Harvey Kurtzman** and many of the artists from **EC Comics**. The title was changed to *MAD Magazine* with issue #24. Satire and parody popular with kids during a time when authority figures took themselves very seriously.

1953

Harvey Comics line of children's comic books, adaptations of animated cartoons featuring **Little Audrey, Casper, The Friendly Ghost,** and others. Most successful comic book was *Richie Rich*.

Speedy Gonzalez debut in *Cat-Tails for Two*, directed by **Robert McKimson**. Later given his own series, Speedy was the last major star from the original **Warner Brothers** animation studio.

1956

The Adventures of Big Boy, a free comic given away at Big Boy restaurants. A very effective advertising tool to draw families back to the restaurants, it was discontinued only in the mid 1990s.

1958

Feiffer by **Jules Feiffer** in national syndication. Best known for his comics in *The Village Voice*, Feiffer went on to do comic strips, graphic novels, movies, and plays.

The Huckleberry Hound Show. With this major hit, Hanna-Barbera became the new superstar studio for cartoons, producing such well-known characters as **Yogi Bear, Quickdraw McGraw**, and **Snagglepuss**.

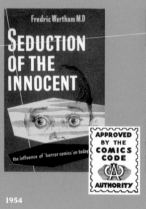

1952 1954 1956 1959

1954

Seduction of the Innocent by **Dr. Fredric Wertham, M.D.** Criticized crime and horror comics. Prompted the U.S. Senate to investigate links between comic books and the recent increase in juvenile delinquency.

Formation of the Comics Magazine Association of America (CMAA). Created the *Comics Code Authority* (CCA) that censored comic books before they went to the newsstand. Many distributors and newsstands refused comics without the CCA Stamp of Approval, thus terminating a number of crime and horror series.

1956

Return of **The Flash** in *Showcase Comics #4*. Other DC Comics' revivals of superheroes included **Green Lantern**, reigniting the superhero genre.

1958

Demise of **American News Company**. Because they distributed fifty percent of all comic books, many smaller distributors and comic book publishers also went out of business.

1959

Sgt. Rock debut in *Our Army at War #81* from **DC Comics**. A major success, Sgt. Rock took over this title, lasting until 1988.

Offbeat animated cartoons from **Jay Ward Productions**. Their stable of popular television characters included **Rocky and Bullwinkle, Dudley Do-Right**, and **George of the Jungle**.

1960

The Flintstones from **Hanna-Barbera**. First television cartoon successfully marketed toward adult viewers. The original series ran until 1966.

1961

The Fantastic Four by **Stan Lee** and **Jack Kirby**. **Marvel Comics** continued to introduce new superheroes with popular characters like **Spider-Man**, **The Hulk**, **Iron Man**, **Thor**, and the **X-men**. **Captain America** and other older superheroes were also revived.

1963

First Japanese cartoons (a.k.a. *anime*) aired in the U.S. The black and white *Astro Boy* cartoon series, based on **Osamu** "The God of Manga" **Tezuka**'s successful Japanese **Mighty Atom** comics (a.k.a. *manga*) about a flying robot boy, was popular in both Japan and America.

1964

Pink Panther debut in cartoon credits of a live-action movie of the same name. His popularity led to theatrical cartoons and network television.

1968

Yellow Submarine, based on the hit Beatles song, directed by **George Dunning** with stylish design work by **Heinz Edelmann**. This unique animated film inspired others to create full-length feature films, once an undertaking of only major studios like Walt Disney. **Disney** released their animated featurette *Winnie the Pooh and the Blustery Day* this same year.

1969

Where Are You, Scooby Doo? First in a series about a gang of teenage detectives and their talking dog, another major success from **Hanna-Barbera** studio.

Hey, Hey, Hey, It's Fat Albert by **Filmation Associates** studio. Based on characters created by **Bill Cosby**, Fat Albert was the first highly successful cartoon with a black cast.

1961

1963

1969

1970

1964

Creepy #1 and other black and white comic magazines by **Warren Publications**. Successful revival of many of the EC artists and their type of stories.

1965

A Charlie Brown Christmas by **Charles Shultz** and directed by **Bill Melendez**. First of a number of animated holiday cartoon specials, including *How the Grinch Stole Christmas* by **Chuck Jones** and **Theodore "Dr. Seuss" Geisel**.

1968

Zap Comix #1 by **Robert Crumb**. Heralded an explosion of underground comic books sold through counterculture head shops and new comic book specialty shops. Often labeled "adults only," these comics broke many taboos of conventional society.

1969

Vampirella from **Warren Publishing**. Its biggest success, a new magazine with a female vampire for its lead in a mix of horror, sci-fi, and comedy.

1970

Appearance of mainstream comic strips and comic books with a left-wing political view. Included the controversial and popular comic strip *Doonesbury* by **Gary Trudeau** and *Green Lantern / Green Arrow* by **Dennis O'Neill** and **Neal Adams**. The latter tried to shake off the campy stigma of the Batman television series by tackling serious social issues of the day.

Conan the Barbarian by **Roy Thomas** and **Barry Windsor-Smith** for **Marvel Comics**. Taken out of novels and put into comic book format, *Conan* had a long run of twenty-three years and inspired several movies.

1971

Amazing Spider-Man #96-98 from **Marvel Comics**, written by **Stan Lee** and drawn by **Gil Kane**. Published without CCA approval, the story dealt with the dangers of drug use. Even though the Department of Health, Education, and Welfare had requested the comic, the CMAA felt that drugs should not be mentioned at all. Public response led the code to be changed to allow negative portrayals of drugs.

Mickey Mouse Meets the Air Pirates #1. Created for the underground comics market by cartoonists **Dan O'Neill** and **Ted Richards**, the comic book showed Mickey Mouse swearing and having sex. Disney took notice and a ten-year legal battle ensued over how close a parody can get before it becomes a copyright infringement. Disney won.

1974

Obscenity trial of **Robert Crumb**'s **Zap Comix #4**, published in 1969 with cover by **Victor Moscoso**. The issue dealt with sexual taboos like incest. The State of New York declared it obscene, then tried and convicted two head shop owners for selling it to adults. The Supreme Court refused to hear their appeal, dampening early enthusiasm within the underground comics culture.

1976

American Splendor by **Harvey Pekar**. Began a wave of autobiographical comic books. Unique in telling stories of everyday life involving its writer/creator. *American Splendor* was made into a live-action film in 2003.

Cathy by **Cathy Guisewite**. A hit with female readers, the comic strip continues to this day.

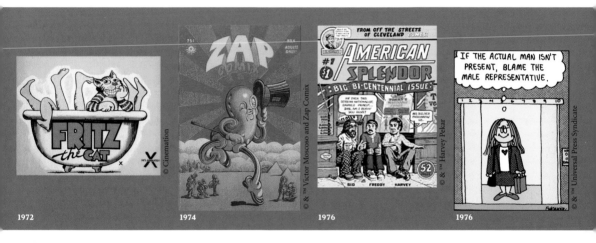

1972 1974 1976 1976

© Cinemation © & ™ Victor Moscoso and Zap Comix © ™ Harvey Pekar © & ™ Universal Press Syndicate

1972

Fritz the Cat directed by **Ralph Bakshi** and produced by **Steve Krantz**. First X-rated feature-length cartoon film, based on the **Robert Crumb** character of the same name. Crumb did not like the movie or its sequel and later retaliated by killing off Fritz in a comic book.

1973

Charlotte's Web directed by **Charles A. Nichols** and **Iwao Takamoto** for **Hanna-Barbera Productions**. A popular cartoon feature adaptation of the much-loved E. B. White book.

Shang-Chi, Master of Kung Fu, debut in **Marvel Comics**' **Special Marvel Edition #15**. Written by **Steve Englehart** with art by **Jim Starlin** and **Al Milgrom**. Took its cue from currently popular martial arts television shows and movies.

1977

Star Wars comic book published by **Marvel Comics** prior to the movie's release. George Lucas made this arrangement in hopes the comic book would help advertise the movie. Both movie and comic book were a huge success. The comic book's six issues went back to press multiple times, selling over a million copies each.

Cerebus by **Dave Sim**. A self-published satirical comic book about a talking aardvark. Opened the idea of self-publishing to many current and future artists by dispelling a lot of myths about publishing perpetrated by the industry.

1978

Garfield by **Jim Davis**. The comic strip would be a monster success both in newspapers and in merchandising tie-ins.

1978

Elfquest by **Richard** and **Wendy Pini**. Highly successful self-published fantasy series, reprinted in many formats.

A Contract With God, a series of stories set in New York during the Depression, by **Will Eisner**. Popularized the term "graphic novel." The graphic novel format took hold and began slowly replacing monthly comic books.

Heavy Metal. Full-color comics magazine showing nudity and very graphic violence previously available only in underground comics. Sold only to adults, it brought many popular European comics (a.k.a. *bande-dessinée*) artists to American attention. In 1981, several comics stories from the magazine were made into a popular animated anthology film, featuring a rock music soundtrack.

1980

RAW magazine by **Art Spiegelman** and **Françoise Mouly**. Called "The Graphix Magazine for Damned Intellectuals," it would attract important contributors, including **Mark Beyer, Linda Barry, Charles Burns, Sue Coe, Kim Deitch, Kaz, Gary Panter,** and **Chris Ware**. The most notable artist was Spiegelman himself, who was doing a biography of his father (see 1991, **Maus**, below).

1982

G.I. Joe, featuring a special military team, from **Marvel Comics**. The comic book was unique for the advertising it received from the t.v. cartoons.

Love and Rockets by **Jaime Hernandez** and **Gilbert Hernandez**. **Fantagraphics** series known for its great nonsequential love stories with a mixed ethnic cast.

1978

1978

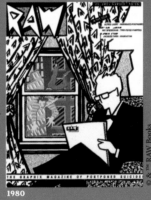

1980

1982

1978

Cartoon History of the Universe by **Larry Gonick**. Used the comics format as an entertaining teaching tool. Gonick later used it for subjects ranging from nuclear physics to sex education.

1979

For Better or Worse by **Lynn Johnston**. Semiautobiographical comic strip that achieved success with its mix of drama and low-key comedy.

Nature's Way by **Gary Larson**. The name of this comic panel later changed to **Garyland** and finally to **The Far Side**. People either loved it or hated it.

DC Comics' new mini-series format, a finite series designed to tell a complete story. Prior to this, most comic books ended with a cliffhanger to get readers to buy the next issue. The first mini-series, **World of Krypton**, described events before **Superman**'s birth.

1982

Groo by **Sergio Aragones**, best known for his work in *Mad* magazine. Started with **Pacific Comics**, but was creator-owned, so could move from publisher to publisher as better deals were offered or small publishers went out of business. *Groo* was a parody of *Conan the Barbarian*.

The Death of Captain Marvel by **Jim Starlin** for **Marvel**. Original graphic novel in which one of the more powerful superheroes dies of cancer. It had sales of over 100,000, causing a small explosion of less successful superhero graphic novels.

1984

Swamp Thing #20 by **Alan Moore** for **DC Comics**. Introduced a new style of psychological horror within comics, turning a traditional low-seller into a best-selling title within a year. Moore's run on the title ended with issue #64.

1984

Teenage Mutant Ninja Turtles by **Peter Laird** and **Kevin Eastman**. These self-published offbeat comic book characters became a massive success in cartoons, movies, and merchandising, making their creator-owners millionaires.

Transformers. Among the most successful of the cartoons that served mainly as advertisements for toys. Featuring two groups of fighting robots that turned into vehicles or other common items, *Transformers* continued in a variety of formats.

1985

Calvin and Hobbes by **Bill Watterson**. Very popular comic strip about an imaginative and mischievous young boy and his stuffed tiger. Watterson ended the strip when he felt he was out of original ideas, refusing to merchandise its characters.

1988

Who Framed Roger Rabbit? Reviving the idea of mixing animation and live action common in early animated cartoons, this feature film directed by **Robert Zemeckis** was a hit, leading to a resurgence of popular interest in traditionally-animated features and commercials.

Akira by **Katsuhiro Otomo**. Published in the U.S. by **Marvel Comics**, this series gave many American comics readers their first taste of modern *manga*. Other comics were imported from Japan and are now a major category in bookstores, usually outselling U.S. graphic novels.

Taboo, a horror anthology by **Steven Bissette**. Though it was targeted to sell internationally, its mission of breaking taboos meant the book had difficulty at first getting into the U.K., Australia, New Zealand, and Canada.

1984 — © & ™ Mirage Licensing, Inc.

1986 — © 1986 DC Comics

1988 — © & ™ Stephen R. Bissette & SpiderBaby Grafix & Pub.

1990 — © & ™ Fantagraphics Books, Inc.

1986

Batman: the Dark Knight Returns by **Frank Miller** and **Watchmen** by **Alan Moore**, both highly successful graphic novels from **DC Comics**. The former, which showed a retired Bruce Wayne becoming **Batman** again, was on *The New York Times* best-seller list for thirty-six weeks. **Watchmen** dissected the superhero motif within a murder mystery story. Moore's 1982 comics series **Marvelman**, from Britain's *Warrior*, was re-titled **Miracleman** and printed in the U.S. at around this time.

1987

The Simpsons by **Matt Groening**. Originating in an animated short on the **Tracy Ullman Show**, the characters soon became popular enough for a full-fledged series. A smash hit with its fast-paced comedy, *The Simpsons'* appearance during prime time triggered an explosion of animated television shows for adults.

1989

Sandman by **Neil Gaiman** with a variety of artists. The **DC Comics** fantasy series went seventy-five issues and was collected into a number of successful graphic novels. Gaiman later wrote other popular and critically acclaimed comics and novels.

Dilbert by **Scott Adams**. A comic strip attacking the cubicle-designed office workplace that pointed out everyday stupidities in corporate America. Later made into an animated television series.

1990

Hate by **Peter Bagge** from **Fantagraphics**. Funny series of "done in one" stories featuring a crew of Gen-X slackers living in Seattle. The book would move from black and white to color with issue #16 and continue until issue #30.

1990–91

Spider-Man #1, **X-Force #1**, and **X-Men #1** from **Marvel Comics**. String of high-selling comic books headed by very popular artists with the gimmick of starting over from issue #1 to convince speculators of their future value. The re-numbered **X-Men #1** sold over eight million issues.

1991

Maus by **Art Spiegelman**. Originating in *RAW* magazine, the two-part graphic novel (published in 1986 and 1991) tells how his father, a Jew in Poland, survived the Auschwitz concentration camp. Together the books won the Pulitzer Prize in 1992.

Rugrats by **Gabor Csupo** and **Arlene Klasky** for cable network **Nickelodeon**. Intelligent kids' cartoon that would move into animated films.

1992

Formation of **Image Comics** by seven artists from Marvel Comics. Became third largest comics company in the U.S. Their first book was **Youngblood** by **Rob Liefeld**, but their most famous book was **Todd McFarlane**'s **Spawn**, which was made into a live-action movie and an animated series in 1997.

Mainstream publicity for "Death of Superman" story. **DC Comics** had **Superman** killed in **Superman #75**, but the character was back in about six months.

Batman: The Animated Series from **Warner Brothers** studios. Its major success led to other animated superhero shows, including **Superman**, **Batman Beyond**, and **Justice League of America**, as well as the Batman animated features.

1991

© & ™ Cartoon Books

1992

© & ™ TMP International, Inc.

1993

© & ™ Fantagraphics Books, Inc.

1991

Liquid TV animated shorts on **MTV**. Some went on to full-fledged shows, including **John Krifcalusi**'s **Ren and Stimpy** and **Peter Chung**'s **Aeon Flux**.

Bone by **Jeff Smith** of **Cartoon Books**. After unsuccessful attempts to achieve a syndicated comic strip, Smith turned toward comic books and a character he created when he was five. *Bone* was a breath of fresh air in the comics industry, with stories entertaining both children and adults.

1992

Sin City mini-series by **Frank Miller** for **Dark Horse Comics**. Made the crime genre popular again, encouraging other creators to do crime comics.

1993

Beavis and Butthead by **Mike Judge** for **MTV**. Playing off the stereotyped MTV audience with its slow-paced story and crude animation, the cartoon showed two heavy metal fans who spent all day watching MTV. It would become an animated movie.

Jimmy Corrigan: the Smartest Kid on Earth by **Chris Ware** as part of his **Fantagraphics** comic **The Acme Novelty Library**. Follows three generations of the Corrigan family. Ware experimented with storytelling and came up with a variety of intricate page layouts in which to tell the story. A graphic novel was published in 2000.

1993

Understanding Comics by **Scott McCloud**. A comic about comic books that explained how comic book storytelling was done, useful for both diehard fans and those new to the genre. In 2000, McCloud wrote a follow-up book called *Reinventing Comics,* including a discussion of digital comics on the internet.

1993

Palestine by **Joe Sacco**. Example of comic book journalism. Sacco went to the Palestinian-occupied areas of Israel, interviewed a number of people, then showed their experiences graphically.

Strangers in Paradise by **Terry Moore**. Comic book notable for the strong dose of romance in its mix of comedy and action, something missing from the comic book industry for a while.

1997

The Boondocks by **Aaron McGruder**. A controversial newspaper comic strip with charged views on race relations and politics. Though many newspapers cut the strip, McGruder stayed his ground.

1998

Ghost World graphic novel compilation by **Daniel Clowes** published by **Fantagraphics**. *Ghost World* originally appeared in Clowes' comic **Eightball** from 1993–1997. Critically acclaimed, it would be turned into an independent film in 2001.

Road to Perdition by writer **Max Allan Collins** and artist **Richard Piers Rayner** from **DC**'s **Paradox Press**. Largely ignored by the industry, it was read by big names in Hollywood and was turned into a hit movie in 2002.

1993

1995

1997

1998

1995

Toy Story. CGI computer-animated feature directed by **John Lasseter** of **Pixar Animation Studios**. The film was a huge success, and other computer-animated movies by various studios followed, most of them successful.

Preacher by **Garth Ennis** and **Steve Dillon** from **DC**'s **Vertigo** imprint. Told the story of a crude-talking Texas preacher who learns that God abandoned earth and then goes on a quest to find and confront God.

Stuck Rubber Baby by **Howard Cruse** from **DC**'s **Paradox Press**. About a black man growing up during the sixties civil rights struggle and coming to terms with being gay. The book was semiautobiographical, but Cruse considered it a work of fiction.

1999

From Hell by **Alan Moore** and **Eddie Campbell**. Originating in **Taboo**, this graphic novel exploring the Jack the Ripper murders was made into a movie that bested its competition on its opening weekend in 2001.

2000

Pedro and Me by cartoonist **Judd Winick**. Winick became the roommate and friend of H.I.V.-positive gay activist Pedro Zamora during the 1994 season of MTV's reality television show *The Real World*. Written after Zamora's death, Winick's graphic novel talks about both their lives and Zamora's impact on those around him.

Catalogue of the Exhibition

Works are listed as they appear in the plates, divided by theme.
Illustrated works are indicated by plate numbers in italics to the right of the titles.
Dimensions are given in inches with height preceding width preceding depth.

SPLAT! Squashing the Force Field of Pop Icons

MEL RAMOS
Captain Midnight, 1962 *pl. 1*
Oil on canvas
32 x 26

The Flash, 1962 *page 10*
Oil on canvas
34 x 18

Batman, 1961
Oil on canvas
34 x 24
All Collection Skot Ramos, San Francisco

ANDY WARHOL
Myths portfolio, 1981 *pl. 2*
Silkscreened ink on paper, ten works
38 x 38, each
Courtesy Ronald Feldman Fine Arts, New York

PETER SAUL
Americans vs. Japanese, 1964 *pl. 3*
Oil on canvas
63 x 59
Private Collection, Chicago

DAVID SANDLIN
Seven Sips of Sin, 1996
Silkscreened ink on Plexiglas
24 x 24 x 6

Sin-occhi, 1995 *pl. 4*
Silkscreened ink on Plexiglas
24 x 15 1/4 x 6

So-White, So-Pure, 1995
Silkscreened ink on Plexiglas
24 x 15 1/4 x 6
All courtesy the artist and Carl Hammer Gallery,
Chicago

DARA BIRNBAUM
Technology/Transformation, 1978–79 *pl. 5*
Video projection
5 minutes 50 seconds
Collection Electronic Arts Intermix (EAI),
New York

LIZA LOU
Business Barbie, 1999 *pl. 6*
Wood, wire, and beads
84 x 48
Collection Mattel, Inc., El Segundo, California

ENRIQUE CHAGOYA
General Merchandise, 2000 *pl. 7*
Amate on linen
48 x 48
Collection Stanley and Mikki Weithorn,
courtesy George Adams Gallery, both New York

Les Aventures des Cannibales, 1999
Color lithography, woodcut on chine collé
7 1/4 x 92
Courtesy the artist and Paule Anglim Gallery,
San Francisco

CANDIDA ALVAREZ
Watch My Back, 2000 *pl. 8*
Thread on fabric
108 x 108
Courtesy the artist and Rena Bransten Gallery,
San Francisco

POLLY APFELBAUM
Townsville, 2000 *pl. 9*
Dye on velvet
16 feet 6 inches diameter
Collection Austin Museum of Art; purchased with
funds from The Mattsson-McHale Art Acquisition
Endowment, Bettye H. Nowlin and
Lee M. Knox 2001.8

ARTURO HERRERA
Night Before Last 5R, 2002 *pl. 10*
Graphite on paper
79 1/2 x 62
Jeanne and Michael Klein, Houston

CAT CHOW
Power Ranger Kimono, 2000 *pl. 11*
Plastic, printed cardboard, brass, and wood
82 x 60 x 24
Courtesy the artist

JENNIFER ZACKIN
Wonder Woman Cosmos, 2002 *pl. 12*
Plastic army, firemen, policemen, cowboy,
Indian, and Wonder Woman figures in resin
70 x 72 x 5
Courtesy the artist

BOOM! Exploding the Language of Art through Alien Technology

ROY LICHTENSTEIN
Atom Burst, 1966
Acrylic on board
24 x 24
Collection Modern Art Museum of Fort Worth;
Museum Purchase, The Benjamin J. Tillar
Memorial Trust

Forget It, Forget Me!, 1962 *pl. 13*
Oil on canvas
80 x 68
Collection Rose Art Museum, Brandeis University,
Waltham, Massachusetts; Gervitz-Mnuchn
Purchase Fund, 1962

SIGMAR POLKE
Untitled, 1994 *pl. 14*
Acrylic on canvas
37 3/8 x 29 1/2
Private Collection, Houston

IDA APPLEBROOG
I Hear You're a Terrorist, 1986 *pl. 15B*
Oil on canvas
14 x 66
Private Collection, New York

Face It, Chaos is Useless, 1980
Oil on canvas
14 x 60
Courtesy Ronald Feldman Fine Arts, New York

ROGER BROWN
Sarajevo, the Serbian Way, 1993 *pl. 16*
Oil on canvas
72 x 48
The Roger Brown Study Collection, The School of
the Art Institute of Chicago

KARA MARIA
L'Eclair, 2000 *pl. 17*
Acrylic on canvas
51 x 39

Boom, 1999
Acrylic on canvas
68 x 68
Both courtesy the artist and Catherine Clark
Gallery, both San Francisco

JULIE MEHRETU
Bombing Babylon, 2001 *pl. 18*
Acrylic and ink on canvas
60 x 84
Private Collection, New York

JASON DUNDA *page 128*
Pair (Fists), 2000
Oil on masonite
6 x 6 x 3, each panel

Supergirl's Bedroom, 2000 *pl. 19*
Oil on masonite
10 x 8
Both collection Dr. Nitin Dilawri, Toronto

MICHAEL GALBINCEA
Vectorized Heroes, 2002 *pl. 20*
Ink jet on paper mounted on poster board, six works
34 x 26, each
Courtesy the artist

MICHAEL RAY CHARLES
Untitled, 2003
Acrylic latex on canvas
36 x 70

Untitled, 2003
Acrylic latex on canvas
36 x 70
Both courtesy the artist, and Tony Shafrazi Gallery,
New York

KERRY JAMES MARSHALL
Another Great Migration, 2002 *pl. 22*
Ink on paper, nine panels
24 x 27, each
Courtesy the artist & Jack Shainman Gallery, New York

LAYLAH ALI
Untitled, 1999
Gouache on paper
19 x 14
Collection Museum of Contemporary Art,
Chicago, The William B. Cook Fund, 1999.58

Untitled, 1999
Gouache on paper
8 1/8 x 13 3/16
Collection Museum of Contemporary Art,
Chicago, Restricted Gift of Robert and Sylvie
Fitzpatrick in memory of William B. Cook.1999.57

Untitled, 2000 *pl. 23*
Gouache on paper
9 1/2 x 25 x 1 1/4

Untitled, 2000
Gouache on paper
19 x 23 x 1 1/4
Both collection John A. Smith and Vicky Hughes,
Raymond, Surrey, U.K.

ELIZABETH MURRAY
Cloud 9, 2002 *pl. 24*
Oil on canvas
93 x 84
Courtesy PaceWildenstein Gallery, New York

POW! Slammin' into Mt. Mythomania and Spewing After Egos and New Super Heroes

HENRY DARGER

recto: **6 Episode 3 Place not mentioned. Escape during violent storm, still fighting though persued** [sic] **for long distance**
verso: **Untitled (Battle scene during lighting storm. Naked Children with Rifles),**
Mid twentieth century
Watercolor, pencil, carbon tracing, and collage on pieced paper
19 x 70½

recto: **At Sunbeam Creek.** *pls. 25A and B*
Are with little girl refugees again in peril from forest fires. but escape this also, but half naked and in burned rags/ At Torrington. Are persued [sic] **by a storm of fire but save themselves by jumping into a stream and swim across as seen in next picture/ Their red color is caused by glare of flames. At Torrington. They reach the river just in the nick of time.**
verso: **73 At Jennie Richee Escape by their help**
Mid twentieth century
Watercolor, pencil, carbon tracing, and collage on pieced paper
19 x 70½

recto: **Untitled (We Shall Slam them with our wings)**
verso: **Untitled (Idyllic landscape with children),**
Mid twentieth century
Watercolor, pencil, and carbon tracing paper
24 x 106½
All Collection American Folk Art Museum, New York. Museum purchase and gift. © Kiyoko Lerner

KEITH HARING

Untitled (Skateboard), 1986 *pl. 26, left*
Black enamel and silver felt-tip pen on wood
30½ x 10¾ x ¼

Untitled (Skateboard), 1986 *pl. 26, middle*
Black enamel and silver felt-tip pen on wood
29⅞ x 9⅞ x ¼

Untitled (Skateboard), 1986 *pl. 26, right*
Black enamel and silver felt-tip pen on wood
29⅞ x 9¾ x ¼
All Collection Estate of Keith Haring, New York

KENNY SCHARF

Fun's Inside, 1983
Oil and spray paint on canvas
90 x 108
Courtesy Tony Shafrazi Gallery, New York

Power Happy, 1986 *pl. 27*
Gold leaf and oil on painted bronze
57½ x 27½ x 26
Private Collection, Houston

JEAN-MICHEL BASQUIAT
Untitled,1985 *pl. 28*
Oil and acrylic on wood doors
80 x 55½
Private Collection, Houston

RAYMOND PETTIBON
No Title (It Got Big), 1990
14 x 11
Gouache and ink on paper

No Title (Whatever You Say), 1990
17½ x 11¼
Gouache and ink on paper

No Title (Get Ready to See Me), 1990
17½ x 11¼
Gouache and ink on paper

No Title (That All Was), 1998 *pl. 29*
22¼ x 30
Gouache and ink on paper

No Title (The Thing that Can Not Be Seen), 2001
74 x 52
Gouache and ink on paper
All Private Collection, Houston

RENEE COX
Lost in Space, from the **Rajé** series, 1998 *pl. 30*
Cibachrome print
48 x 60

Chillin' with Liberty, from the **Rajé** series, 1998
Cibachrome print
60 x 48

Taxi, from the **Rajé** series, 1998
Cibachrome print
48 x 60
All courtesy Robert Miller Gallery, New York

ROGER SHIMOMURA
Jap's a Jap: #2, 2000 *pl. 31*
Acrylic on canvas
36 x 48
Courtesy the artist and Greg Kucera Gallery, Seattle

Jap's a Jap: #6, 2000 *page 2*
Acrylic on canvas
36 x 48
Courtesy the artist and Bernice Steinbaum Gallery, Miami

Frat Rats, 2000
Acrylic on canvas
72 x 48
Courtesy the artist and Bernice Steinbaum Gallery, Miami

TAKASHI MURAKAMI
Untitled, 2000 *not illustrated, see pl. 32*
Video projection
8 minutes
Courtesy Blum & Poe, Santa Monica, California

YOSHIMOTO NARA
Little Red Riding Hood, 1997
Lacquer and cotton on fiberglass, resin, and wood
22 x 16 x 13

Grinning Little Bunny, 1997
Lacquer and cotton on fiberglass, resin, and wood
24 x 23 x 14

Dog From Your Childhood, 1997
Lacquer and cotton on fiberglass, resin, and wood
15 x 17 x 18¾

Sheep From Your Dream, 1997
Lacquer and cotton on fiberglass, resin, and wood
18 x 20 x 11

Round Eyed Pilot, 1997
Lacquer and cotton on fiberglass, resin, and wood
18½ x 17 x 11

Upset Kitty, 1997
Lacquer and cotton on fiberglass, resin, and wood
19 x 20 x 12
All courtesy Blum & Poe Gallery, Santa Monica,
California

Quiet, Quiet, 1999 *pl. 33*
Lacquer on fiberglass and resin
56 x 37 x 37
Collection Reggie and Leigh Smith, Houston

RACHEL HECKER
Japa Mere, 2003 *pl. 34, left*
Plastic coating and acrylic paint on carved Styrofoam
31 x 24 x 25

Baby Mere, 2003
Plastic coating and acrylic paint on carved Styrofoam
37 x 24 x 25

Guru Mere, 2003 *pl. 34, right*
Plastic coating and acrylic paint on carved Styrofoam
37 x 24 x 25

Sweet Mere, 2003
Plastic coating and acrylic paint on carved Styrofoam
37 x 24 x 25
All courtesy the artist and Texas Gallery, Houston

DAVID SHRIGLEY
Untitled (I cherish these moments), 2000 *pl. 35*
Mixed media on paper
12½ x 16

Untitled (Profile of cave man with spear), 2000
Marker on paper
15 x 11

Untitled (Tom Thumb), 2000
Acrylic and ink on paper
13⅜ x 16⅝

Untitled (Healthy looking hair), 2001
Acrylic on paper
16 x 18, each (diptych)

Untitled (Rare bird's egg), 2001
Ink on paper
14⅛ x 17¼
All courtesy Stephen Friedman Gallery, London

JOHN BANKSTON
Riding Desire, 2001 *pl. 36*
Oil on canvas
54 x 48

Taken By Desire, 2001
Oil on linen
72 x 60
Both courtesy Jack Shainman Gallery, New York

KOJO GRIFFIN
Untitled (man with gun, man on *pl. 37*
knees, man looking at watch), 2001
Mixed media on wood panel
71⅞ x 88¾
Gayle and Charles Atkins, New York

GEORGE CONDO
6 Figures, 2002 *not illustrated, see pl. 38*
Oil on canvas
80 x 96
Courtesy Luhring Augustine Gallery, New York

ROBERT PRUITT
Black Stuntman, 2002 *pls. 39A–D*
Video projection
10 minutes
Courtesy the artist

TRENTON DOYLE HANCOCK
Eight works from the
For a Floor of Flora series, 2002 *pl. 40*
Acrylic on canvas
11¼ x 19¾ each
Courtesy Dunn and Brown Contemporary,
Dallas, and James Cohan Gallery, New York

SPLAT

SQUASHING
THE FORCE FIELD
OF POP ICONS

As early as the late 1600s,
European artists were depicting public figures
in their work to comment on social, political, and religious
issues. American artists continued this tradition. By the late 1950s
and early 1960s, artists living in America and Europe had simultaneously
begun to focus on everyday objects as subject matter, giving birth to
Pop Art. As part of this movement, a number of American artists incorporated
existing cartoon iconography in their work to critique an increasingly commercial
and consumer-oriented society. Subsequent decades saw the continuation
of this appropriation to promote increasingly divergent views on the U.S.
government's policy on the Vietnam War and injustices relating to racism,
sexism, and other social issues. By the 1990s, a number of artists were
employing cartoon iconography, reshaping its content and
context. Other artists of the decade returned to more
painterly investigations, dissolving popular
icons into abstraction.

MEL RAMOS

1. **Captain Midnight**, 1962

 Oil on canvas
 32 x 26 inches
 Collection Skot Ramos, San Francisco

ANDY WARHOL

2. **Mickey Mouse** from the **Myths** portfolio, 1981
 Silkscreened ink on paper
 38 x 38 inches
 Courtesy Ronald Feldman Fine Arts, New York

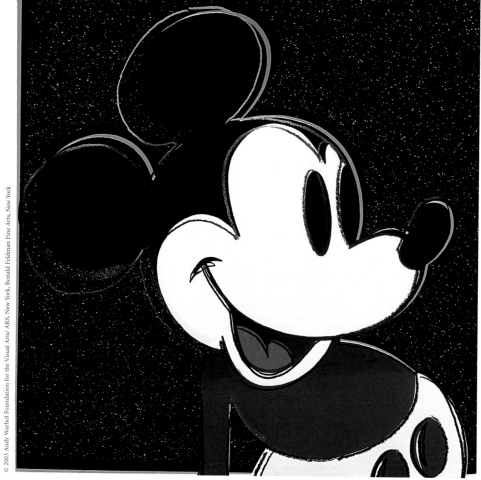

PETER SAUL

3. **Americans vs. Japanese**, 1964
 Oil on canvas
 63 x 59 inches
 Private Collection, Chicago

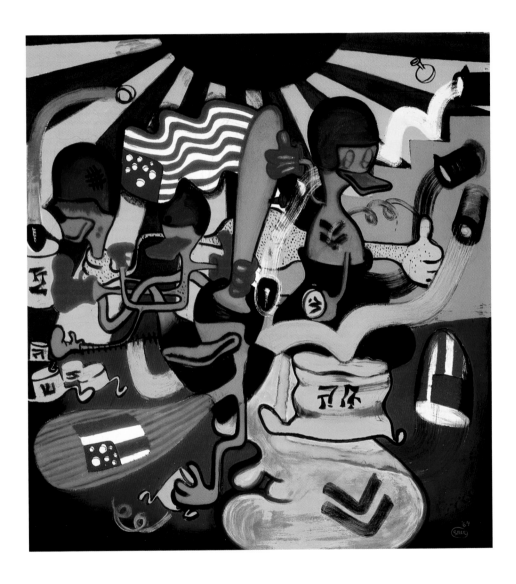

DAVID SANDLIN

4. **Sin-occhi**, 1995

Silkscreened ink on Plexiglas

24 x 15 ¼ x 6 inches

Courtesy the artist and Carl Hammer Gallery, Chicago

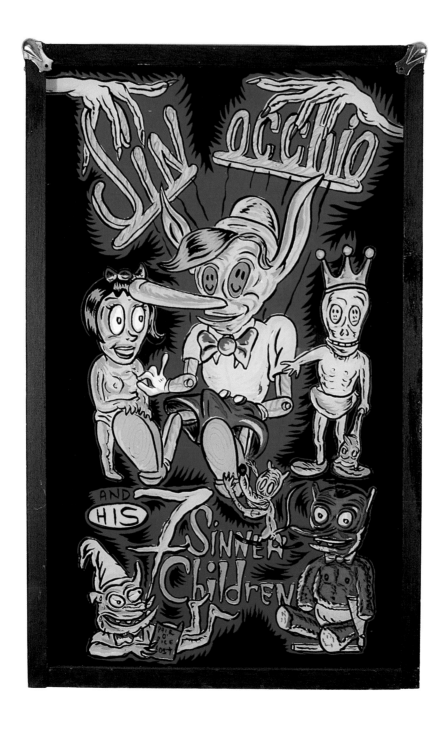

DARA BIRNBAUM

5. **Technology/Transformation**, 1978–79

Video projection
5 minutes 50 seconds
Collection Electronic Arts Intermix (EAI), New York

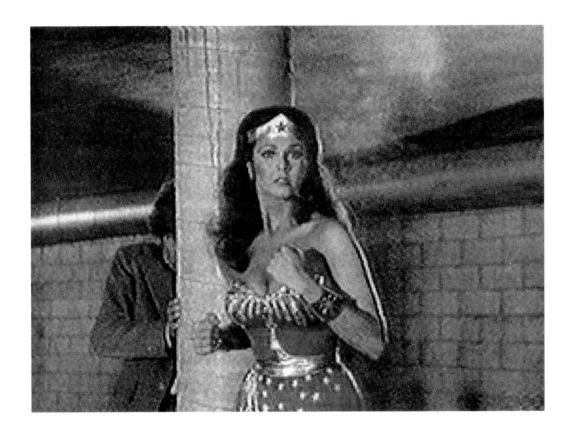

6. **Business Barbie** (detail), 1999
 Wood, wire, and beads
 84 x 48 inches
 Collection Mattel, Inc., El Segundo, California

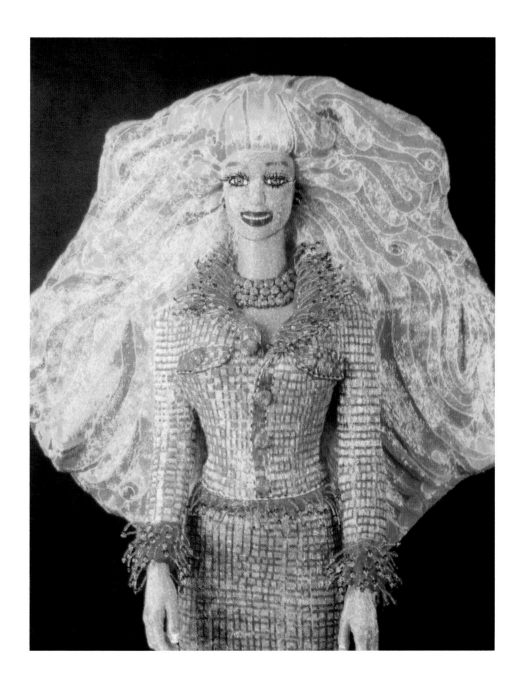

ENRIQUE CHAGOYA

7. **General Merchandise**, 2000

 Amate on linen
 48 x 48 inches
 Collection Stanley and Mikki Weithorn and
 courtesy George Adams Gallery, both New York

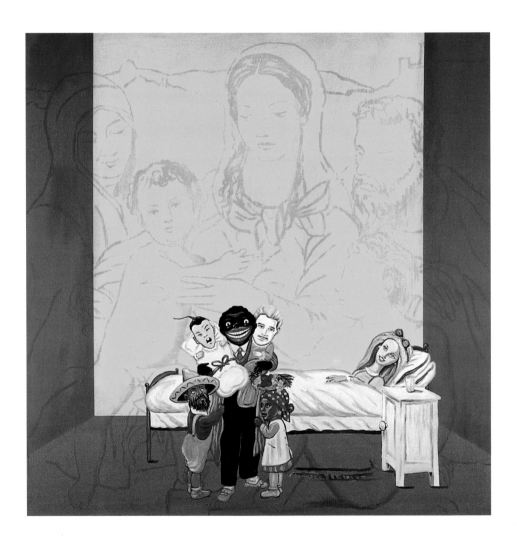

CANDIDA ALVAREZ

8. **Watch My Back**, 2000
 Thread on fabric
 9 x 9 feet
 Courtesy the artist and Rena Bransten Gallery, San Francisco

POLLY APFELBAUM

9. **Townsville**, 2000
 Dye on velvet
 16 feet 6 inches diameter
 Collection Austin Museum of Art, Austin, purchased
 with funds from The Mattsson-McHale Art Acquisition
 Endowment, Bettye H. Nowlin and Lee M. Knox 2001.8

ARTURO HERRERA

10. **Night Before Last 5R**, 2002
 Graphite on paper
 79 1/2 x 62 inches
 Jeanne and Michael Klein, Houston

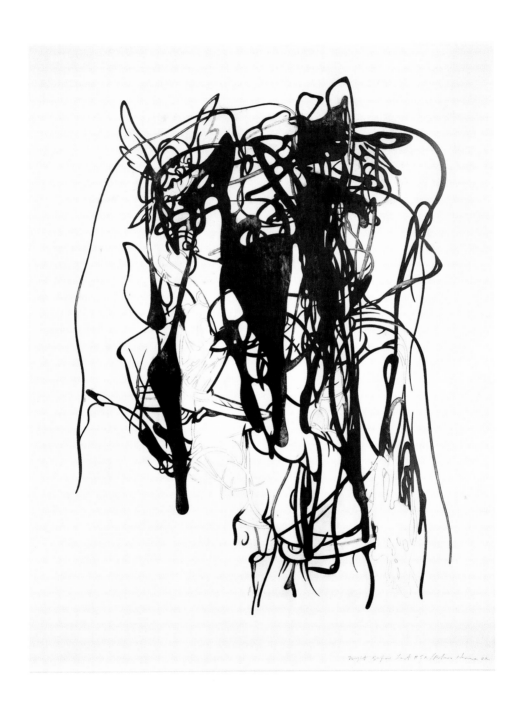

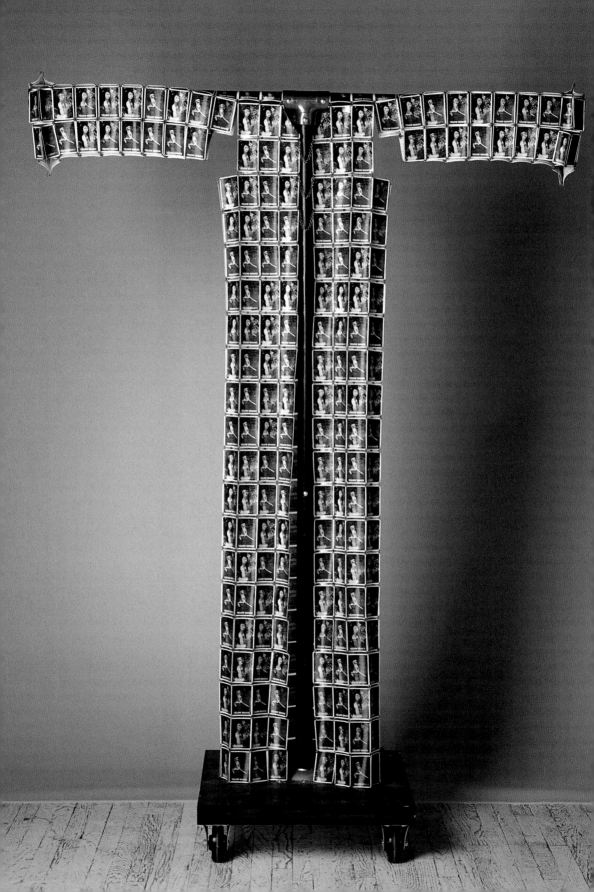

CAT CHOW

11. **Power Ranger Kimono**, 2000
 Plastic, printed cardboard, brass, and wood
 82 x 60 x 24 inches
 Courtesy the artist

JENNIFER ZACKIN

12. **Wonder Woman Cosmos**, 2002
 Plastic army, firemen, policemen, cowboy,
 Indian, and Wonder Woman figures in resin
 70 x 72 x 5 inches
 Courtesy the artist

EXPLODING
THE LANGUAGE OF ART
THROUGH ALIEN TECHNOLOGY

A quintessential aspect
of the work of many Pop artists was its appropriation
not only of images, but also of the symbols and techniques
common to mass media printing. The use of silkscreen printing
technology and the pilfering of its visual characteristics, including
the appearance of enlarged Benday dots, were strategies adopted by
a number of artists. Pop icon Andy Warhol freely used these media
techniques, sometimes even making his work using mass production
strategies at his studio, pointedly named The Factory. Over the
next three decades, artists would broaden their appropriation strategies,
adopting tools drawn from the cartoon genre, including sequential
narratives; the symbolic use of color; flat, geometric line and form;
and movement through gesture notations. When computer
technology became commonly available, artists quickly
adopted it, assuming a variety of digital
strategies into their work.

13. **Forget It, Forget Me!**, 1962

Oil on canvas

80 x 68 inches

Collection Rose Art Museum, Brandeis University, Waltham,
Massachusetts; Gervitz-Mnuchn Purchase Fund, 1962

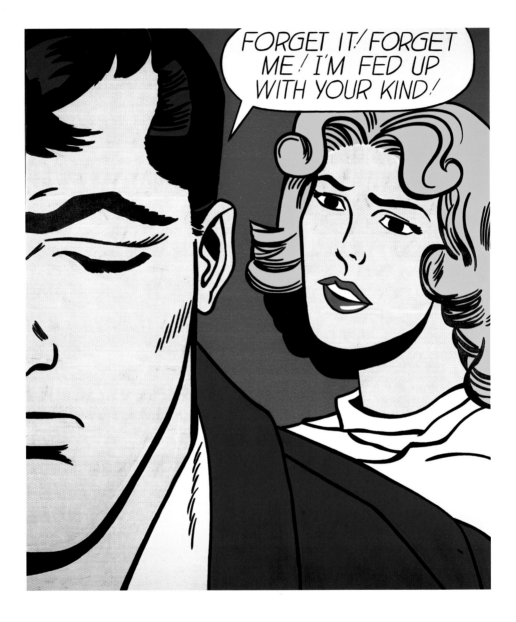

SIGMAR POLKE

14. **Untitled**, 1994

Acrylic on canvas
37 1/2 x 29 1/2 inches
Private Collection, Houston

IDA APPLEBROOG

15A. **Untitled (Farewell, Robert)**, 1986 *(illustrated)*
 Oil on canvas
 14 x 66 inches
 Courtesy of Ronald Feldman Fine Arts, New York

15B. **I Hear You're a Terrorist**, 1986 *(exhibited and illustrated)*
 Oil on canvas
 14 x 66 inches
 Private Collection, New York

15C. **Untitled (Muscle Man)**, 1986 *(illustrated)*
 Oil on canvas
 14 x 66 inches
 Courtesy of Ronald Feldman Fine Arts, New York

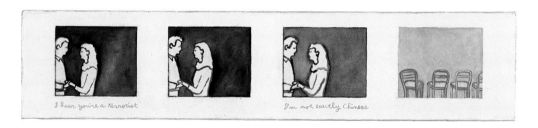

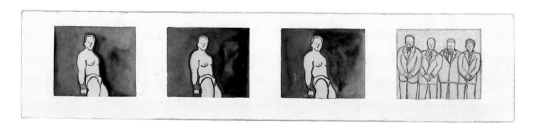

ROGER BROWN

16. **Sarajevo, the Serbian Way**, 1993

Oil on canvas
72 x 48 inches
The Roger Brown Study Collection,
The School of the Art Institute of Chicago

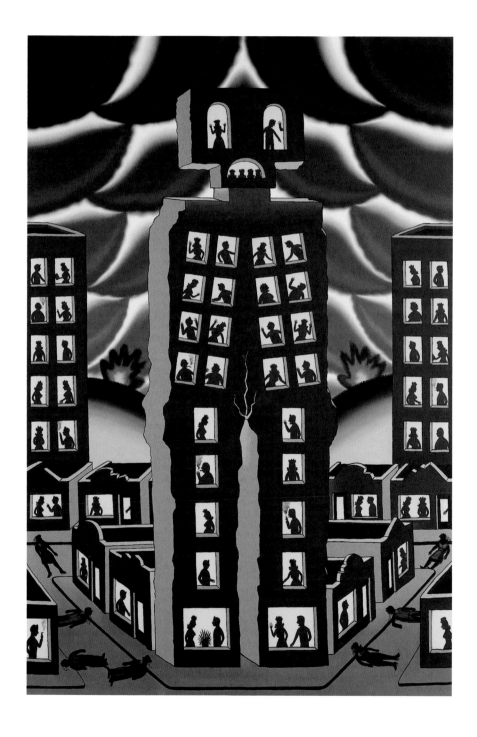

Kara Maria

17. **L'Eclair**, 2000
 Acrylic on canvas
 51 x 39 inches
 Courtesy the artist and Catherine Clark Gallery, San Francisco

JULIE MEHRETU

18. **Bombing Babylon**, 2001
 Acrylic and ink on canvas
 60 x 84 inches
 Private Collection, New York

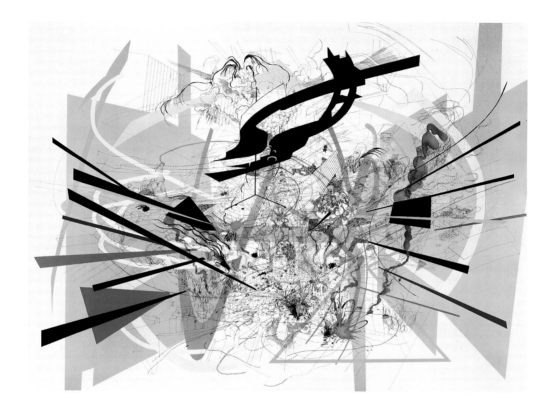

JASON DUNDA

19. **Supergirl's Bedroom**, 2000
 Oil on masonite
 10 x 8 inches
 Collection Dr. Nitin Dilawri, Toronto

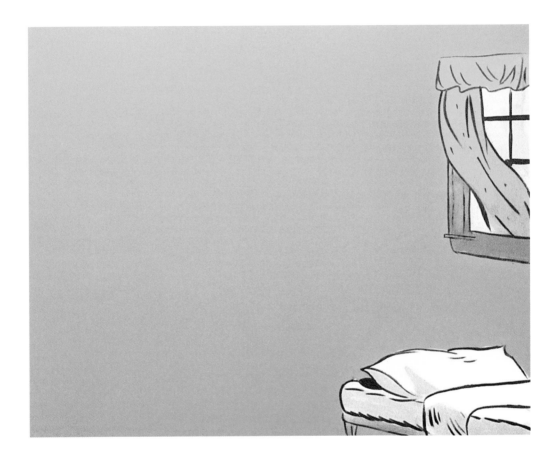

MICHAEL GALBINCEA

20. **Vectorized Heroes**, 2002

 Ink jet on paper mounted on poster board, one of six works
 34 x 26 inches
 Courtesy the artist

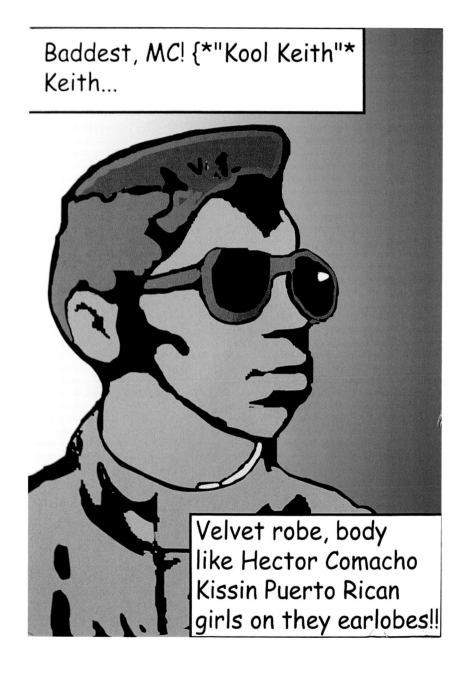

21. **Re-action Jackson**, 2001 *(not in exhibition)*
Acrylic latex on canvas
60 x 60 inches
Courtesy the artist and Galerie Hans Mayer, Düsseldorf

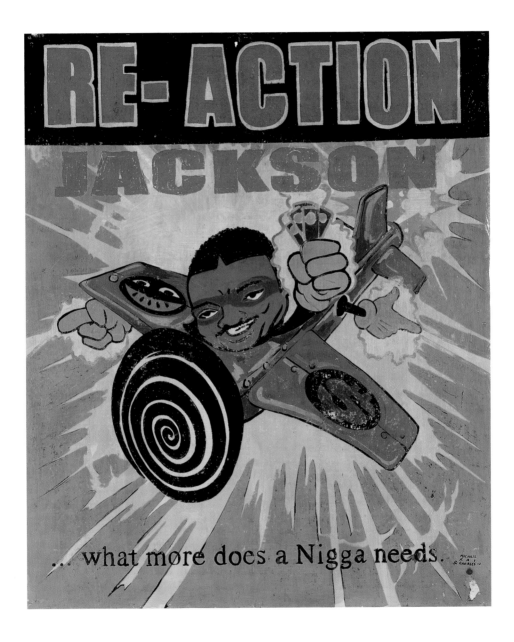

KERRY JAMES MARSHALL

22. **Another Great Migration** (detail), 2002
Ink on paper, one of nine panels
24 x 27 inches
Courtesy the artist and Jack Shainman Gallery, New York

23. **Untitled**, 2000
 Gouache on paper
 9 ½ x 25 x 1 ¼ inches
 Collection John A. Smith and Vicky Hughes,
 Raymond, Surrey, U.K.

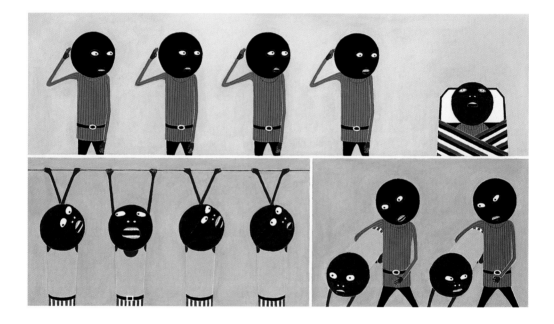

ELIZABETH MURRAY

24. **Cloud 9**, 2002
 Oil on canvas
 93 x 84 inches
 Courtesy PaceWildenstein Gallery, New York

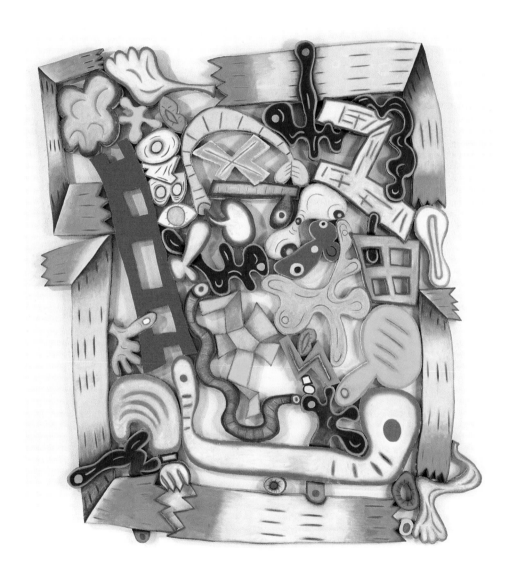

SLAMMIN' INTO
MT. MYTHOMANIA AND
SPEWING ALTER EGOS AND
NEW SUPERHEROES

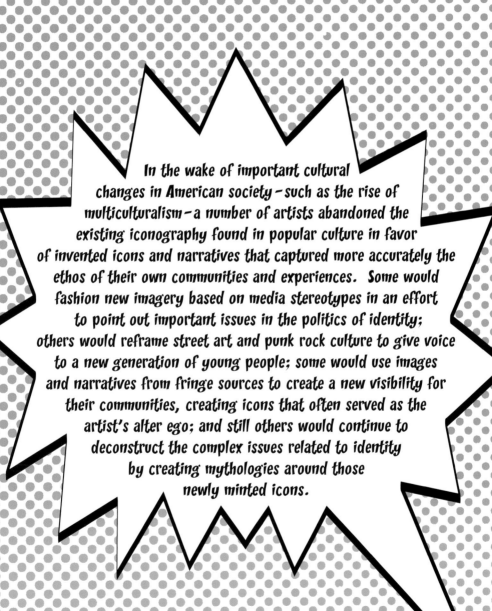

In the wake of important cultural
changes in American society – such as the rise of
multiculturalism – a number of artists abandoned the
existing iconography found in popular culture in favor
of invented icons and narratives that captured more accurately the
ethos of their own communities and experiences. Some would
fashion new imagery based on media stereotypes in an effort
to point out important issues in the politics of identity;
others would reframe street art and punk rock culture to give voice
to a new generation of young people; some would use images
and narratives from fringe sources to create a new visibility for
their communities, creating icons that often served as the
artist's alter ego; and still others would continue to
deconstruct the complex issues related to identity
by creating mythologies around those
newly minted icons.

HENRY DARGER

25A. **At Sunbeam Creek. Are with little girl refugees again in peril from forest fires. but escape this also, but half naked and in burned rags/ At Torrington. Are persued [sic] by a storm of fire but save themselves by jumping into a stream and swim across as seen in next picture/ Their red color is caused by glare of flames. At Torrington. They reach the river just in the nick of time.** *(recto)*
Mid twentieth century
Watercolor, pencil, carbon tracing, and collage on pieced paper
19 x 70 ½ inches
Collection American Folk Art Museum, New York; Museum purchase and gift. © Kiyoko Lerner

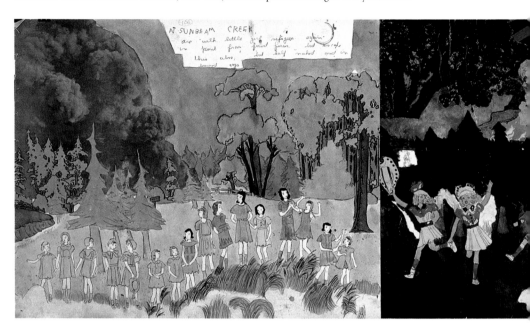

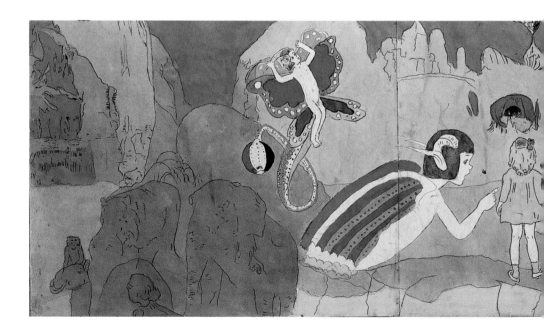

25B. **73 At Jennie Richee Escape by their help** *(verso)*
Mid twentieth century
Watercolor, pencil, carbon tracing, and collage on pieced paper
19 x 70 ½ inches
Collection American Folk Art Museum, New York;
Museum purchase and gift. © Kiyoko Lerner

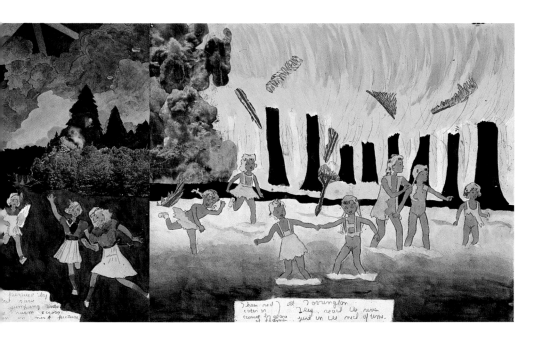

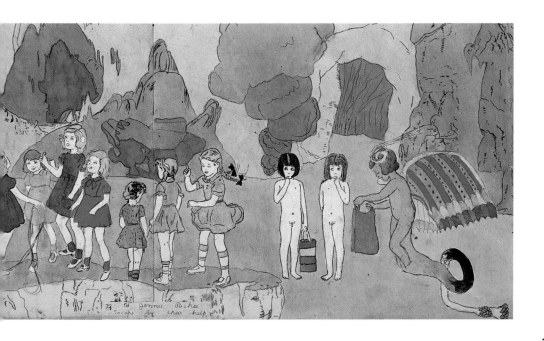

KEITH HARING

26. **Untitled (3 Skateboards)**, 1986
Black enamel and silver felt-tip pen on wood
left to right: 30 1/2 x 10 3/4 x 1/4, 29 7/8 x 9 7/8 x 1/4,
and 29 7/8 x 9 3/4 x 1/4 inches
Collection Estate of Keith Haring, New York

KENNY SCHARF

27. **Power Happy**, 1986
Gold leaf and oil on bronze
57 1/2 x 27 1/2 x 26 inches
Private Collection, Houston

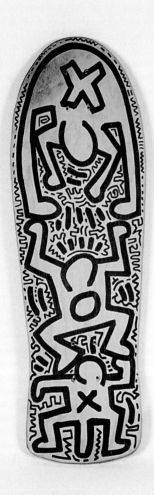
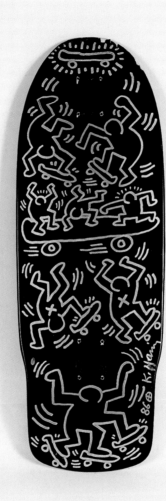
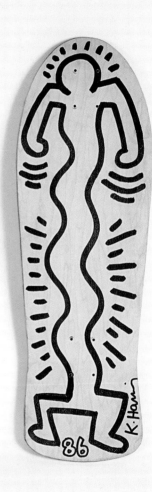

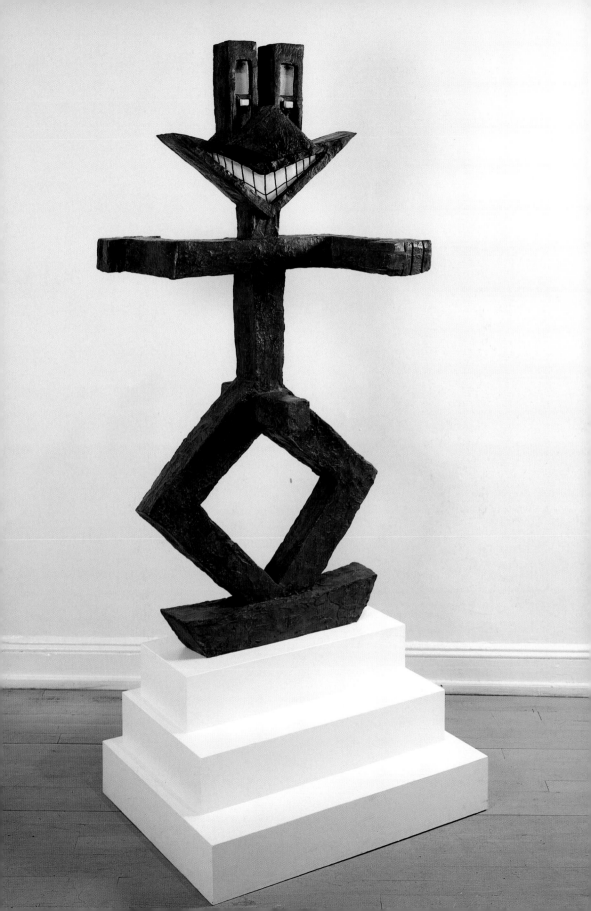

JEAN-MICHEL BASQUIAT

28. **Untitled**, 1985
 Oil stick and acrylic on wood doors
 80 x 55 1/2 inches
 Private Collection, Houston

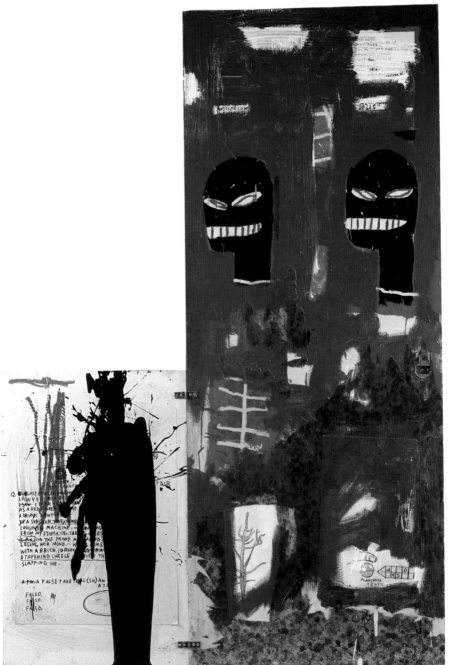

RAYMOND PETTIBON

29. **No Title (That All Was)**, 1998

22 ¼ x 30 inches

Gouache and ink on paper

Private Collection, Houston

RENEE COX

30. **Lost in Space**, from the **Rajé** series, 1998
 Cibachrome print
 60 x 48 inches
 Courtesy Robert Miller Gallery, New York

ROGER SHIMOMURA

31. **Jap's a Jap: #2**, 2000
 Acrylic on canvas
 36 x 48 inches
 Courtesy the artist and Greg Kucera Gallery, Seattle

TAKASHI MURAKAMI

32. **Dream of Opposite World**, 1999 *(illustrated)*
Acrylic on canvas on board
71 x 71 inches

Untitled, 2000 *(exhibited)*
Video projection
8 minutes
Dimensions variable
Both courtesy Blum & Poe, Santa Monica, California

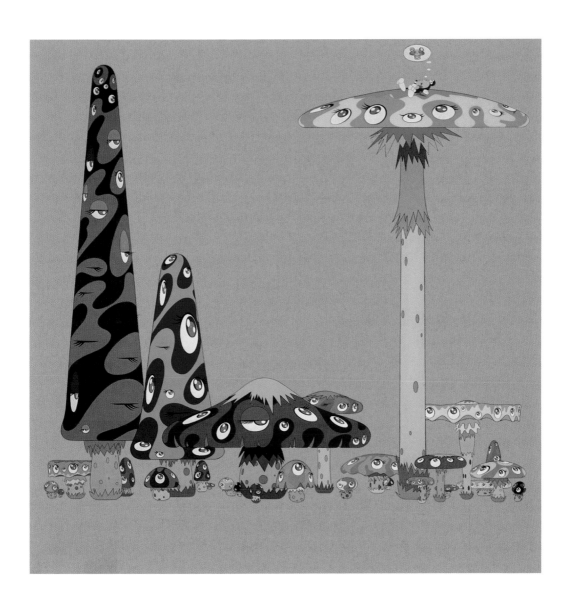

33. **Quiet, Quiet**, 1999
 Lacquer on fiberglass and resin
 56 x 37 x 37 inches
 Collection Reggie and Leigh Smith, Houston

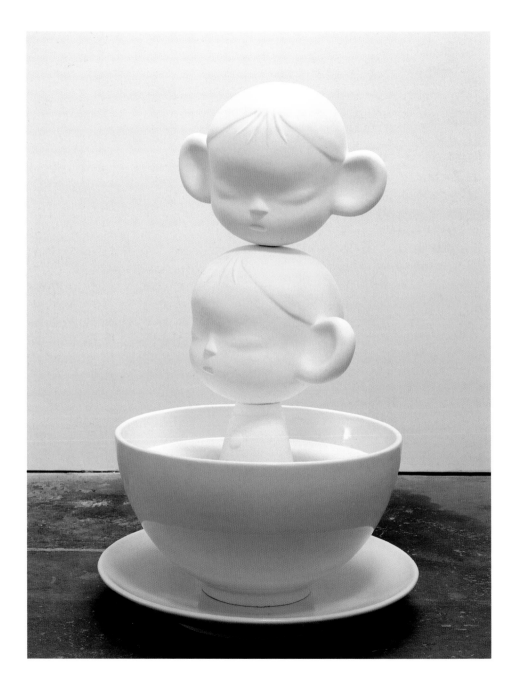

RACHEL HECKER
34. **Japa Mere** and **Guru Mere**, 2003
 Plastic coating and acrylic paint on carved styrofoam
 left to right: 31 x 24 x 25 and 37 x 24 x 25 inches
 Courtesy the artist and Texas Gallery, Houston

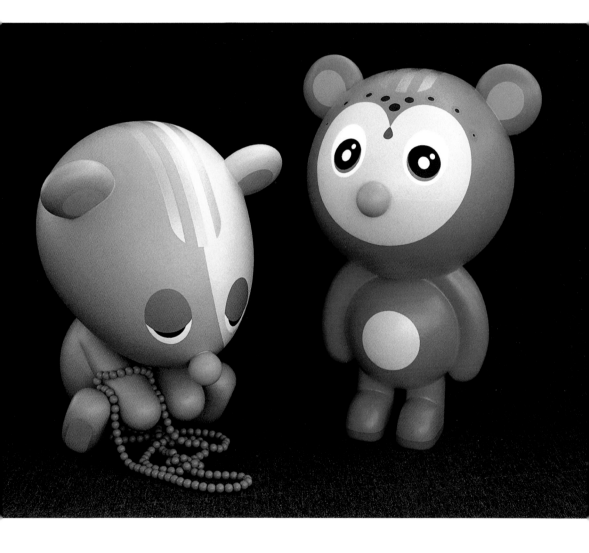

David Shrigley

35. **Untitled (Tom Thumb)**, 2000
Acrylic and ink on paper
13 3/8 x 16 5/8 inches
Courtesy Stephen Friedman Gallery, London

John Bankston

36. **Riding Desire**, 2001
 Oil on canvas
 54 x 48 inches
 Courtesy Jack Shainman Gallery, New York

KOJO GRIFFIN

37. **Untitled (man with gun, man on knees, man looking at watch)**, 2001
Mixed media on wood panel
71 7/8 x 88 3/4 inches
Gayle and Charles Atkins, New York

GEORGE CONDO

38. **The Stockbroker**, 2002

Oil on canvas

96 x 80 inches

Collection Vicki and Kent Logan, Vail, Colorado

(not in exhibition)

ROBERT PRUITT

39A–D. **Black Stuntman**, 2002

Four drawings from a video projection (eight minutes)

Pencil on paper

8 x 11 inches, each

Courtesy the artist

TRENTON DOYLE HANCOCK

40. **Esther**, from the **For a Floor of Flora** series, 2002
 Acrylic on canvas
 11 1/4 x 19 3/4 inches
 Courtesy the artist and Dunn and Brown Contemporary, Dallas,
 and James Cohan Gallery, New York

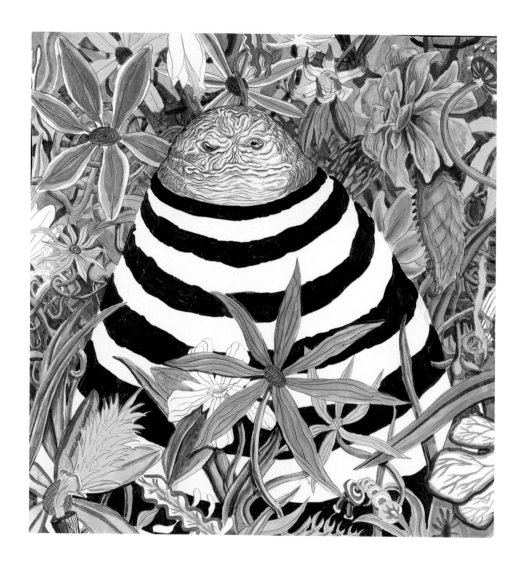

Artists' Biographies & Bibliographies

Compiled by *Clare Elliott*

⊘ LAYLAH ALI

Born 1968, Buffalo, New York
1991, Williams College, Williamstown, BFA
1991–92, Whitney Independent Study Program (New York)
1993, Skowhegan School of Painting and Sculpture, Maine
1994, Washington University, St. Louis, MFA
Lives and works in Williamstown, Massachusetts

SELECTED SOLO EXHIBITIONS
2002
Laylah Ali: Paintings on Paper, The Atlanta College of Art,
　Atlanta, October 10–November 24.
Projects 75: Laylah Ali, The Museum of Modern Art, New York,
　March 14–May 21. Brochure, text by Kristin Helmick-Brunet.
2001
Laylah Ali, The Institute of Contemporary Art, Boston, April 18–
　July 1. Catalogue, text by Suzanne Wise and Rebecca Walker.
2000
Paintings on Paper, Mass MoCA, North Adams, Massachu-
　setts, November 9–January 21, 2001.
Yerba Buena Center for the Arts, San Francisco, February.
1999
Laylah Ali, Museum of Contemporary Art, Chicago,
　August 2–November 7.
1994
Hallwalls Contemporary Arts Center, Buffalo, New York.
　Catalogue, text by Sheila Lloyd.

SELECTED GROUP EXHIBITIONS
1999
The 1999 De Cordova Annual Exhibition, De Cordova
　Museum and Sculpture Park, Lincoln, Massachusetts,
　June 12–September 6.
Collectors Collect Contemporary, The Institute of
　Contemporary Art, Boston.
Try This On!, Yerba Buena Center for the Arts, San Francisco.
　Catalogue, text by Arnold J. Kemp.
1998
Paradise 8, Exit Art, New York.
Selections Summer '98, The Drawing Center, New York.

SELECTED BIBLIOGRAPHY
Artner, Alan G. "MCA's Dual Exhibit Gives Creativity Short
　Shrift." *Chicago Tribune,* September 2, 1999.
Bonami, Francesco, and Hans Ulrich Obrist, eds. *Dreams.*
　Torino: Sandretto Re Rebaudengo Foundation, 1999.
Cotter, Holland. "Art in Review: Laylah Ali." *The New York
　Times,* June 30, 2000.
Lloyd, Ann Wilson. "Not-So-Comic Strips That Act Out Big
　Social Issues." *The New York Times,* August 8, 1999, p. AR33.
Morgan, Margaret. "Laylah Ali, 303 Gallery." *art/text,* Novem-
　ber 2000, p. 81.
Sirmans, Franklin. "Laylah Ali." *Time Out New York,* June
　29–July 6, 2000, p. 65.

⚐ CANDIDA ALVAREZ

Born 1955, Brooklyn, New York
1977, Fordham University, Bronx, New York, BFA
1997, Yale University, New Haven, MFA
Lives and works in Chicago

SELECTED SOLO EXHIBITIONS
2002
I Will Always Remember You, TBA Exhibition Space, Chicago,
　October 25–November 30.
1996
New/Now, New Britain Museum of American Art, New Britain,
　Connecticut.
1991
Paintings and Works on Paper, Queens Museum of Art,
　New York.
1984
Exit Art, New York.

SELECTED GROUP EXHIBITIONS
2000
*Snapshot: An Exhibition of Snapshots Portraying Intimate
　or Family Photos,* Contemporary Museum, Baltimore,
　November 2–February 4, 2001.
Out of Line: Drawings by Illinois Artists, Chicago Cultural
　Center.
1999
Passages: Contemporary Art in Transition, The Studio Museum
　in Harlem, New York, November 17–January 17, 2000.
　Traveled to Chicago Cultural Center; Miami Art Museum.
　Catalogue, text by Deirdre Scot and Frank Stewart.
1997
Heaven: Public View, Private View, P.S.1 Contemporary Art
　Center, Long Island City, New York.
1995
Artists Talk Back: Visual Conversations with El Museum,
　El Museo Del Barrio, New York.
1991
Third International Bienal of Painting, Cuenca, Ecuador.
　Catalogue.
1990
Working on Paper: Contemporary American Drawing, High
　Museum of Art, Atlanta.
1989
The Blues Aesthetic, The Washington Project for the Arts,
　Washington, D.C. Traveled to six venues. Catalogue, text by
　Rick Powell.
1988
Treasures from the Permanent Collection 1970–1987, The
　Studio Museum in Harlem, New York.
1987
*Masters and Pupils: The Education of the Black Artist in New
　York,* The Jamaica Center for Arts and Learning, New York.
1985
Surplus?: today's art in an overpopulated city, Exit Art, New
　York, March 28–April 20. Catalogue, text by Jeanette
　Ingberman and Papo Colo.
Artists-In-Residence Exhibition, The Studio Museum in
　Harlem, New York.
Surfacing Images: A Selection of Works on Paper, The Bronx
　Museum of the Arts Satellite Gallery, Hostos, New York.
1983
Books Alive, Metropolitan Museum of Art, New York.
1980
International Studio and Workspace Program, P.S.1 Contem-
　porary Art Center, Long Island City, New York.
1979
Recollections: Candida Alvarez and Vincent Smith, Brooklyn
　Museum of Art, New York.

SELECTED BIBLIOGRAPHY

Aguirre, George. *Shero I, a Portfolio: Artists and Their Work in Exhibition/ 20 Photographs by George Aguirre.* Lunenburg, Vt.: Stinehour, 1984.

Balken, Debra Bricker. "June Kelly Gallery, New York, Exhibit." *Art in America,* April 1997, p. 127.

Cyphers, Peggy. "June Kelly Gallery, New York, Exhibit." *Arts Magazine,* February 1990, p. 100.

Macadam, Barbara. "Candida Alvarez: Myth, Memory, and Old Lace." *ARTnews,* February 1993, pp. 67–68.

Pacheco, Patrick. "The New Faith in Painting." *Art and Antiques,* May 1991, pp. 56–69.

⚡ POLLY APFELBAUM

Born 1955, Abington, Pennsylvania
1978, Tyler School of Art, Philadelphia, BFA
Lives and works in New York

SELECTED SOLO EXHIBITIONS
2000
Skin and Bones, Bowdoin College Museum of Art, Brunswick, Maine, January 28–March 19. Catalogue, text by Alison Ferris.
1998
Polly Apfelbaum, Museum of Contemporary Art, Kiasma, Helsinki, May 30–August 30. Catalogue, text by Libby Lumpkin.
1994
This Is Where I Come From, Neuberger Museum of Art, State University of New York at Purchase. Brochure.
1990
The Language of Flowers, P.S.1 Contemporary Art Center, Long Island City, New York.

SELECTED GROUP EXHIBITIONS
2001
As Painting Division and Displacement, Wexner Center for the Arts, The Ohio State University, Columbus, May 11–August 12. Catalogue, text by Philip Armstrong, Laura Lisbon, and Stephen Melville.
The Return of the Real: A Selection from the Daniel Hechter Art Collection, Tel Aviv Museum of Art, Tel Aviv.
1999
The Body in Question: Tracing, Displacing, and Remaking the Human Figure in Contemporary Art, The Speed Art Museum, Louisville, Kentucky, July 6–August 22.
Postmark: An Abstract Effect, SITE Santa Fe, March 27– June 13. Catalogue.
Hindsight: Recent Contemporary Acquisitions, Whitney Museum of American Art, New York.
1998
Abstract Painting, Once Removed, Contemporary Arts Museum, Houston, October 3–December 6. Traveled to Kemper Museum of Contemporary Art, Kansas City, April 23–July 18, 1999. Catalogue, text by Dana Friis-Hansen, David Pagel, Raphael Rubenstein, and Peter Schjeldahl.
Everyday 1998, 11th Biennale, Sydney, September 18– November 8. Catalogue, text by Jonathan Watkins.
1997
Fashion Moda, Cleveland Center for Contemporary Art, May 2–August 10. Brochure, text by Lisa Marie Marks.
Women's Work, Examining the Feminine in Contemporary Painting, Southeastern Center for Contemporary Art, Winston-Salem, North Carolina.
1995
Painting Outside Painting, 44th Biennial, Corcoran Gallery of Art, Washington, D.C., December 16–February 19, 1996. Catalogue, text by Terrie Sultan and David Pagel.
Art at the Edge: Tampering, High Museum of Art, Atlanta, October 10–January 7, 1996. Brochure, text by Susan Krane.

1994
Sense and Sensibility: Women and Minimalism in the 90's, The Museum of Modern Art, New York, June 16–September 11. Catalogue, text by Lynn Zelevanksy.
1990
Suggestive Objects, Art in General, New York.

SELECTED BIBLIOGRAPHY

Apfelbaum, Polly. "Polly Apfelbaum: Varieties of Abstraction, a Partial Taxonomy." *Journal of Philosophy and the Visual Arts,* no. 5, 1995, pp. 86–89.

Cotter, Holland. "A Tour Through Chelsea." *The New York Times,* May 15, 1998, p. E33.

Dailey, Megan. "Polly Apfelbaum, 'Powerpuff.'" *Time Out New York,* November 2000, pp. 23–30.

Frank, Peter. "Polly Apfelbaum, Kate Shepherd, Pure De(sign)." *Los Angeles Weekly,* April 13, 2000.

Higgie, Jennifer. "Spookie Knowledge." *frieze,* May 2002, p. 87.

Mahoney, Robert. Review. *Flash Art,* March/April 1991.

Myers, Terry R. "Polly Apfelbaum." *Artext,* August/October 2000.

Pagel, David. "Polly Apfelbaum: Ring-A-Ring-A-Rose." *Art and Text,* January 1996, pp. 48–53.

_____. "A Supersaturated Return to the Spirit of the Punk Era." *Los Angeles Times,* May 10, 2002, p. F26.

Rubenstein, Raphael. "Extended Abstraction." *Art in America,* November 1997, pp. 104–15.

Ryan, David. "Interdeterminate Relations." *Contemporary Visual Arts,* no. 23, 1999, pp. 48–54.

Scott, Andrea K. "An Eloquent Silence." *Tema Celeste,* Fall 1992, pp. 37–38.

Smith, Roberta. "Abstraction: A Trend That May Be Coming Back." *The New York Times,* January 10, 1992.

Stein Greben, Deidre. "Stain Power." *ARTnews,* June 2001, pp. 98–105.

∂ IDA APPLEBROOG

Born 1929, Bronx, New York
1950, New York Institute of Applied Arts and Sciences, Booklyn, New York
1968, The School of the Art Institute of Chicago
1997, Parsons School of Design, New York, Honorary Doctorate
Lives and works in New York

SELECTED SOLO EXHIBITIONS
1998
Ida Applebroog: Nothing Personal, Paintings 1987–1997, Pennsylvania Academy of the Fine Arts, Philadelphia, September 12–January 3, 1999. Traveled to Corcoran Gallery of Art, Washington, D.C., March 14–June 1, 1999. Catalogue, text by Terry Sultan, Arthur Danto, and Dorothy Allison.
1993
Arion Press, Metropolitan Museum of Art, New York, October 24–November 26.
Ida Applebroog, Orchard Gallery, Derry, Northern Ireland, March 20–April 30. Traveled to Irish Museum of Modern Art, Dublin, May 20–September 5; Cubitt Street Gallery, London, November 30–January 28, 1994. Catalogue, text by Mira Schor.
Everything Is Fine, Brooklyn Museum of Art, New York, January 29–April 25. Traveled to Freedman Gallery-Albright College, Reading, Pennsylvania, March 29–April 26, 1994. Brochure.
1991
Ida Applebroog: Bilder, Ulmer Museum, Ulm, Germany, September 29–November 10. Traveled to Bonner Kunstverein, Bonn, Germany, November 29–January 20, 1992; NGBK, Berlin, April 4–April 31, 1992. Catalogue, text by Brigitte Reinhardt, Annelie Pohlen, Robert Storr, and Carla Schulz-Hoffmann.
1990
Happy Families, Contemporary Arts Museum, Houston, February 24–May 20. Traveled to The Power Plant, Toronto,

June 22–September 3. Catalogue, text by Marilyn Zeitlin, Thomas Sokolowski, and Lowery Sims.

1989
Art at the Edge: Ida Applebroog, High Museum of Art, Atlanta, September 12–October 29. Traveled to Carnegie Museum of Art, Pittsburgh, November 11–December 22. Catalogue, text by Susan Kane.

1987
Wadsworth Atheneum, Hartford, Connecticut, September 19–November 11. Brochure, text by Andrea Miller-Keller.

1986
Investigations 1986, Institute of Contemporary Art, University of Pennsylvania, Philadelphia, June 12–July 27. Catalogue, text by Judith Tannenbaum.

1983
Spectacolor Board, Times Square (Public Art Fund), New York.

1979
Manuscript, Franklin Furnace, New York.

1978
Whitney Museum of American Art, New York.

1971
Soft Forms: Ida Horowitz, Boehm Gallery, San Marcos, California.

SELECTED GROUP EXHIBITIONS

1999
The American Century: Art and Culture 1900–2000, Part II, 1950–2000, Whitney Museum of American Art, New York, November 26–February 13, 2000. Catalogue, text by Lisa Phillips.

1996
Reality Bites, Kemper Museum of Contemporary Art, Kansas City, May 6–June 23.

1995
Human/Nature, The New Museum of Contemporary Art, New York, April 20–May 18.

ARS 95 Helsinki, Museum of Contemporary Art Kiasma/ Finnish National Gallery, Helsinki, February 11–May 28. Catalogue, text by Jonathan Friedman, Maaretta Jaukkuri, Michael Glasmeier, Yonah Foncé-Zimmerman, and Asko Mäkelä.

1993
43rd Biennial Exhibition of Contemporary American Paintings, Corcoran Gallery of Art, Washington, D.C., October 30–January 2, 1994.

1993 Biennial Exhibition, Whitney Museum of American Art, New York, March 4–June 20. Catalogue, text by Elizabeth Sussman, Thelma Golden, John G. Hanhardt, and Lisa Phillips.

1992
Not For Sale, Tel Aviv Museum of Art, Tel Aviv, October 22–December 27. Catalogue.

1991
1991 Biennial Exhibition, Whitney Museum of American Art, New York, April 19–June 16. Catalogue, text by Richard Armstrong, John G. Hanhardt, Richard Marshall, and Lisa Phillips.

1990
Word as Image: American Art 1960–1990, Milwaukee Art Museum, Milwaukee, June 15–August 26. Traveled to Oklahoma City Art Museum, Oklahoma City, November 17–February 2, 1991; Contemporary Arts Museum, Houston, February 23–May 12, 1991. Catalogue, text by Dean Sobel.

1988
Committed to Print: An Exhibition of Recent American Printed Art with Social and Political Themes, The Museum of Modern Art, New York, January 31–April 19. Catalogue, text by Deborah Wye.

1987
The Viewer as Voyeur, Whitney Museum of American Art, New York, April 30–July 8. Catalogue, text by Andrea Inselmann, Grant Kester, James Peto, and Charles A. Wright.

1984
Twentieth Century American Artists, The Baltimore Museum of Art, Baltimore. October–November.

An International Survey of Recent Painting and Sculpture, The Museum of Modern Art, New York, May 17–August 19. Catalogue, edited by Kynaston McShine.

Verbally Charged Images, Queens Museum of Art, New York, April 28–June 10. Traveled to University of South Florida Contemporary Art Museum, Tampa, September 21–November 2; University Art Gallery, San Diego State University, San Diego, February 2–March 2, 1985; Robert V. Fullerton Art Museum, California State University, San Bernardino, April 10–May 8, 1985. Catalogue.

1983
Directions 1983, Hirshhorn Museum and Sculpture Garden, Smithsonian Institution, Washington, D.C., March 10–May 15. Catalogue, text by Phyllis D. Rosenzweig.

1977
American Narrative/Story Art: 1967–1977, Contemporary Arts Museum, Houston. Catalogue, text by Paul Schimmel.

The Proscenium: The Staged Works of Ida Applebroog, Manny Farber and Patricia Patterson, P.S.1 Contemporary Art Center, Long Island City, New York.

1972
Invisible/Visible, Long Beach Museum of Art, California. Catalogue, text by Judy Chicago and Debra Frankel.

SELECTED BIBLIOGRAPHY

Brenson, Michael. "Art People: Sculpture 'Speaks Out' at Downtown Landmark." *The New York Times,* November 12, 1982, p. C25.

Cameron, Dan. "Illustration Is Back in the Picture." *ARTnews,* November 1985, pp. 114–20.

Danto, Arthur. "Correspondence School Art." *The Nation,* March 29, 1999, pp. 30–34.

Diehl, Carol. "Birds, Beads and Banner Stones." *ARTnews,* Summer 1996, pp. 76–84.

Johnson, Patricia. *The Houston Chronicle,* March 5, 1990, pp. D9–10.

Kozloff, Max. "The Cruelties of Affection." *Art in America,* September 1995, pp. 82–87.

Lippard, Lucy. *The Pink Glass Swan: Selected Feminist Essays on Art.* New York: New Press, 1995.

Lucie-Smith, Edward. *Art Today.* London: Phaidon, 1995.

Plagens, Peter. "Frail Fellows." *Artforum,* September 1998, p. 43.

Raven, Arlene. *Crossing Over: Feminism and Art of Social Concern.* Ann Arbor, Mich.: University of Michigan Research Press, 1988.

Roth, Moira. *The Amazing Decade: Women and Performance Art in America 1970–1980.* Los Angeles: Astro Artz, 1980.

Saltz, Jerry. "Let Us Now Praise Artists' Artists." *Art and Auction,* April 1993, pp. 74–79, 115.

Sayre, Henry M. *The Object of Performance, The American Avant Garde Since 1970.* Chicago: University of Chicago Press, 1989.

Schor, Mira. "Medusa Redux, Ida Applebroog and the Spaces of Post-Modernity." *Artforum,* March 1990, pp. 116–22.

_____. *Wet: On Painting, Feminism, and Art Culture.* Durham, N.C.: Duke University Press, 1997.

Schwendenwien, Jude. "Social Surrender: An Interview with Ida Applebroog." *Real Life,* Winter 1987, pp. 40–44.

Smith, Roberta. "Exercises for the Figure." *The Village Voice,* November 20, 1984, p. 120.

Solomon-Godeau, Abigail. "Ida Applebroog at Nathalie Pariente." *Art in America,* March 2001, pp. 142–43.

Sultan, Terrie. "Ida Applebroog: Exposing the Personal." *Ms.,* March/April 1998, pp. 71–73.

Taubin, Amy. "Body Electric." *The Village Voice,* April 30, 1991, pp. 45–46.

Wallach, Amei. "The Contemporary Collector's Art." *The New York Times Magazine,* October 26, 1997, pp. 42–46.

✄ JOHN BANKSTON

Born 1963, San Francisco
1985, University of Chicago, AB
1989, Skowhegan School of Painting and Sculpture, Maine
1990, The School of the Art Institute of Chicago, MFA
Lives and works in San Francisco

SELECTED SOLO EXHIBITIONS
2002
John Bankston, Temptation and Desire, Atlanta College of Art
Gallery, March 21–April 28.
2001
Lovers, Rena Bransten Gallery, San Francisco, October 11–
November 24.
The Capture and Escape of Mr. M, Chapter 1, The Studio
Museum in Harlem, New York.
1999
John Bankston, Recent Work, Bucheon Gallery, San Francisco.

SELECTED GROUP EXHIBITIONS
2002
Fantasyland, D'Amelio Terras, New York, May 30–July 26.
2001
Freestyle, The Studio Museum in Harlem, New York, April
28–June 24. Catalogue.
Comic Relief, Rena Bransten Gallery, San Francisco, March 22–
April 28.
Starry Night, Jack Shainman Gallery, New York.
2000
A Big Picture Show, Bucheon Gallery, San Francisco, August 8–
September 22.
1999
Bay Area Now 2, Yerba Buena Center for the Arts, San Fran-
cisco, November 20–February 13, 2000. Catalogue.
1998
Insomnia, Bucheon Gallery, San Francisco.
1997
Fellows Invitational, Fine Arts Work Center, Provincetown,
Massachusetts.
1996
Don Baum Says Chicago Has Famous Artists, Hyde Park Art
Center, Chicago.
1994
Emerging Talent: African-American Artists in California, Skyline
College, San Bruno, California.
Just Good Art, Hyde Park Art Center, Chicago.
1993
Emerging Chicago Abstraction, Rockford Art Museum, Rock-
ford, Illinois.
1992
Chicago International Art Exhibition, Struve Gallery, Chicago.
1990
Abstraction–New Talent, Struve Gallery, Chicago.
Artist from Outline, MWMWM Gallery, Chicago.
Skowhegan Group Show, Hokin-Kaufman Gallery, Chicago.
1988
A Part of the Whole, The School of the Art Institute of
Chicago.

SELECTED BIBLIOGRAPHY
Baker, Kenneth. "Local Heroes." *San Francisco Chronicle,*
November 20, 1999.
Birnbaum, Daniel, Dennis Cooper, Kate Bush, Bob Nickas,
Robert Storr, Hans-Ulrich Obrist, Philip Nobel, Matthew
Higgs, Tom Holert, Katy Siegel, and Hamza Walker. "First
Take." *Artforum,* January 2002, pp. 119–31.
Brockington, Horace. "'Freestyle' Studio Museum in Harlem."
New York Arts, June 2001, pp. 36–37.
Camhi, Leslie. "Satyrs, Slaves and Monsters in the Color of
Childhood." *The New York Times,* March 18, 2001.

Cotter, Holland. "A Full Studio Museum Show Starts with 28
Young Artists and a Shoehorn." *The New York Times,* May
11, 2001, p. E36.
_____. "Material and Matter, John Bankston." *The New York
Times,* March 9, 2001.
DeCarol, Tessa. "Bay Area Now: MFA's in Toyland." *Wall Street
Journal,* January 27, 2000.
Murray, Derek Conrad. "Freestyle." *NKA: Journal of Contem-
porary African Art,* Fall–Winter 2001, pp. 92–93.
Nadelman, Cynthia. "Freestyle." *ARTnews,* September 2001,
p. 173.
Schjeldahl, Peter. "Breaking Away." *The New Yorker,* June 2,
2001, pp. 90–91.

✠ JEAN-MICHEL BASQUIAT

Born 1960, Brooklyn, New York
Died 1988, New York

SELECTED SOLO EXHIBITIONS
2002
Jean-Michel Basquiat, Chiostro di S. Maria della Pace, Rome.
Catalogue, text by Gianni Mercurio and Mirella Panepinto.
1999
Jean Michel Basquiat: Gemälde und Arbeit auf Papier, Kunst-
haus Wien, Vienna, February 11–March 2. Catalogue, text
by Jacob Baal-Teshuva.
1994
Jean-Michel Basquiat, Henry Art Gallery, Seattle, February 18–
April 6.
1993
Jean-Michel Basquiat, Newport Harbor Museum, Newport
Beach, California, July 10–September 12.
Jean-Michel Basquiat, Musée d'Art Contemporain, Pully-
Lausanne, Switzerland, July 10–November 7.
1992
Jean-Michel Basquiat, Whitney Museum of American Art, New
York, October 23–February 14, 1993. Traveled to The Menil
Collection, Houston, March 11–May 9, 1993; Des Moines
Art Center, Des Moines, Iowa, May 22–August 15, 1993;
Montgomery Museum of Fine Arts, Alabama, November 18,
1993–January 9, 1994. Catalogue, text by Richard Marshall
and Dick Hebdige.
Jean-Michel Basquiat, une retrospective, Musée Cantin,
Marseille, July 4–September 20. Catalogue.
1986
Jean Michel Basquiat, Kestner-Gesellschaft, Hannover, Germany,
November 28–January 25, 1987. Catalogue, text by Robert
Farris Thompson and Carl Albrecht Haenlein.
J.M. Basquiat, Centre Culturel Français d'Abidjan, Abidjan,
Ivory Coast, October 10–November 7.
1985
Jean-Michel Basquiat, Berkeley Art Museum and Pacific Film
Archives, University of California, January–March.
Traveled to Museum of Contemporary Art, San Diego, May
4–June 16. Brochure.
1984
Jean Michel Basquiat: Paintings 1981–1984, The Fruitmarket
Gallery, Edinburgh, August 1–September 23. Traveled to
Institute of Contemporary Arts, London, December 15–
January 27, 1985; Museum Boijmans Van Beunigen, Rotter-
dam, February 9–March 31, 1985. Catalogue, text by Mark
Francis.

SELECTED GROUP EXHIBITIONS
2002
Warhol, Basquiat, Clemente: Obras en Colaboración, Museo
Nacional Centro de Arte Reina Sofia, Madrid, February 5–
April 29. Catalogue.

1999
Other Narratives, Contemporary Arts Museum, Houston,
May 15–July 4. Catalogue, text by Dana Friis-Hansen,
Robert Atkins, and Greg Tate.
1993
The Theatre of Refusal: Black Art and Mainstream Criticism,
University of California Art Gallery and Beall Center for
Art and Technology, Irvine, April 8–May 12. Traveled to
Richard L. Nelson Gallery and The Fine Arts Collection,
University of California, Davis, November 7–December 17;
Sweeney Art Center, University of California, Riverside,
January 2–February 27, 1994. Catalogue, text by Charles
Gaines and Catherine Lord.
1990
The Decade Show: Frameworks of Identity in the 1980s, Museum
of Contemporary Hispanic Art, The New Museum of Con-
temporary Art, and The Studio Museum in Harlem, New
York, May 16–August 19. Catalogue, edited by Kinshasha
Holman-Conwill, Nilda Peraza, and Marcia Tucker.
1989
Jean-Michel Basquiat/Julian Schnabel, Rooseum, Malmö,
Sweden, April 8–May 28. Catalogue, text by Jeffery Deitch.
1986
Prospect '86, Frankfurter Kunstverein, Frankfurt, September 9–
November 2. Catalogue.
1984
Content: A Contemporary Focus, 1975–1984, Hirshhorn
Museum and Sculpture Garden, Smithsonian Institution,
Washington, D.C., October 4–January 6, 1985. Catalogue,
text by Howard N. Fox, Miranda McClintock, and Phyllis
D. Rosenzweig.
An International Survey of Recent Painting and Sculpture, The
Museum of Modern Art, New York, May 17–August 19.
Catalogue, edited by Kynaston McShine.
1983
1983 Biennial Exhibition, Whitney Museum of American Art,
New York, March 15–May 29. Catalogue, text by John G. Han-
hardt, Barbara Haskell, Richard Marshall, and Patterson Sims.
1982
Documenta 7, Kassel, Germany, June 19–September 23.
Catalogue, text by Coosje van Bruggen, Germano Celant,
Johannes Gachnang, and Gerhard Storck.
Transavanguardia: Italia/America, Galleria Civica del Comune
di Modena, Modena, Italy, March 21–May 2. Catalogue,
text by Achille Bonita Oliva.
1980
Times Square Show, Colab (Collaborative Projects Inc.) and
Fashion Moda, 41st Street and Seventh Avenue, New York,
July.

SELECTED BIBLIOGRAPHY

Als, Hilton. "Jean-Michel Basquiat, 1960–1988." *The Village
Voice,* August 30, 1988, p. 82.
Baker, Kenneth. "Taking Stock of Basquiat's Raw-Edge Power."
San Francisco Chronicle, November 18, 1992, p. E3.
Castle, Frederick Ted. "Saint Jean Michele." *Arts Magazine,*
February 1989, pp. 60–61.
Cotter, Holland. "Jean-Michel Basquiat: 'A Tribute.'" *The New
York Times,* November 1, 1996, p. C32.
De Ak, Edit, and Diego Cortez. "Baby Talk." *Flash Art,* May
1982, pp. 34–48.
Deitch, Jeffrey. "Jean-Michel Basquiat: Annina Nosei." *Flash
Art,* May 1982, p. 49.
_____. "Report from Times Square." *Art in America,* September
1980, pp. 58–63.
Fairbrother, Trevor. "Double Feature: Collaborative Paintings
of Andy Warhol and Jean-Michel Basquiat." *Art in America,*
September 1996, pp. 76–83.
Gablik, Suzi. "Report from New York: The Graffiti Question."
Art in America, October 1982, pp. 33–39.
Geldzahler, Henry. "Art: From Subways to Soho, Jean-Michel
Basquiat." *Interview,* January 1983, pp. 44–46.
Kawachi, Taka. *King for a Decade/Jean-Michel Basquiat.* Kyoto:
Korinsha, 1997.
McEvilley, Thomas. "On the Manner of Addressing Clouds."
Artforum, June 1984, pp. 61–70.
_____. "Royal Slumming: Jean Michel Basquiat Here Below."
Artforum, November 1992, pp. 92–97.
McGuigan, Cathleen. "New Art, New Money: The Marketing
of an American Artist." *The New York Times Magazine,*
February 10, 1985, pp. 20–28, 32–35, 74.
Moufarrege, Nicolas. "X Equals Zero, as in Tic Tac Toe." *Arts
Magazine,* February 1983, pp. 116–21.
Richard, Rene. "The Radiant Child." *Artforum,* December 1981,
pp. 35–43.
Smith, Roberta. "Basquiat: Man for His Decade." *The New
York Times,* October 23, 1992, p. C1.
Tomkins, Calvin. "The Art World: Disco." *The New Yorker,*
July 22, 1984, pp. 64–66.
Winter, Peter. "The Drawings of Jean Michel Basquiat."
Art International, Spring 1990, pp. 94–95.

✺ DARA BIRNBAUM

Born 1946, New York
1969, Carnegie Mellon University, Pittsburgh, BA
1973, San Francisco Art Institute, MFA
Lives and works in New York

SELECTED SOLO EXHIBITIONS
2001
Erwartung, Galerie Marian Goodman, Paris, February 3–
March 2.
1995
Dara Birnbaum, Kunsthalle Wien, Vienna, October 8–Novem-
ber 19. Catalogue, text by Eleonora Louis and Toni Stooss.
Dara Birnbaum, Museum für Moderne Kunst, Frankfurt am
Main, Germany.
1994
Hostage, Paula Cooper Gallery, New York.
1990
Dara Birnbaum, IVAM Centre del Carme, Valencia, Spain,
March 1–May 13. Catalogue, text by Germano Celant and
Judy Cantor.
1988
Many Charming Landscapes: The Video Tapes of Dara Birnbaum,
Pacific Film Archives, Berkeley, California.
1985
Retrospective, First International Video Biennial, Vienna.
1984
Dara Birnbaum–Retrospective Screening, Institute of Contem-
porary Arts, London.
1983
Dara Birnbaum, Musée d'art contemporain de Montréal.
1980
Dara Birnbaum, The Kitchen Center for Video, Music, Dance,
Performance, Film and Literature, New York.

SELECTED GROUP EXHIBITIONS
2002
*Dara Birnbaum and Dan Graham: A Program of Video at the
Urban Rooftop Park Project,* Dia Center for the Arts and
Electronic Arts Intermix, New York, June 7.
2000
Au-dela du Spectacle, Centre Georges Pompidou, Musée Na-
tional d'Art Moderne, Paris, November 22–January 8, 2001.
1997
*Postmodern Media: Nam June Paik, Dara Birnbaum, and Gen-
eral Idea,* San Francisco Museum of Modern Art, May 9–
September 16.

1995

L'effet Cinéma, Musée d'art contemporain de Montréal, Montreal, October 27–January 14, 1996. Catalogue, text by Réal Lussier and Olivier Asselin.

1992

Art at the Armory: Occupied Territory, Museum of Contemporary Art, Chicago, September 13–January 23, 1993. Catalogue, text by Robert Bruegmann, Ann Rorimer, Beryl J. Wright, and Nadine Wasserman.

1989

Video Drive-In: 3 Programmes de Vídeo Americà, IVAM Centre Julio González, Valencia, Spain, September 17–19. Catalogue, text by Kate Horsfield and Carole Ann Klonarides.

A Forest of Signs: Art in the Crisis of Representation, Museum of Contemporary Art, Los Angeles, May 7–August 13. Catalogue, text by Mary Jane Jacob, Ann Goldstein, Anne Rorimer, and Howard Singerman.

1986

Remembrances of Things Past, Long Beach Museum of Art, Long Beach, California, November 23–January 18, 1987. Catalogue, text by Howard Singerman, Lydia Davis, Bernard Welt, Amy Gerstler, T. S. Martin, Anne Turyn, Bob Fiengo, Douglas Blau, and David Antin.

A Different Climate: Women Artists Use New Media, Städtische Kunsthalle, Dusseldorf, Germany, March 28–May 11. Catalogue, text by G. Honnef-Harling, H. Arendt, J. Baudrillard, L. Lorenz, W. Franke, M. L. Syring, and S. von Wiese.

1984

Heroes/Anti-Heroes, Contemporary Arts Museum, Houston, September–December 2. Catalogue, text by Dana Friis-Hansen.

The American Filmmakers Series, The Whitney Museum of American Art, New York.

Het Lumineuze Beeld, Stedelijk Museum of Modern Art, Amsterdam.

1982

Documenta 7, Kassel, Germany, June 19–September 23. Catalogue, text by Coosje van Bruggen, Germano Celant, Johannes Gachnang, and Gerhard Storck.

1981

Video Viewpoints, The Museum of Modern Art, New York.

1980

Deconstruction/Reconstruction: The Transformation of Photographic Information into Metaphor, The New Museum of Contemporary Art, New York, July 12–September 18. Catalogue.

SELECTED BIBLIOGRAPHY

Birnbaum, Dara. "Elemental Forces, Elemental Dispositions: Fire/Water." *October,* Fall 1999, pp. 109–35.

Buchloh, B.H.D. "Allegorical Procedures: Appropriation and Montage in Contemporary Art." *Artforum,* September 1982, pp. 43–56.

_____. "From Gadget Video to Agit Video: Some Notes on Four Recent Video Works." *Art Journal,* Fall 1985, pp. 217–27.

Canning, Susan. "An Interview with Dara Birnbaum." *Art Papers,* November/December 1991, pp. 54–58.

Carl, Katherine, Stewart Kendall, and Kirsten Swenson. "Video Art in the 90s." *Art Criticism,* vol. 14, no. 2, 1999, pp. 74–93.

Gorney, S. Paul. "Dara Birnbaum." *Juliet Art Magazine,* April/May 1988, p. 37.

Hanhardt, John G. "Expanded Forms, Notes Towards a History." *Art and Design,* July/August 1993, pp. 18–25.

Hanhardt, John G., and Maria Christina Villaseñor. "Video/media Culture of the Late Twentieth Century." *Art Journal,* Winter 1995, pp. 20–25.

Kirshner, Judith Russi. "Dara Birnbaum." *Forum International,* March/April 1993, pp. 90–96.

Klein, Norman M., and Dara Birnbaum. *Dara Birnbaum: Rouge Edits—Popular Image Video Works 1977–1980.* Halifax: Nova Scotia College of Art and Design, 1987.

Kolbowski, Silvia. "An Inadequate History of Conceptual Art." *October,* Spring 2000, pp. 52–70.

Kujakovic, Daniel, and Sebastian Lohse. *Andere Taume, andere Stimmen.* Zurich: Memory, Cage Editions, 1999.

McCarthy, Anna. "From Screen to Site: Television's Material Culture, and its place." *October,* Fall 2001, pp. 93–111.

Owens, C. "Phantasmagoria of the Media." *Art in America,* May 1982, pp. 98–100.

Rush, Michael. *New Media in Late Twentieth Century Art.* London: Thames and Hudson, 1999.

Straayer, Chris. "Sexuality and the Video Narrative." *Afterimage,* May 1989, pp. 8–11.

Sturken, Marita. "Feminist Video: Reiterating the Difference." *Afterimage,* April 1985, pp. 9–11.

Sustersic, Aplonija. "An Interview with Dara Birnbaum." *M'Ars,* vol. 9, no.1, 1997, pp. 1–14.

Tarkaa, Minna. "Viestintapolitiikan taidetta." *Taide,* vol. 29, no. 4, 1989, pp. 14–17.

☞ ROGER BROWN

Born 1941, Alabama

1968, The School of the Art Institute of Chicago, BFA
1970, The School of the Art Institute of Chicago, MFA
Died 1997, Chicago

SELECTED SOLO EXHIBITIONS

1997

Phyllis Kind Gallery, Chicago.

1987

Roger Brown, Hirshhorn Museum and Sculpture Garden, Smithsonian Institution, Washington, D.C., August 13–October 18. Traveled to Museum of Contemporary Art, San Diego, November 20–January 10, 1988; Lowe Art Museum, University of Miami, Coral Gables, Florida, February 11–March 27, 1988; Des Moines Art Center, Des Moines, Iowa, April 28–June 12, 1988. Catalogue, text by Sidney Lawrence and John Yau.

1980

Roger Brown, Montgomery Museum of Fine Arts, Montgomery, Alabama, October 5–November 23. Traveled to Contemporary Arts Museum, Houston, December 12–January 19, 1981; Museum of Contemporary Art, Chicago, February 13–April 12, 1981. Catalogue, text by Mitchell Douglas Kahan, Dennis Adrian, and Russel Bowman.

1977

Roger Brown, Phyllis Kind Gallery, Chicago, October.

1974

Roger Brown: Magic Landscapes, Galerie Darthea Speyer, Paris.

SELECTED GROUP EXHIBITIONS

1997

A Singular Vision: Prints from the Landfall Press, The Museum of Modern Art, New York, February 6–May 6. Catalogue.

1992

American Figurations: A Directory–Works from the Lilja Collection, Henie Onstad Kunstsenter, Hovikodden, Norway, February 15–March 29. Catalogue, text by Torsten Lilja and Kim Levin.

1991

Image and Likeness: Figurative Works from the Permanent Collection, Whitney Museum of American Art, New York, January 23–March 20. Catalogue.

1989

A Certain Slant of Light, Dayton Art Institute, Ohio. Catalogue, text by Peter Bacon Hales and Naomi Vine.

1987

Surfaces: Two Decades of Painting in Chicago, Terra Museum of American Art, September 12–November 15. Catalogue, text by Judith Russi Kirschner.

The Chicago Imagist Print, The David and Alfred Smart Museum

of Art, University of Chicago, October 6–December 6. Catalogue, text by Dennis Adrian and Richard Born.

1985

Points of View: Four Painters, Bass Museum of Art, Miami Beach, May 17–June 16. Traveled to Lehman College Art Gallery, Bronx, New York, September 17–October 27; Cleveland Center for Contemporary Art, January 17– February 15, 1986. Catalogue, text by Eric Gibson.

Sources of Light: Contemporary American Luminism, Henry Art Gallery, Seattle, April 3–May 26. Catalogue, text by H. West and C. Bruce.

1981

Contemporary Artists, The Cleveland Museum of Art, October 21–November 29. Catalogue.

1980

Collaborations, Mary and Leigh Block Museum of Art, Northwestern University, Evanston, Illinois, September 28– October 26.

1978

American Chairs: Form, Function, and Fantasy, John Michael Kohler Arts Center, Sheboygan, Wisconsin, April 16–May 28. Catalogue.

1977

76th Exhibition by Artists of Chicago and Vicinity, The Art Institute of Chicago, February 27–March 27. Catalogue, text by J. Livingston, A. J. Speyer, I. Petlin, and J. Maxon.

1974

Made in Chicago, National Museum of American Art, Smithsonian Institution, Washington, D.C., October 31–December 29. Traveled to Museum of Contemporary Art, Chicago, January 11–March 2, 1975. Catalogue, text by J. C. Taylor, D. Baum, W. Halstead, and D. Adrian.

1972

What They're up to in Chicago, National Gallery of Canada, Ottawa.

SELECTED BIBLIOGRAPHY

Barbiero, Daniel. "Mr. Brown Goes to Washington." *New Art Examiner,* December 1987, pp. 36–37.

Bell, J. "Roger Brown." *Arts Magazine,* October 1975, p. 8.

Bowman, R. "An Interview with Roger Brown." *Art in America,* January/February 1978, pp. 106–109.

Cameron, Dan. "Illustration Is Back in the Picture." *ARTnews,* November 1985, pp. 114–20.

"Una Ciudad en el Lienzo: Chicago Visto por sus Pintores." *Correo del Arte,* January 1988, pp. 16–17.

Cohen, R. H. "Roger Brown." *Arts Magazine,* December 1977, p. 11.

De Montebello, Phillipe. *Notable Acquisitions 1982–1983.* New York: Metropolitan Museum of Art, 1983.

Freuh, J. "Allegory, an-other-world." *Art Journal,* Winter 1985, pp. 323–29.

Garvey, Timothy J. "Garden Becomes Machine: Images of Suburbia in the Painting of Roger Brown." *Smithsonian Studies in American Art,* Summer 1989, pp. 2–23.

Gedo, Mary Mathews. "Interconnections: A Study of Chicago-Style Relationships in Painting." *Arts Magazine,* September 1983, pp. 92–97.

_____. "Public Art/Private Iconography: Roger Brown's Transformation of the Myth of Daedalus and Icarus." *Art Criticism,* vol. 11, no. 2, 1996, pp. 38–53.

Holg, Garrett. "June and Francis Speizer: In Love with Eccentricity." *ARTnews,* October 1996, pp. 101–102, 104.

Johnson, Ken. "Other Vision: The Art of Roger Brown." *Arts Magazine,* December 1987, pp. 61–63.

Kahan, M. D. "The World According to Brown." *Portfolio,* September/October 1981, pp. 88–91.

Loughery, John. "An Uneasy Balance: The Political Art of Sue Cole and Roger Brown." *Arts Magazine,* November 1987, pp. 33–35.

Luke, Timothy W. "Roger Brown: Tracing the Silhouettes from the Shadow of the Silent Majorities." *Art Papers,* March/April 1988, pp. 31–32.

_____. *Shows of Force: Power, Politics, and Ideology in Art Exhibitions.* Durham, N.C.: Duke University Press, 1992.

"Mothers, Mentors and Mischief." *ARTnews,* January 1996, pp. 110–13.

Pieszak, D. "The Packaging of Vulgarity: Will It Double Your Pleasure?" *New Art Examiner,* March 1977, p. 11.

Price, Mark. "Interview with Roger Brown." *Sculpture,* September 1997, pp. 48–43.

Ratcliff, C. "Narrative." *Print Collector's Newsletter,* January/February 1982, pp. 170–73.

Ulrich, Polly. "INTUIT: Outsider Art at Home in Chicago." *American Craft,* December 1998/January 1999, p. 8.

🐟 ENRIQUE CHAGOYA

Born 1953, Mexico City
1984, San Francisco Art Institute, BFA
1986, University of California at Berkeley, MA
1987, University of California at Berkeley, MFA
Lives and works in San Francisco

SELECTED SOLO EXHIBITIONS

2002

The Enlightened Savage, George Adams Gallery, New York, March 1–April 6.

2001

Utopian Canniba: Adventures in Reverse Anthropology, Forum for Contemporary Art, St. Louis, January 19–March 10.

2000

utopiancannibal.com, Gallery Paule Anglim, San Francisco, October.

Enrique Chagoya: Locked in Paradise, Nevada Museum of Art, Reno, May 6–June 25. Catalogue.

An American Primitive in Paris, George Adams Gallery, New York, April 12–May 20.

1996

Beyond Boundaries, Galería de la Raza, San Francisco.

1993

Enrique Chagoya, Arizona State University Art Museum, Tempe, October 15–November 26. Brochure, text by Jacqueline Butler-Diaz and Enrique Chagoya.

1990

Enrique Chagoya: Not Good for Funding, De Saisset Museum, Santa Clara, California, October 6–December 7. Brochure, text by Robert McDonald.

Recent Work, Gallery Paule Anglim, Sn Francisco, April 5–28.

1989

Thesis/Antithesis, Artspace, San Francisco, September 26– November 18.

Enrique Chagoya: When Paradise Arrived: Political Satire, Alternative Museum, New York, March 11–April 29. Catalogue, text by Robbin Légère Henderson and Moira Roth.

1984

Enrique Chagoya, Galería de la Raza, San Francisco.

SELECTED GROUP EXHIBITIONS

2002

I-5 Resurfacing: Four Decades of California Art, San Diego Museum of Art, California.

2000

Made in California: Art, Image and Identity 1900–2000, Los Angeles County Museum of Art, October 22–February 25, 2001. Catalogue, text by Stephanie Barron, Sheri Bernstein, and Ilene Susan Fort.

Open Ends, Los Angeles County Museum of Art.

1999

Other Narratives, Contemporary Arts Museum, Houston, May 15–July 4. Catalogue, text by Dana Friis-Hansen, Robert Atkins, and Greg Tate.

1998
Mouse an American Icon, Alternative Museum, New York.
1997
American Stories: Amidst Displacement and Transformation, Setagaya Art Museum, Tokyo, August 30–October 19. Traveled in Japan to Chiba Municipal Museum of Art, November 1–December 23; Fukui Fine Arts Museum; Kurashiki City Art Museum; Akita Prefectural Integrated Life Cultural Hall, Akita, August 7–September 6, 1998. Catalogue.
Singular Impressions, The Monotype in America, National Museum of American Art, Smithsonian Institution, Washington, D.C. Catalogue.
1996
Muertos de Gusto, Mexican Fine Arts Center Museum, Chicago.
1995
On Beyond the Book, Forum for Contemporary Art, St. Louis.
Selections from the Permanent Collection, San Francisco Museum of Modern Art.
1993
Muertos de Gusto! Day of the Dead: Memory and Ritual, Mexican Fine Arts Center Museum, Chicago.
The Year of the White Bear, Walker Art Center, Minneapolis.
1992
Imágenes de Guerra, Centro Cultural de Arte Contemporáneo, Mexico City. Catalogue.
1991
Artists of Conscience: 16 Years of Political and Social Commentary, Alternative Museum, New York.
Boxes, Museum of Craft and Folk Art, San Francisco.
Fridomania, Frida Kahlo/Diego Rivera Museum, Mexico City.
Text/Context, San Jose Institute of Contemporary Art, California.
1986
La VII Bienal de San Juan del Grabado Latinoamericano y del Caribe, Instituto Puertorriqueño de Arte y Cultura de ASPIRA, San Juan, Puerto Rico.
Lo del Corazón: Heartbeat of a Culture, The Mexican Museum, San Francisco.
1984
Artist's Call Against US Intervention in Central America, San Francisco Art Institute, Walter/McBean Gallery, Stephen Wirtz Gallery, and Mission Cultural Center, San Francisco.
What's Happening: Contemporary Art from the West Coast, Alternative Museum, New York.

SELECTED BIBLIOGRAPHY

Baker, Kenneth. "Bleeding Hands Signal Chagoya's Retablos." *San Francisco Chronicle,* September 26, 1992.
_____. "Chagoya's Cultural Clashes." *San Francisco Chronicle,* September 15, 1994, p. E1.
Bonetti, David. "Chagoya's Wondrous Clash of Cultures." *San Francisco Examiner,* October 27, 2000.
_____. "To Bay Area Artists, He's a Patron Saint." *San Francisco Chronicle,* March 25, 1994.
Chagoya, Enriqe. "Burning Desire: The Art of the Spray Can and a New Direction at the Mexican Museum." *Shift,* vol. 5, no. 2, 1992.
Chun, Kimberly. "Superman Meets Aztec Idols." *San Francisco Chronicle,* August 29, 1997.
Cohn, Terri. "Recording Special Moments." *Artweek,* November 5, 1988, p. 5.
_____. "Sanctuaries of Contrast." *Artweek,* November 4, 1989, p. 7.
Gomez-Peña, Guillermo, with illustrations by Enrique Chagoya. *Codex, Espangliensis (from Columbus to the Border Patrol).* Santa Cruz, Calif.: Moving Parts, 1998.
_____. *Friendly Cannibals.* San Francisco: Artspace, 1997.
"Guillermo Gomez-Peña and Enrique Chagoya." *Art on Paper,* January/February 1999, p. 52.
Heartney, Eleanor. "Enrique Chagoya." *New Art Examiner,* September 1989, pp. 59–60.
Krayna, Philip. "History, unfolded." *Print,* January/February 1999, pp. 90–93.
Lippard, Lucy. *Mixed Blessings: New Art in Multicultural America.* New York: Pantheon, 1990.
Miller, Joe. "Enrique Chagoya." *New Art Examiner,* October 1997, p. 57.
Porges, Maria. "Enrique Chagoya." *Art Issues,* November/December 1992.
_____. "Enrique Chagoya." *Artforum,* November 1994, pp. 91–92.
Rapko, John. "Enrique Chagoya at Gallery Paule Anglim." *ArtWeek,* December 2000.
Smith, Joan. "Chagoya's Funny Way of Painting." *San Francisco Examiner,* November 25, 1994.
Torres, Anthony. "Thesis/Antithesis: Enrique Chagoya at the M. H. de Young Museum." *Artweek,* October 20, 1994, p. 15.
Wilson, William. "Trio of California Artists Mix It Up in the Mythic Present." *Los Angeles Times,* December 9, 1995.

♥ MICHAEL RAY CHARLES

Born 1967, Lafayette, Louisiana
1989, McNeese State University, Lake Charles. Louisiana, BFA
1993, University of Houston, MFA
Lives and works in Austin

SELECTED SOLO EXHIBITIONS
2002
Michael Ray Charles: Not the Same Song and Dance, John Michael Kohler Arts Center, Sheboygan, Wisconsin, September 1–December 8.
2000
Bamboozled, Tony Shafrazi Gallery, New York.
1998
Galerie Hans Mayer, Düsseldorf, Germany.
Contemporary Arts Center, Cincinnati, Ohio.
1997
Michael Ray Charles, Tony Shafrazi Gallery, New York, September 20–October 25. Catalogue, text by Calvin Reid, Tony Shafrazi, and Spike Lee.
Michael Ray Charles, 1989–1997: An American Artist's Work, Blaffer Gallery, The Art Museum of the University of Houston, June–August. Traveled to Austin Museum of Art, September–December; Contemporary Arts Center, Cincinnati, January–March 1998. Catalogue, text by Spike Lee.
Michael Ray Charles, Albright-Knox Art Gallery, Buffalo, New York, March 15–May 11. Brochure, text by Cheryl Brutvan.
Tony Shafrazi Gallery, New York.
1996
Tony Shafrazi Gallery, New York.
1994
Tony Shafrazi Gallery, New York.
1991
Barnes-Blackman Galleries, Houston.

SELECTED GROUP EXHIBITIONS
2002
Continued Reflections: Walker Art Center Celebrates Black History Month, Walker Art Center, Minneapolis, January–June.
1999
Re/Righting History: Counternarratives by Contemporary African-American Artists, Katonah Museum of Art, Katonah, New York, March 14–May 16.
1998
Looking Forward, Looking Black, Wayne State University Art Galleries, Detroit. Traveled to eleven venues. Catalogue, text by Emma Amos, Jo Anna Isaak, Marilyn Jiménez, Heather Sealy Lineberry, Rob Perrée, Ingrid Schaffner, Christina Sharp, and Peter Williams.
1996
Bucking the Texan Myth: Scouting the Third Frontier, Austin Museum of Art, July 6–August 18.

Texas Modern and Post-Modern, The Museum of Fine Arts, Houston, January 21–March 23.
1995
The State of the State: Contemporary Art in Texas, San Antonio Museum of Art.
1994
I Remember: Images of the Civil Rights Movement 1963–1993, Blaffer Gallery, University of Houston January 22–March 27.
Speaking of Artists: Words and Works from Houston, The Museum of Fine Arts, Houston, January 11–July 10.
1993
Contemporary Identities: 23 Artists—The Phoenix Triennial, Phoenix Art Museum, Phoenix, August 21–October 10. Catalogue.
1992
Fresh Visions, New Voices: Emerging African-American Artists in Texas, The Glassell School of Art, The Museum of Fine Arts, Houston, September 13–November 29. Traveled to Galveston Arts Center, Texas; Arlington Museum of Art, Texas. Catalogue.

SELECTED BIBLIOGRAPHY

Bowles, Juliette, Kara Walker, and Don Bacigalupi. "Stereotypes subverted? The debate continues." *International Review of African American Art,* vol. 15, no. 2, 1998, pp. 44–51.
Brimberry, Katherine, Michael Ray Charles, Kenneth Hale, and Jack Hanley. "Michael Ray Charles." *Contemporary Impressions,* Spring 1995, pp. 10–14.
Chadwick, Susan. "Texas Artist Bursts onto the N.Y. Scene." *The Houston Post,* June 14, 1994.
Collum, Jerry. "'Stereotype This!'" *Art Paper,* November/December 1998, pp. 16–21.
Gibson, Janice, and Sandy Zavoleta. "An Artist and Realism." *The Acadiana Ebony Journal,* February 1993, p. 2.
Harris, Michael D. "Memories and Memorabilia, Art and Identity: Is Aunt Jemima Really a Black Woman?" *Third Text,* Autumn 1998, pp. 25–42.
Heller, Steven, and Elinor Pettit, eds. *Design Dialogues.* New York: Allworth Press, 1998.
Jock, Heinz-Norbert. "Ich will mich der Ängste vergewissern, die Freiden und Kommunikation verhindern." *Kunstforum International,* October 1996–January 1997, pp. 322–30.

⚡ CAT CHOW

Born 1973, Morristown, New Jersey
1995, Northwestern University, Evanston, Illinois, BS
Lives and works in Chicago

SELECTED PERFORMANCES
2000
Fashion and Identity, Museum of Contemporary Art, Chicago.
1999
Ultrabrite, Museum of Contemporary Art, Chicago.

SELECTED GROUP EXHIBITIONS
2001
Brat(wurst), Vox Populi, Philadelphia.
Each to Each: Young Chicago Artists, Hothouse Gallery, Chicago.
Faces in the Field, The Field Museum of Natural History, Chicago.
Uncommon Threads: Contemporary Artists and Clothing, Herbert F. Johnson Museum of Art, Ithaca, New York. Catalogue, text by Sean M. Ulmer.
2000
ADressing the Body, Fassbender Gallery, Chicago.
Window Installation, The New Museum of Contemporary Art, New York.
Women Artists Under Thirty, Woman Made Gallery, Chicago.

1999
The Feel of Fiber, Barrington Art Center, Illinois.
Material Evidence: Chicago Architecture at 2000, Museum of Contemporary Art, Chicago. Catalogue.
This Way to the Egress, The Butcher Shop, Chicago.
Urban Conditions: Young Chicago Artists, Wabash College, Crawfordsville, Indiana.

SELECTED BIBLIOGRAPHY

Bergold, Cali. "An Artist to Know." *Woman Made News,* Summer 2000, p. 4.
Brunwasser, Yael. "Wearable Art." *Northwestern,* Winter 2000, p. 56.
"Eye on Chicago Style." *Chicago Magazine,* Fall 2000, p. 234.
Glass, Barbara. "Local Star." *Chicago Social,* June 2000, p. 72.
Henke, Laura. "Industrial Strength Fashion." *Ten by Ten,* vol. 1, no. 1, 2000, p. 6.
"Hometown Hero." *UR Chicago,* March 19–April 16, 2001, p. 9.
Kenny, Heather. "Gallery Tripping: Cat Chow's Rampant Materialism." *Chicago Reader,* May 19, 2000, p. 42.
"Made in Chicago." *New City,* May 10, 2001, p. 8.
Slowley, Anne. "Catpower." *Elle,* September 2000, p. 234.
"The Third Annual Avant Guardians Portfolio and Touring Exhibit." *Surface,* no. 26, 2000, p. 171.
Wallace-Albert, Stacy. "Artful Dodge." *Chicago Magazine,* August 2000, p. 34.
Wiersema, Chris. "Considering Wearable Art with Designer Cat Chow." *New City,* July 27, 2000, p. 5.

✗ GEORGE CONDO

Born 1957, Concord, New Hampshire
Lives and works in New York

SELECTED SOLO EXHIBITIONS
2002
George Condo, Luhring Augustine, New York, November 9–December 21.
2001
Physiological Abstraction, Galerie Jerome de Noirmont, Paris, April 4–May 31. Catalogue
1995
Paintings and Drawings, PaceWildenstein, New York, September 15–October 21. Catalogue, text by Donald B. Kuspit.
1994
George Condo: Recent Paintings, McKinney Avenue Contemporary, Dallas, December 30–January 15, 1995. Catalogue, text by Tom Moody. Traveled to Contemporary Arts Museum, Houston, April 30–June 11, 1995. Catalogue.
1992
Obra 1990–1992, Galería Soledad Lorenzo, Madrid, March 12–April 18. Catalogue.
1988
Paintings and Drawings, Pace Gallery, New York, March 11–April 2.

SELECTED GROUP EXHIBITIONS
2002
New York Expression, Bergen Kunstmuseum, Bergen, Norway, February 15–April 28. Catalogue, text by Gret Arbu.
1999
Bad Bad–That Is a Good Excuse, Staatliche Kunsthalle, Baden-Baden, Germany, April 18–June 20. Catalogue, text by Margrit Brehm, Wolf Pehlke, and Uli Bohnen.
1994
Modern Drawings II, The Museum of Modern Art, New York.
U.S. Painting in the 1980's, Irish Museum of Modern Art, Dublin.
1992
Allegories of Modernism: Contemporary Drawings, The Museum of Modern Art, New York, February 16–May 5. Catalogue, text by Bernice Rose.

1991

Mito y Magico: Los Ochenta. Museo de Arte Contemporáneo de Monterrey, Mexico. Catalogue, text by Miguel Cervantes, Charles Merewether, Francesco Pellizzi, Alberto Ruy Sanchez, Peter Schjeldahl, and Edward J. Sullivan.

1990

Drawings of the Eighties: Part II, The Museum of Modern Art, New York.

Parmakon '90, Nippon Convention Center (Makuhari Messe), Chiba City, Japan. Catalogue.

Le Visage dans l'art contemporain, Musée des Jacobins, Toulouse, France. Traveled to Musée du Luxembourg, Paris.

1989

Exposition Inaugarale, Fondation Daniel Templon, Musée Temporaire, Frejus, France.

I triennal de Dibuix–Joan Miro, Fundació Joan Miró Centre d'Estudis d'Art Contemporani, Barcelona.

1988

Recent Drawings, Whitney Museum of American Art, New York.

1987

1987 Biennial Exhibition, Whitney Museum of American Art, New York.

SELECTED BIBLIOGRAPHY

Beyer, Lucie. "George Condo." *Flash Art,* Summer 1985, pp. 42–43.

Bonney, Anney. "George Condo." Interview. *Bomb,* Summer 1992, pp. 34–39.

Chateau, Dominique. "Kant Goes Condo: A Short Critique of Pure Aesthetics." *Art Press,* May 1996, pp. 42–45.

Cotter, Holland. "Art in Review: George Condo." *The New York Times,* November 29, 2002.

Dickhoff, Wilfried. *After Nihilism: Essays on Contemporary Art.* Cambridge, England: Cambridge University Press, 2000.

Goy, Bernard. "George Condo." Interview. *Journal of Contemporary Art,* Spring/Summer 1990, pp. 7–15.

Heere, Heribert. "Neues Pathos." *Artefactum,* April/May 1986, pp. 28–35.

Johnson, Ken. "Art in Review: George Condo." *The New York Times,* December 31, 1999.

Kuspit, Donald. *Idiosyncratic Identities: Artists at the End of the Avant-garde.* Cambridge, England: Cambridge University Press, 1996.

Verzotti, Giorgio. "Portrait of the Artist as an Infant." *Flash Art,* May/June 1986, pp. 42–45.

❧ RENÉE COX

Born 1960, Colgate, Jamaica

1992, School of Visual Arts, New York, MFA
1992–1993, Whitney Independent Study Program, New York
Lives and works in New York

SELECTED SOLO EXHIBITIONS

2001

Renée Cox: American Family, Robert Miller Gallery, New York, October 10–November 10. Catalogue, text by Jo Anna Isaak.

1998

Rajé: A Superhero: The Beginning of a Bold New Era, Cristinerose Gallery, New York, February 21–March 28. Catalogue, text by Sean Gibbons.

SELECTED GROUP EXHIBITIONS

2002

Art and Outrage, Robert Miller Gallery, New York, June 5–15.

2001

Committed to the Image, Brooklyn Museum of Art, New York, February 16–April 29. Catalogue, text by Barbara Head Millstein, Clyde Taylor, and Debra Patnaik.

2000

Reflections in Black: A History of Black Photography, Anacostia Museum and Center for African American History and Culture, Smithsonion Institution, Washington, D.C.

1999

48th esposizione internazionale d'arte, La Biennale di Venezia, Venice, June 13–November 7. Catalogue.

The Nude in Contemporary Art, The Aldrich Museum of Contemporary Art, Ridgefield, Connecticut, June 6–September 12. Catalogue.

Picturing of the Modern Amazon, The New Museum of Contemporary Art, New York, March 3–July 2. Catalogue, text by Joanna Frush, Laurie Feinstein, and Judith Stein.

1998

Looking Forward, Looking Black, Wayne State University Art Galleries, Detroit. Traveled to eleven venues. Catalogue, text by Emma Amos, Jo Anna Isaak, Marilyn Jiménez, Heather Sealy Lineberry, Rob Perrée, Ingrid Schaffner, Christina Sharp, and Peter Williams.

Postcards from Black America: Contemporary African American Art, De Beyerd Centrum voor Beeldende Kunst, Amsterdam. Traveled to Museum of Contemporary Art, Antwerp, Belgium; Frans Hals Museum, Haarlem, The Netherlands.

Welcome, Assozione Cultural IDRIA, Città Sant'Angelo, Pecara, Italy.

1997

Auto Portrait: The Calligraphy of Power, Exit Art, New York.

1996

Sexual Politics: Judy Chicago's 'Dinner Party' in Feminist Art History, UCLA Hammer Museum, Los Angeles, April 24–August 18. Catalogue, text by Amelia Jones and Laura Cottingham.

1994

Bad Girls, The New Museum of Contemporary Art, New York, March 5–April 10. Catalogue, text by Marcia Tucker and Marcia Tanner.

Black Male: Representations of Masculinity in Contemporary American Art, Whitney Museum of American Art, New York, November 10–March 5, 1995. Catalogue, text by Thelma Golden, Henry Louis Gates, Elizabeth Alexander, and Hilton Als.

1993

Artist Select Show, Artists Space, New York.

SELECTED BIBLIOGRAPHY

Berger, Maurice. *White Lies: Race and the Myths of Whiteness.* New York: Farrar, Straus, Giroux, 1999.

Bloch, Phillip. *Elements of Style.* New York: Warner Books, 1998.

Britton, Crystal A. *African American Art: The Long Struggle.* New York: Smithmark Publishers, 1996.

Edwards, Audrey. *Essence: 2 Years Celebrating Black Women.* New York: Harry N. Abrams, 1995.

Field, Genevieve, ed. *Nerve/The New Nude.* San Francisco: Chronicle Books, 1991.

Gottesman, Jane, ed. *Game Face: What Does a Female Athlete Look Like?* New York: Random House, 2001.

Guillory, Monique, and Richard Green, eds. *Soul: Black Power, Politics, and Pleasure.* New York: New York University Press, 1998.

Hirsch, Marianne, ed. *The Familial Gaze.* Hanover, N.H.: University Press of New England, 1999.

Joselit, David. "Exhibiting Gender." *Art in America,* January 1997, pp. 36–39.

Miglietti, Francesca Alfano. *Rosso Vivo: Mutation, Transfiguration and Blood in Contemporary Art.* Milan: Electa, 1999.

Nochlin, Linda. "Learning from 'Black Male.'" *Art in America,* March 1995, pp. 86–91.

Plagens, Peter. "Bad Girls for Goodness Sake." *Newsweek,* February 14, 1994, p. 53.

Smith, Roberta. "A Raucous Caucus of Feminists Being Bad." *The New York Times,* January 21, 1994.

☙ HENRY DARGER

Born 1892, Chicago
Died 1972, Chicago

SELECTED SOLO EXHIBITIONS
2001
Henry Darger, 1892–1972, American Folk Art Museum, New York, December–May 2002. Catalogue, text by Brooke Davis Anderson, Michel Thévoz, and Catherine Sweeney.
1996
Henry Darger: The Unreality of Being, University of Iowa Museum of Art, Iowa City, January 13–March 10. Traveled to The Museum of American Folk Art, New York, January 11–February 8, 1997. Catalogue, text by Stephen Prokopff.

SELECTED GROUP EXHIBITIONS
2002
American Radiance, American Folk Art Museum, New York, March–June.
2001
La Planete Exilee: Art Brut et Vision du Monde, Musée d'art moderne Lille Métropole, Villeneuve d'Asq, France, June 3–October 7.
2000
Disasters of War, P.S.1 Contemporary Art Center, Long Island City, New York, November 19–March 25, 2001.
1995
A World of Their Own: Twentieth Century American Folk Art, The Newark Museum, New Jersey, March–May.
1992
Parallel Visions: Modern Artists and Outsider Art, Los Angeles County Museum of Art, October 18–January 3, 1993.
1990
Visions: Expressions Beyond the Mainstream from Chicago Collections, Arts Club of Chicago, September 17– November 3. Catalogue, text by Lisa Stone.
1987
In Another World: Outsider Art from Europe and America, Ferens Art Gallery, Kingston-upon-Hull, England, June 13–July. Traveled to seven venues. Catalogue, text by Monika Kinley, Victor Willing, and David Maclagan.

SELECTED BIBLIOGRAPHY
Cohrs, Timothy. "Henry Darger, Artist (Outside, Naïve, Folk, Autistic, or Genuine Fine)." *Arts Magazine,* January 1987, pp. 14–17.
Cotter, Holland. "Visions of Childhood, Showing Purity and Evil." *The New York Times,* April 19, 2002, p. B36.
Darger, Henry. *Henry Darger: Art and Selected Writings.* Edited by Michael Bonesteel. New York: Rizzoli, 2000.
De Diego, Estrella. "A Proposito de Henry (Darger)." *Arte y Parte,* February/March 2000, pp. 70–76, 78.
"Henry Darger." *Kunstforum International,* March/April 1991, pp. 202–203.
Homes, A. M. "Inside Out: The Art of Henry Darger." *Artforum,* May 1997, pp. 92–97, 142.
Jones, Ronald, and Joe Scanlan. "Every Man for Himself: Ronald Jones and Joe Scanlan on Henry Darger." *frieze,* June–August 1997, pp. 54–57.
MacGregor, John. "Henry Darger: Art by Adaptation." *Raw Vision,* Winter 1995–1996, pp. 26–35.
_____. *Henry J. Darger: In the Realms of the Unreal.* New York: Delano Greenridge Editions, 2002.
Morris, Randall Seth. "Good vs. Evil in the World of Henry Darger." *Clarion,* Fall 1986, pp. 30–35.
Rubenstein, Raphael. "Ashbery in Dargerland." *Art in America,* February 2000, pp. 37, 39.
Saltz, Jerry. "Lord of the Lolitas." *The Village Voice,* December 26, 2001–January 1, 2002.
Schjeldahl, Peter. "The Lost Photograph: The Work of Henry Darger." *Art Issues,* March–April 1993, pp. 17–20.
Sellen, Betty-Carol, and Cynthia J. Johanson. *Outsider, Self-taught, and Folk Art: Annotated Bibliography–Publications and Films of the 20th Century.* London: McFarland and Company, 2002.
Vine, Richard. "Thank Heaven for Little Girls." *Art in America,* January 1998, pp. 72–79.

JASON DUNDA

Born 1972, Toronto
1995, York University, Toronto, BFA
2001, School of the Art Institute of Chicago, MFA
Lives and works in Chicago

SELECTED SOLO EXHIBITIONS
2002
I am trying to break your, BUS Gallery, Toronto, November 7–December 1.
2001
Charming Holiday, Katharine Mulherin Gallery, Toronto, June 1–July 29.
1999
Joy $1.00, BUS Gallery, Toronto, December 9–January 2, 2000.
Lucky Best Wash, Red Head Gallery, Toronto.
1998
Emerging Artists Wall, Art Gallery of Ontario Rental Gallery, Toronto.
Red Head Showcase, Red Head Gallery, Toronto.
1995
Living Space, Upper Canada Brewery Art Gallery, Toronto.

SELECTED GROUP EXHIBITIONS
2002
More than Meets the Eye, Agnes Etherington Art Gallery, Kingston, Ontario, January 20–June 9.
2001
Modest @ 1926, 1926 Exhibition Space, Chicago.
1999
Fresh, Angell Gallery, Toronto, June 3–26.
Tag Team, The Launch Pad, Toronto.
1998
The Edge of Everything, Loggia Gallery, New York.
Giant Special, Red Head Gallery, Toronto.
Social Secrets, MEG Gallery, Toronto.
1997
Kinderspiel, Angell Gallery, Toronto, December 10–January 16, 1998.

SELECTED BIBLIOGRAPHY
"Artist-Run Culture." *Mix,* December 1995, p. 25.
"Artist-Run Culture." *Mix,* Summer 1998, p. 21.
Dault, Gary Michael. "Dunda and Peñaloza at Katharine Mulherin." *The Globe and Mail,* June 2, 2001, p. C10.
_____. "Jason Dunda and Tegan Smith at the BUS Gallery." *The Globe and Mail,* June 26, 1999.
_____. "Wry Musings of a Pocket Metaphysician." *The Globe and Mail,* August 22, 1998, p. C9.
Enright, Robert. "The Formalities of Kitsch." *BorderCrossings,* May 1999, p. 8.
"Fast Forward." *Canadian Art,* Summer 1999, p. 26.
"Fast Forward." *Canadian Art,* Winter 1998, p. 27.
MacDonnell, Virginia. "Fall Art Scene: Taking the Institution Out of Art." *Artfocus,* Winter 1996, pp. 24–27.
MacKay, Gillian. "Freud for the Young at Heart." *The Globe and Mail,* January 17, 1998, p. C13.
_____. "Jason Dunda at Red Head." *The Globe and Mail,* January 23, 1999, p. C10.
Osborne, Catherine. "Toys R Art: Playing at Painting with Jason Dunda." *Broken Pencil,* Spring 1999, p. 78.

Peñaloza, Si Si. "Garnish Paintings Aren't Just Cheap Frills." *Now Magazine,* June 19, 1999, p. 94.

_____. "Open House on Jersey Gets New Meaning." *Now Magazine,* April 1, 1999, p. 72.

Smith, Tegan. "Shotgun." *Lola,* Summer 1999, p. 70.

Vaughan, R. M. "Rubber Ducks and Dapper Duds." *Eye Magazine,* September 3, 1998, p. 31.

Waxman, Lori. "A Large Font Review of a Very Small Gallery." *F Newsmagazine,* May 2000, p. 14.

 # Michael Galbincea

Born 1974, Cleveland

1999, Cleveland State University, Ohio, BA
2001, The School of the Art Institute of Chicago, MFA
Lives and works in Chicago

SELECTED SOLO PERFORMANCES

2002

Interlaced NYQC enterlace, Méduse, Quebec City, Canada, September 7.

World New Media Blender, Arts International, New York, July 2.

Antipop Consortium, Empty Bottle, Chicago, May 5.

Version.02, Museum of Contemporary Art, Chicago, April 18.

2001

Bounce, The Bronx Museum of the Arts, New York, December 14.

SELECTED GROUP EXHIBITIONS

2002

Word, with Fotofest 2002, DiverseWorks Art Space, Houston, March 2–April 6. Catalogue.

2001

SW United, Aurora Picture Show, Houston, April 4.

Kojo Griffin

Born 1971, Farmville, Virginia

1995, Morehouse College, Atlanta, BA
Lives and works in Atlanta

SELECTED SOLO EXHIBITIONS

2002

Kojo Griffin: Recent Paintings, Miller Block Gallery, New York, April 26–May 28.

2001

Kojo Griffin, Mitchell-Innes and Nash, New York, September 6–October 13.

Kemper Museum of Contemporary Art, Kansas City, January 12–April 18.

2000

Vaknin Schwartz Gallery, Atlanta.

1999

Mint Museum, Charlotte, North Carolina, April.

Kojo Griffin: Moving with Change, Vaknin Schwartz Gallery, Atlanta, April 2–May 8.

SELECTED GROUP EXHIBITIONS

2002

Super Natural Playground, Marella Arte Contemporanea, Milan, March.

2001

In Cold Blood, Samuel Dorsky Museum of Art, State University of New York at New Paltz, New York, August 13–September 23.

Freestyle, The Studio Museum in Harlem, New York, April 28–June 24. Traveled to Santa Monica Museum of Art, California, September 29–November 18. Catalogue, text by Thelma Golden and Hamza Walker.

Abstraction/Distraction, Miller Block Gallery, New York.

2000

2000 Biennial Exhibition, Whitney Museum of American Art, New York, March 23–June 4. Catalogue, text by Michael Auping, Valerie Cassel, Hugh M. Davis, Jane Farver, Andrea Miller-Keller, and Lawrence R. Rinder.

30/10, Tubman African American Museum, Macon, Georgia, March 6–April 30.

Do It, Atlanta College of Art, Atlanta.

Our New Day Begun: African American Artists Entering the Millennium, Lyndon Baines Johnson Library, Austin. Traveled to University Museum, Texas Southern University, Houston; African American Museum, Dallas.

A Selection of Work from Atlanta Artists in the 2000 Whitney Biennial, Atlanta Contemporary Art Center, Atlanta.

1998

Two Thumbs Up: Best Picks of Vaknin and Schwartz, Vaknin and Schwartz, Atlanta, August.

Under One Roof, Myott Studio Workshop, Atlanta.

When Tears Come Down Like Falling Rain, City Gallery East, Atlanta.

1997

Atlanta Biennial Show, Nexus Contemporary Arts Center, Atlanta.

1996

Cipher, Eden Gallery, Atlanta.

Sampling an Insistent Beat, King Plow Arts Center, Atlanta.

1995

African Influences: American Diversity, Arts Exchange, Atlanta.

SELECTED BIBLIOGRAPHY

Auslander, Philip. "Kojo Griffin." *Artforum,* September 2000, p. 181.

Canning, Susan. "You Can't Always Get What You Want: Sifting Through the Whitney Biennial." *Art Papers,* July/August 2000, pp. 20–25.

Chambers, Christopher. "Kojo Griffin." *Flash Art,* October 2001, pp. 102–103.

Cochran, Rebecca Dimling. "Kojo Griffin at Vaknin Schwartz." *Art in America,* December 1999.

_____. "Rebecca Dimling Cochran Visits Kojo Griffin." *Art Papers,* July/August 1999, pp. 14–15.

Cullum, Jerry. "Branching Out." *ARTnews,* December 2000, pp. 106, 108, 110.

_____. "Kojo Griffin." *ARTnews,* February 2001, p. 164.

_____. "Mixing of Cultures." *The Atlanta Journal-Constitution,* April 16, 1999, p. Q8.

Fox, Catherine. "Mixing It Up in Style." *The Atlanta Journal-Constitution,* August 21, 1998.

Gilman-Sevcik, Frantiska, and Tim Gilman-Sevcik. "New York's Mega-shows: Whitney Biennial and Greater New York." *Flash Art,* May/June 2000, pp. 88–90.

Glueck, Grace. "Kojo Griffin." *The New York Times,* September 28, 2001.

Murray, Derek Conrad. "Freestyle." *NKA: Journal of Contemporary African Art,* Fall/Winter 2001, pp. 92–93.

Riva, Alessandro. "America, si riparte: dalla figurazione." *Arte,* March 2002, p. 45.

Schwabsky, Barry. "2000 Biennial Exhibition." *Nu: The Nordic Review,* nos. 3–4, 2000, p. 87.

Sorkin, Jenni. "The Whitney Biennial." *Art Monthly,* May 2000, pp. 36–38.

Valdez, Sarah. "Freestyling." *Art in America,* September 2001, pp. 134–39.

⚡ TRENTON DOYLE HANCOCK

Born 1974, Oklahoma City
1994, Paris Junior College, Texas, AS
1997, Texas A&M University at Commerce, BFA
2000, Tyler School of Art, Temple University, Philadelphia, MFA
Lives and works in Houston

SELECTED SOLO EXHIBITIONS
2001
The Life and Death of #1, Contemporary Arts Museum, Houston, August 31–October 14. Traveled to the Modern Art Museum of Fort Worth, October 21–January 20, 2002; Arthouse at the Jones Center, Austin, January 31–March 3, 2002. Catalogue, text by Trenton Doyle Hancock and Lynn M. Herbert.
The Legend Is in Trouble, James Cohan Gallery, New York, June 21–July 28.
2000
Wow That's Me?, Dunn and Brown Contemporary, Inc., Dallas, July 7–August 12.
1998
Off Colored, Gerald Peters Gallery, Dallas, May 30–July 11.

SELECTED GROUP EXHIBITIONS
2002
2002 Biennial Exhibition, Whitney Museum of American Art, New York, March 7–May 26. Catalogue, text by Lawrence Rinder, Chrissie Iles, Christiane Paul, and Debra Singer.
2000
Out of the Ordinary: New Art from Texas, Contemporary Arts Museum, Houston, August 12–October 8. Catalogue, text by Lynn M. Herbert and Paola Morsiani.
2000 Biennial Exhibition, Whitney Museum of American Art, New York, March 23–June 4. Catalogue, text by Michael Auping, Valerie Cassel, Hugh M. Davis, Jane Farver, Andrea Miller-Keller, and Lawrence R. Rinder.
Artistic Centers in Texas: Dallas/Ft. Worth, Arthouse at the Jones Center, Austin.
1998
Texas Dialogues: Parallels, Dallas/San Antonio, Blue Star Art Space, San Antonio, October 20–November 20.

SELECTED BIBLIOGRAPHY
Bell, Cherie. "Artist's Fusion Comments on Race and Society." *The Paris News,* December 20, 1998, p. 3.
Cuellar, Catherine. "Dallas Museum Honors Seven Young Artists." *Dallas Morning News,* May 28, 1997, p. 28A.
Daniel, Mike. "Young Artist Comes into His Own." *Dallas Morning News,* May 29, 1998, p. 52.
Ennis, Michael. "Northern Exposure." *Texas Monthly,* February 2000, p. 130.
Franklin, Geoffrey. "Trenton Hancock: An Art Profile." *The Special,* Fall/Winter 1997.
Goddard, Dan R. "Blue Star Finds Artistic Common Ground in Dallas and San Antonio." *San Antonio Express News,* November 16, 1998.
Hunter, Glenn. "Colorfast." *Dallas Business Journal,* June 5–11, 1998, p. 36.
Johnson, Patrica. "Boyhood musings lend artist's works a sense of fantasy," *Houston Chronicle,* September 15, 2001, p. 9.
_____. "Millenial Biennial/Whitney Includes 9 Texans in Show, " *Houston Chronicle,* December 9, 1999.
Kutner, Janet. "Art Outlet." *Dallas Morning News,* July 8, 2000, pp. 1C, 7C.
_____. "Artworks Poke Fun at Their Antecedents." *Dallas Morning News,* February 23, 1997, p. 39A.
_____. "Gallery Gourmet." *Dallas Morning News,* July 4, 1998, p. 8C.
_____. "Texas Artist Receives Award." *Dallas Morning News,* November 3, 1999, p. 37A.
Levin, Kim. "Voice Choices: Trenton Doyle Hancock." *The Village Voice,* July 10, 2001, 76.

Mitchell, Charles Dee. "Trenton Doyle Hancock at Gerald Peters." *Art in America,* November 1998, p. 138.
Newhall, Edith. "On the Edge: The Hamburger's Got Legs." *ARTnews,* April 2000, p. 140.
Peppard, Alan. "A Dreamy Show." *Dallas Morning News,* June 7, 1998, p. 2E.
Reed, C. D. "Artist Puts Self into Latest Work." *The Commerce Journal,* December 10, 1998.
Rees, Christina. "Biting Back." *Dallas Observer,* February 10–16, 2000, p. 15.
_____. "Guts 'R Us." *Dallas Observer,* June 18–24, 1998, p. 64.
Smith, Roberta. "Trenton Doyle Hancock—'The Legend Is in Trouble.'" *The New York Times,* July 13, 2001.

✐ KEITH HARING

Born 1958, Kutztown, Pennsylvania
1977–1978, University of Pittsburgh
1978–1979, School of Visual Arts, New York
Died 1990, New York

SELECTED SOLO EXHIBITIONS
1997
Keith Haring: A Retrospective, Whitney Museum of American Art, New York, June 25–September 21. Traveled to four venues. Catalogue, text by Richard Pandiscio, Elizabeth Sussman, and Jellybean Benitez.
1996
Keith Haring: A Retrospective, Museum of Contemporary Art, Sydney.
1994
Keith Haring Retrospective, Castello di Rivoli, Turin, Italy, February 3–April 30. Traveled to Malmö Kunsthalle, Sweden; Deichtorhallen, Hamburg; Tel Aviv Museum of Art, Tel Aviv; Fundación La Caixa, Madrid; Kunsthaus Wien, Vienna. Catalogue, text by Ida Gianelli and Germano Celant.
1993
Keith Haring, A Retrospective, Mitsukoshi Museum of Art, Tokyo. Catalogue, text by Germano Celant.
1986
Haring: Schilderijen, Tekeningen en een Velum, Stedelijk Museum of Modern Art, Amsterdam, March 15–May 12. Catalogue, text by W.A.L. Beeren, Rini Dippel, and Dorine Mignot.
1985
Keith Haring, capc Musée d'art contemporain, Bordeaux, France, December 15–February 23, 1986. Catalogue, text by Brion Gysin and Sylvie Coudere.
1981
Club 57, New York.

SELECTED GROUP EXHIBITIONS
2001
Amerikanische Kunst der 90er Jahre, Ludwig Museum, Oberhausen, Germany, November 30–February 24, 2002.
One Planet Under a Groove: Hip Hop and Contemporary Art, The Bronx Museum of the Arts, New York, October 26–May 26, 2002.
1999
The American Century: Art and Culture 1900–2000, Part II, 1950–2000, Whitney Museum of American Art, New York, November 26–February 13, 2000. Catalogue, text by Lisa Phillips.
1998
Concept/Image/Object, The Art Institute of Chicago,
1997
Multiple Identity: Amerikanische Kunst 1975–1995 Aus Dem Whitney Museum of American Art, Kunstmuseum Bonn, Bonn, Germany.

1996

Private Passions, Musée d'Art Moderne de la Ville de Paris.

Thinking Print: Books to Billboards, 1980–95, The Museum of Modern Art, New York.

1995

Temporarily Possessed: The Semi-Permanent Collection, The New Museum of Contemporary Art, New York, September 15–December 17.

1994

Outside the Frame, Cleveland Center for Contemporary Art, Ohio.

1993

American Art in the 20th Century: Paintings and Sculpture, 1913–1993, Martin-Gropius-Bau, Berlin, May 8–July 25. Traveled to Royal Academy of Arts and Saatchi Gallery, London, September 16–December 12. Catalogue, text by Christos Joachimides, Donald B. Kuspit, Arthur C. Danto, et al.

1992

Coming from the Subway: New York Graffiti Art, Groningen Museum, The Netherlands, October 4–January 10, 1993. Catalogue.

Allegories of Modernism: Contemporary Drawings, The Museum of Modern Art, New York, February 16–May 5. Catalogue, text by Bernice Rose.

The Power of the City/The City of Power, Whitney Museum of American Art, New York. Catalogue, text by Christel Hollevoex, Karen Jones, and Timothy Nye.

1991

1991 Biennial Exhibition, Whitney Museum of American Art, New York, April 19–June 16. Catalogue, text by Richard Armstrong, John G. Hanhardt, Richard Marshall, and Lisa Phillips.

Keith Haring, Walt Disney, and Andy Warhol, Phoenix Art Museum, March 23–May 12. Catalogue, text by Bruce D. Kurtz and Bruce Hamilton.

1988

Committed to Print: An Exhibition of Recent American Printed Art with Social and Political Themes, The Museum of Modern Art, New York, January 31–April 19. Catalogue, text by Deborah Wye.

1987

L'Epoque, La Mode, La Morale, La Passion: Aspects de l'Art d'Aujourd'hui, 1977–1987, Centre Georges Pompidou, National d'Art Moderne, Paris. Catalogue, text by Bernard Blistene, Catherine David, and Alfred Pacquement.

Avant-Garde in the Eighties, Los Angeles County Museum of Art. Catalogue, text by Howard Fox.

Comic Iconoclasm, Institute of Contemporary Arts, London, June–September. Traveled to Douglas Hyde Gallery, Trinity College, Dublin, October–November; Cornerhouse, Manchester, England, January–February 1988. Catalogue, text by Sheena Wagstaff and Iwona Blazwick.

1985

American Art of the Eighties, Phoenix Art Museum, Phoenix.

Havana Bienal, Cuba.

New York 85, ARCA, Centre d'Art Contemporain, Marseille. Catalogue, text by Marcelin Pleynet, Roger Pailhas, and Jean Lou Marcos.

1984

Content: A Contemporary Focus, 1975–1984, Hirshhorn Museum and Sculpture Garden, Smithsonian Institution, Washington, D.C., October 4–January 6, 1985. Catalogue, text by Howard N. Fox, Miranda McClintock, and Phyllis D. Rosenzweig.

Television's Impact on Contemporary Art, Queens Museum of Art, New York, September 13–October 26. Catalogue, text by Marc H. Miller.

41st esposizione internazionale d'arte, La Biennale di Venezia, Venice, June–August.

Biennial III—The Human Condition, San Francisco Museum of Modern Art, San Francisco. Traveled to The Aldrich Museum of Contemporary Art, Ridgefield, Connecticut. Catalogue, text by Henry Hopkins and Dorothy Martinson.

1983

1983 Biennial Exhibition, Whitney Museum of American Art, New York, March 15–May 29. Catalogue, text by John G. Hanhardt, Barbara Haskell, Richard Marshall, and Patterson Sims.

Bienal de São Paulo, São Paulo, Brazil.

Terrae Motus, Villa Campolieto, Ercolano, Italy. Traveled to The Institute of Contemporary Art, Boston; Institute of Contemporary Art, Philadelphia; Pittsburgh Center for the Arts, Pittsburgh. Catalogue, text by Michele Bonuomo, David Robbins, Barbara Rose, and Diego Cortez.

1982

Documenta 7, Kassel, Germany, June 19–September 23. Catalogue, text by Coosje van Bruggen, Germano Celant, Johannes Gachnang, and Gerhard Storck.

The UFO Show, Queens Museum of Art, New York.

Urban Kisses, Institute of Contemporary Arts, London.

SELECTED BIBLIOGRAPHY

Celant, Germano, ed. *Keith Haring.* Munich: Prestel, 1992.

Grigoteit, Ariane, John Rolls, and Herbert Zapp. *Zwischen Tradition und Zeitgeist.* Cologne: DuMont, with Deutsche Bank AG, 1995.

Haring, Keith. *Keith Haring: Journals.* Edited by David Hockney. London: Fourth Estate, 1994.

Hodge, Nicola, and Libby Anson. *The A-Z of Art: The World's Greatest Artists and Their Works.* London: Carlton Books, 1996.

Mirzoeff, Nicholas. *Bodyscape: Art, Modernity and the Ideal Figure.* London: Routledge, 1995.

O'Connor, John, Benjamin Liu and Glenn O'Brien. *Unseen Warhol.* New York: Rizzoli, 1996.

Votolato, Gregory. *American Design in the Twentieth Century: Personality and Performance.* Manchester, England: Manchester University Press, 1998.

Weiermair, Peter, ed. *Ideal and Reality: The Image of the Body in 20th Century Art from Bonnard to Warhol.* Zurich: Edition Stemmle, 1999.

✄ RACHEL HECKER

Born 1958, Providence, Rhode Island

1980, Moore College of Art, Philadelphia, BFA

1982, Rhode Island School of Design, Providence, MFA

Lives and works in Houston

SELECTED SOLO EXHIBITIONS

2002

Sad and Pissed: New Paintings, Texas Gallery, Houston, February 1–28.

1996

Dead Yankees, ArtPace, San Antonio.

1995

Pleasure and Commerce, Contemporary Arts Museum, Houston, April 29–June 18. Catalogue, text by Ann Cvetkovich.

1986

Texas Gallery, Houston.

SELECTED GROUP EXHIBITIONS

2001

Postmodern Americans, The Menil Collection, Houston.

Reactions, Exit Art, New York.

1998

Tendances Actuelles de la Peinture á Houston/Texas, Musée de L'Echevinage, France. Catalogue.

1996

Selections From the 20th Century Collection, San Antonio Museum of Art.

1995

Encounters 6: Peter Halley and Rachel Hecker, Dallas Museum of Art.

New Orleans Triennial, New Orleans Museum of Art.

1993

Cutting Bait, Randolph Street Gallery, Chicago.

1991

Out! Voices From a Queer Nation, DiverseWorks Art Space, Houston.

Pop Art: The Object Transformed, The Museum of Fine Arts, Houston.

1990

Tradition of Innovation: A Museum Celebration of Texas Art, The Museum of Fine Arts, Houston.

Women View Women, Women and Their Work and the RKG Foundation, Austin.

1988

6 Artists/6 Idioms, Blaffer Gallery, University of Houston.

First Texas Triennial, Contemporary Arts Museum, Houston. Traveled in Texas to Texas A&M University, College Station; Art Museum of South Texas, Corpus Christi; Lubbock Fine Arts Center, Lubbock; San Angelo Museum of Fine Arts, San Angelo; Center for Research in Contemporary Art, University of Texas at Arlington.

1980

The Eighties: Points of View, Cheltenham Arts Center, Pennsylvania.

SELECTED BIBLIOGRAPHY

Chadwick, Susan. "Two Artists Collaborate in Electric Showcase at Gallery." *Houston Post,* October 23, 1993, p. F1.

Colpitt, Frances. "Space City Takes Off." *Art in America,* October 2000, pp. 66–75.

Curtis, Cathy. "Odd Coupling: Cartoons Show Life's Tensions." *Los Angeles Times,* October 31, 1995.

Hecker, Rachel. "Art About Art." *Artlies Magazine,* Fall 1997.

_____. "Life Was Good." *Artlies Magazine,* Summer 2001.

Johnson, Patricia C. *Contemporary Art in Texas.* Sydney: Craftsman House, 1995.

_____. "Texas Art." *Houston Chronicle,* September 24, 1993, p. E1.

Lucie-Smith, Edward. "Deep in the Art of Texas." *Art Review,* May 2001, pp. 64–65.

McCombie, Mel. "Six Artists/Six Idioms." *ARTnews,* May 1988, p. 87.

Moody, Tom. "The First Texas Triennial." *Art Papers,* vol. 13, no. 1, 1989.

Van Ryzin, Jeanna Claire. "Drawing Opens Doors to Worlds Both Strange and Subversive." *Austin American Statesman,* December 2000, p. D8.

Vetrocq, Marcia E. "Dixie Buffet." *Art in America,* September 1995, pp. 61–63.

✦ ARTURO HERRERA

Born 1959, Caracas

1982, University of Tulsa, Oklahoma, BFA
1992, University of Illinois at Chicago, MFA
Lives and works in New York

SELECTED SOLO EXHIBITIONS

2002

Fragments and Figments: Works on Paper, Art Gallery of Ontario, Toronto. Brochure.

2001

Arturo Herrera, UCLA Hammer Museum, Los Angeles, February 4–May 6. Brochure, text by Carolyn Christov-Bakagriev.

2000

Vertical Paintings, P.S.1 Contemporary Art Center, Long Island City, New York, November 19–January 31, 2001.

Centre d'Art Contemporain, Geneva.

Arturo Herrera, ArtPace, San Antonio, March 9–April 16.

1998

Wall Project, Worcester Art Museum, Massachusetts, July 1–December 31.

Arturo Herrera, The Renaissance Society at the University of Chicago, January 11–February 22. Catalogue, text by Neville Wakefield and Maria Tatar.

(Un)conscious Articulations: Fifty Drawings by Arturo Herrera, The Art Institute of Chicago.

1996

University Club, Chicago.

1995

Museum of Contemporary Art, Chicago.

Tale, Randolph Street Gallery, Chicago.

SELECTED GROUP EXHIBITIONS

2002

2002 Biennial Exhibition, Whitney Museum of American Art, New York, March 7–May 26. Catalogue, text by Lawrence Rinder, Chrissie Isles, Christiane Paul, and Debra Singer.

Urgent Painting, Musée d'Art Moderne de la Ville de Paris, February 17–March 3. Catalogue, text by Sandra Antelo-Suarez.

2001

Frontside: A Temporary Invasion in Basel's Cityscapes, Littmann Kulturprojekte Foundation, Switzerland, October.

Painting at the Edge of the World, Walker Art Center, Minneapolis, February 10–May 6. Catalogue, text by Douglas Fogle, Marcel Broodthaers, Yve-Alain Bois, Midori Matsui, Daniel Birnbaum, Paulo Herkenhoff, Hélio Oiticica, Andrew Blauvelt, Jörg Heiser, Mike Kelley, Hubert Damisch, Marlene Dumas, Reinaldo Laddaga, Takashi Murakami, Frances Stark, and Rudolf Stingel.

Locating Drawing, Lawing Gallery, Houston.

2000

Drawing on the Figure: Works on Paper of the 1990s from the Manilow Collection, Museum of Contemporary Art, Chicago, March 18–June 25. Catalogue, text by Staci Boris.

Greater New York: New Art in New York Now, P.S.1 Contemporary Art Center, Long Island City, New York, February 27–May. Catalogue.

From a Distance: Approaching Landscape, The Institute of Contemporary Art, Boston.

1999

Colour Me Blind! Malerei in Zeiten von Computergame und Comic, Württembergischer Kunstverein, Stuttgart, Germany, November 13–January 16. Catalogue, text by Ralph Christofori.

6th International Biennial, Istanbul Foundation for Culture and Art, September 17–October 30.

1996

Arturo Herrera and Carla Preiss, Thread Waxing Space, New York.

1995

Some Late 20th Century Abstraction, Los Angeles Contemporary Exhibitions.

1994

Arturo Herrera: Sculptures and Steven Rotter: Photographs, P.S.1 Contemporary Art Center, Long Island City, New York.

Selections Spring '94: The Sick Rose, The Drawing Center, New York.

1993

Petah Coyne: Sculpture/Arturo Herrera: Collages and Sculpture, The Center of Contemporary Arts, Santa Fe.

SELECTED BIBLIOGRAPHY

Bauman, Zigmunt, Liam Gillick, Elisabeth Grosz, Boris Groys, Jackie Kay, Hanif Kureishi, Valerey Podoroga, Douglas Rushkoff, Carlos Varela, and Marina Warner. *Fresh Cream: Contemporary Art in Culture.* London: Phaidon, 2000.

Briggs, Patricia. "Painting at the Edge of the World." *Artforum,* Summer 2001, pp. 185–86.

Fechter, Isabel. "Dino-Eier Jetzt zu Erweben! Frontside von Littmann Kulturprojecte interveniert in Basels City." *Weltkunst,* October 2001, pp. 39–41.

Helguera, Pablo. "Arturo Herrera: The Edges of the Invisible." *Art Nexus,* August/October 1999, pp. 48–52.

Smith, Roberta. "Art in Review: Arturo Herrera." *The New York Times,* May 17, 2002, p. 35.

"Working Proof." *Art on Paper,* July/August 2000, pp. 50–55.

☼ ROY LICHTENSTEIN

Born 1923, New York
1946, Ohio State University at Columbus, BFA
1949, Ohio State University at Columbus, MFA
Died 1997, New York

SELECTED SOLO EXHIBITIONS

1999
Roy Lichtenstein, interiors, Museum of Contemporary Art, Chicago, July 24–October 10. Catalogue, text by Robert Fitzpatrick, Dorothy Lichtenstein, et al.

Lichtenstein: Sculpture and Drawings, Corcoran Gallery of Art, Washington, D.C., June 5–September 30. Catalogue.

1994
The Prints of Roy Lichtenstein, National Gallery of Art, Washington, D.C. Traveled to Los Angeles County Museum of Art; Dallas Museum of Art.

1993
Roy Lichtenstein, Solomon R. Guggenheim Museum, New York. Traveled to 5 venues. Catalogue, text by Diane Waldman.

1987
The Drawings of Roy Lichtenstein, The Museum of Modern Art, New York, March 15–June 2. Traveled to six venues. Catalogue, text by Bernice Rose.

1981
Roy Lichtenstein 1970–1980, Saint Louis Museum of Art, May 8–June 28. Traveled to nine venues. Catalogue, text by Jack Cowart.

1978
Roy Lichtenstein: The Modern Work 1965–1970, The Institute of Contemporary Art, Boston. Catalogue, text by Elizabeth Sussman.

1975
Roy Lichtenstein: Zeichnungen, Nationalgalerie Berlin, Staatliche Museen Preussischer Kulturbesitz, Berlin, April 30–June 15. Traveled to Stadt Aachen, Neue Galerie, Sammlung Ludwig, Aachen, Germany, July 12–September 14. Catalogue, text by B. Dieterich and Wieland Schmied.

Roy Lichtenstein: Dessins sans Bandes, Centre Georges Pompidou, Musée National d'Art Moderne, Paris, January 10–February 17. Catalogue.

1972
Roy Lichtenstein, Contemporary Arts Museum, Houston, June 21–August 20. Catalogue, text by Lawrence Alloway

1969
Roy Lichtenstein, Solomon R. Guggenheim Museum, New York, September 16–November 16. Traveled to Museum of Contemporary Art, Chicago; Nelson-Atkins Museum of Art, Kansas City; Seattle Art Museum; Columbus Gallery of Fine Arts, Columbus. Catalogue, text by Diane Waldman.

1967
Roy Lichtenstein, Pasadena Art Museum, Pasadena, California, April–May. Traveled to Stedelijk Museum of Modern Art, Amsterdam; Tate Gallery, London, January 6–February 4, 1968; Kunsthalle Berne, Berne, Switzerland; Kestner Gesellschaft, Hannover, Germany. Catalogue.

1966
Works by Roy Lichtenstein, The Cleveland Museum of Art.

1963
Roy Lichtenstein, Leo Castelli Gallery, New York.

SELECTED GROUP EXHIBITIONS

2001
Pop Art: U.S./U.K. Connections, 1956–1966, The Menil Collection, Houston, January 26–May 13. Catalogue, text by David E. Brauer, Jim Edwards, Christopher Finch, and Walter Hopps.

1999
Made in USA: Between Art and Life, 1940–1970—de l'expressionisme abstracte al pop, Fundació la Caixa, Barcelona, January 28–March 28. Traveled to Schirn Kunsthalle, Frankfurt, April 30–July 10. Catalogue.

1993
American Art in the 20th Century: Paintings and Sculpture, 1913–1993, Martin-Gropius-Bau, Berlin, May 8–July 25. Traveled to Royal Academy of Arts and Saatchi Gallery, London, September 16–December 12. Catalogue, text by Christos Joachimides, Donald B. Kuspit, Arthur C. Danto, et al.

1991
1991 Biennial Exhibition, Whitney Museum of American Art, New York, April 19–June 16. Catalogue, text by Richard Armstrong, John G. Hanhardt, Richard Marshall, and Lisa Phillips.

1989
La Colleziona Sonnabend: Dalla Pop Art in Poi, Galleria Nazionale d'Arte Moderna, Rome, April 14–October 2. Catalogue, text by Augusta Monferini, Jean Louis Froment, Christos M. Joachimides, and Michel Bourel.

1988
Made in the Sixties, Whitney Museum of American Art at Federal Reserve Plaza, New York, April 18–July 13. Catalogue, text by Karl Willers.

1976
Twentieth-Century American Drawing: Three Avant-garde Generations, Solomon R. Guggenheim Museum, New York. Catalogue, text by Diane Waldman.

1974
American Pop Art, Whitney Museum of American Art, New York, April 6–June 6. Catalogue, text by Lawrence Alloway.

SELECTED BIBLIOGRAPHY

Alloway, Lawrence. *Roy Lichtenstein.* New York: Abbeville, 1983.

Corlett, Mary Lee. *The Prints of Roy Lichtenstein: A Catalogue Raisonné, 1948–1993.* New York: Hudson Hills Press; Washington D.C.: National Gallery of Art, 1994.

_____. *The Prints of Roy Lichtenstein: A Catalogue Raisonné, 1948–1997.* Rev. ed. New York: Hudson Hills Press; Washington D.C.: National Gallery of Art, 2002.

Glenn, Constance. *Roy Lichtenstein: Landscape Sketches 1984–1985.* New York: Harry N. Abrams, 1986.

Gopnik, Adam. "The Wise Innocent." *The New Yorker,* November 8, 1993, pp. 119–23.

Gruen, John. "Roy Lichtenstein: From Outrageous Parody to Iconographic Elegance." *ARTnews,* March 1976, pp. 39–42.

Heartney, Eleanor. "Master of the Benday Dot." *ARTnews,* Summer 1987, p. 210.

Kerber, Bernhard. *Roy Lichtenstein: Ertrinkended Mädchen.* Stuttgart: Reclam, 1970.

Lippard, Lucy R., Lawrence Alloway, Nancy Marmer, and Nicolas Calas. *Pop Art.* New York: Praeger, 1966.

"Rosenquist and Lichtenstein Are Alive." *Time,* January 26, 1968, p. 56.

Smith, Roberta. "Inviting (If Fanciful) Rooms by Roy Lichtenstein." *The New York Times,* June 2, 1992, p. C23.

_____. "Reviews." *Artforum,* February 1975, pp. 63–66.

Taylor, P. "Roy Lichtenstein." Interview. *Flash Art,* October 1989, pp. 87–93.

Tomkins, Calvin. *Roy Lichtenstein: Mural with a Blue Brushstroke.* New York: Harry N. Abrams, 1987.

Waldman, Diane. *Roy Lichtenstein, Drawings and Prints.* New York: Chelsea Hotel Publisher, 1971.

_____. "Wham! Blam! Pow! Roy Lichtenstein!" *ARTnews,* November 1993, pp. 134–39.

Whiting, Cécile. "Borrowed Spots: The Gendering of Comic Books, Lichtenstein's Paintings, and Dishwater Detergent." *American Art,* Spring 1992, pp. 9–35.

☛ LIZA LOU

Born 1969, New York
San Francisco Art Institute, California
Lives and works in Los Angeles

SELECTED SOLO EXHIBITIONS
2002
Testimony, Deitch Projects, New York, October 12–November 30.
Liza Lou, Museum Kunst Palast, Düsseldorf, Germany, February 2–May 5. Catalogue.
Liza Lou: Leaves of Grass, Henie Onstad Kunstsenter, Hovikodden, Norway. Catalogue, text by Selene Wend.
2001
Trailer, Southeastern Center for Contemporary Art, Winston-Salem, North Carolina.
2000
Renwick Gallery of the National Museum of American Art, Smithsonian Institution, Washington, D.C.
1999
In the Kitchen with Liza Lou, Contemporary Arts Center, Cincinnati, June 19–August 29.
1998
Kitchen and Back Yard, Kemper Museum of Contemporary Art, Kansas City, July 25–October 18.
Back Yard, Fundació Joan Miró Centre d'Estudis d'Art Contemporani, Barcelona.
Kitchen and Back Yard, Santa Monica Museum of Art, California. Catalogue, text by Peter Schjeldahl and Marcia Tucker.
1996
Kitchen, The Minneapolis Institute of Arts.
1995
Socks and Underwear, Franklin Furnace, New York, opened July 4.
New Sculpture, John Natsoulas Gallery, Davis, California.

SELECTED GROUP EXHIBITIONS
2002
Melodrama, Atrium Museum, Granada, Spain. Catalogue.
2001
Give and Take, Serpentine Gallery, London, and Victoria and Albert Museum, London, January–April. Catalogue, text by Lisa G. Corrin.
ARS 01, Museum of Contemporary Art Kiasma/Finnish National Gallery, Helsinki.
2000
Made in California: Art, Image and Identity 1900–2000, Los Angeles County Museum of Art, October 22–February 25, 2001. Catalogue, text by Stephanie Barron, Sheri Bernstein, and Ilene Susan Fort.
Taipei Biennial, Taipei Fine Arts Museum, Taipei, Taiwan.

SELECTED BIBLIOGRAPHY
Baer, Martha. "Her Glass House." *Nest Magazine,* Fall 2001.
"Bead Here Now." *Utne Reader,* February 1997.
Gallo, Ruben. "A Labour of Love." *Art Nexus,* April–June 1996.
Hayt, Elizabeth. "Make It Extravagant." *The New York Times,* January 3, 2000.
Kandel, Susan. "A Promising Aesthetic in Feminist Art." *The Los Angeles Times,* June 22, 1995, p. F4.
"Kitsch Sink Drama." *Evening Standard,* January 29, 2001.
Knight, Christopher. "Santa Monica Museum opens new space with two shows that share a homemade flavor." *The Los Angeles Times,* May 9, 1998, p. 1.
Koplos, Janet. "Labor of Love." *Art in America,* October 1996.
"Liza Lou's Back Yard." *American Craft Magazine,* February/March 1999, pp. 84–85, 96.
O'Sullivan, Michael. "Getting a Bead on Power." *The Washington Post,* November 24, 2000, p. N62.
Ollman, Leah. "Liza Lou's American Dream." *Art in America,* June 1998, pp. 98–101.
Pederson, Victoria. "Gallery Go 'Round." *Paper Magazine,* February 1996.
Pincus, Robert. *Liza Lou.* Davis, Calif.: John Natsoulas Press, 1996.
Schwartz, Jeffrey. "Art Review." *ARTnews,* May 1998.
Smith, Roberta. "Fine Art and Outsiders: Attacking the Barriers." *The New York Times,* February 9, 1996, p. C18.
Strickland, Carol. "A Labour of Love Focuses on Artist's Heart as well as Hand." *Christian Science Monitor,* February 12, 1996.
Williams, Alena. "Liza Lou." *Tema Celeste Contemporary Art,* May/June 2001.

❧ KARA MARIA

Born 1968, Binghamton, New York
1993, University of California at Berkeley, BA
1998, University of California at Berkeley, MFA
Lives and works in San Francisco

SELECTED SOLO EXHIBITIONS
2001
Emerging Bay Area Artist Exhibition, Babilonia 1808, San Francisco, June 16–July 28.
Plastic Picnic, Catharine Clark Gallery, San Francisco.
2000
Plastic Dreams, a.o.v., San Francisco.
1999
Doggie Doo Hop Scotch, Cité Internationale des Arts, Paris.

SELECTED GROUP EXHIBITIONS
2002
I Hate Being a Girl, Spanganga, San Francisco.
Trillium Press: Past, Present and Future, Kala Art Institute, Berkeley, California.
2001
Rising Tide, Orange County Center for Contemporary Art, Santa Ana, California. Catalogue.
2000
Chill Factor, New Langton Arts, San Francisco.
1999
Liste 99, Jack Hanley Gallery, Basel, Switzerland.
New American Talent, Arthouse at the Jones Center, Austin. Catalogue.
1998
Works on Paper, Bolinas Museum, Bolinas, California.
1996
National Exhibition, Berkeley Art Center, Berkeley, California.
1995
California Artists, SF Women Artists Gallery, San Francisco.

SELECTED BIBLIOGRAPHY
Baker, Kenneth. "The Last Gasps of Abstraction." *San Francisco Chronicle,* September 2, 2000.
Bonetti, David. "Art Notes." *San Francisco Chronicle,* August 7, 2001.
Egan, Carol. "Driven to Abstraction." *Dean Lesher Regional Center for the Arts Magazine,* July–September 2000.
Morris, Barbara. "'Trillium Press: Past, Present and Future' at Kala." *Artweek,* April 2002.
Rath, Sara. "In Praise of Pork." *Copia,* vol. 4, no. 2, 2001.
Rodriguez, Juan. "Abstraction: From Raucous to Refined at the Bedford Gallery." *Artweek,* October 2000.
_____. "Kara Maria at a.o.v." *Artweek,* September 2000.
Rothbart, Daniel. "West Berkeley: A Hotbed Still." *NY Arts,* vol. 6, no. 11, 2001.
Wetter, Terri D. "Blurring Boundaries: Two Presses Lend Artists a Helping Hand." *Dean Lesher Regional Center for the Arts Magazine,* April–June 2002.

❦ KERRY JAMES MARSHALL

Born 1955, Birmingham, Alabama
1978, Otis Art Institute, Los Angeles, BFA
1999, Otis Art Institute, Los Angeles, Honorary Doctorate
Lives and works in Chicago

SELECTED SOLO EXHIBITIONS
1999
Jack Shainman Gallery, New York, March 20–April 17.
1998
Mementos, The Renaissance Society at the University of
Chicago, May 6–June 28. Traveled to Brooklyn Museum of
Art, New York; San Francisco Museum of Modern Art, San
Francisco; The Institute of Contemporary Art, Boston; Santa
Monica Museum of Art, California, December 17–March 4,
2000; Boise Art Museum, Idaho, May 20–June 30, 2000.
Catalogue, text by Alexander Will and Cheryl I. Harris.
A Narrative of Everyday, Orlando Museum of Art, Orlando,
Florida. Brochure, text by Sue Scott.
1997
Recent Paintings and Drawings, Addison Gallery of American
Art, Andover, Massachusetts.
1995
Kerry James Marshall, The Garden Project, Jack Shainman
Gallery, New York, September 9–October 29.
1994
Telling Stories: Selected Paintings, Cleveland Center for Con-
temporary Art, Ohio. Traveled to Gallery of Art, Johnson
County Community College, Overland Park, Kansas;
Gallery 210, University of Missouri, St. Louis; Pittsburgh
Center for the Arts, Pittsburgh; Southeastern Center for
Contemporary Arts, Winston-Salem, North Carolina. Cata-
logue, text by Terrie Sultan.
1993
Kerry James Marshall: Paintings, Jack Shainman Gallery, New
York, January 9–February 13.
1986
Artist-in-Residence Exhibition, The Studio Museum in Harlem,
New York.

SELECTED GROUP EXHIBITIONS
2002
Shelf Life: Works by 12 International Artists, Spike Island,
Bristol, England, January 25–March.
2000
Illusions of Eden: Visions of the American Heartland, Colum-
bus Museum of Art, Ohio, February 18–April 30. Traveled
to Museum of Modern Art/Ludwig Foundation, Palais
Lichtenstein, Vienna, June 3–September 3; Museum Lud-
wig, Museum of Contemporary Art, Budapest, September
25–November 26; Madison Art Center, Wisconsin, Febru-
ary 24–May 13, 2001; Washington Pavilion of Art and Sci-
ences, Sioux Falls, Iowa, June 15–August, 2001. Catalogue,
text by Robert Stearns.
1999
Carnegie International 1999/2000, Carnegie Museum of Art,
Pittsburgh, November 6–March 26, 2000. Catalogue, text
by Madeleine Grynsztejn, Jonathan Crary, Jean Fisher,
Saskia Sassen, and Slavoj Zizek.
Other Narratives, Contemporary Arts Museum, Houston,
May 15–July 4. Catalogue, text by Dana Friis-Hansen,
Robert Atkins, and Greg Tate.
Trouble Spot: Painting, Museum of Contemporary Art, Antwerp,
Belgium, May 8–August 22. Catalogue, text by Vincent
Geyskens, Cyril Jarton, Hans Rudolf Reust, and Wim Peeters.

1998
*Postcards from Black America: Contemporary African American
Art,* De Beyerd Centrum voor Beeldende Kunst, Amster-
dam. Traveled to Museum of Contemporary Art, Antwerp,
Belgium; Frans Hals Museum, Haarlem, The Netherlands.
1997
1997 Biennial Exhibition, Whitney Museum of American Art,
New York, March 20–June 1. Catalogue, text by Louise Neri
and Lisa Phillips.
Documenta 10, Kassel, Germany, June 21–September 28. Cat-
alogue, text by Jean Christophe Bailly, Catherine David,
and Paul Virilio.
Heart, Mind, Body, Soul: American Art in the 1990s, Whitney
Museum of American Art, New York.
1996
Art in Chicago, 1945–1955, Museum of Contemporary Art,
Chicago, November–December 1997. Catalogue, text by
Jeff Abel, Monique Meloche, and Dominic Molon.
1995
About Place: Recent Art of the Americas, The Art Institute of
Chicago, March 11–May 21.
Art at the Edge: Social Turf, High Museum of Art, Atlanta.
Catalogue.
1993
43rd Biennial Exhibition of Contemporary American Paintings,
Corcoran Gallery of Art, Washington, D.C., October
30–January 2, 1994.
1992
*Terra Incognita: Works by Kerry James Marshall and Santiago
Vaca,* Chicago Cultural Center, Chicago.
1986
The Flower Show, Design Center, Los Angeles.
1979
Newcomers 1979, Municipal Art Gallery, Los Angeles.

SELECTED BIBLIOGRAPHY

Bauman, Zigmunt, Liam Gillick, Elisabeth Grosz, Boris Groys,
Jackie Kay, Hanif Kureishi, Valerey Podoroga, Douglas
Rushkoff, Carlos Varela, and Marina Warner. *Fresh Cream:
Contemporary Art in Culture.* London: Phaidon, 2000.
Hixon, Kathryn. "Kathryn Hixon Visits Kerry James Marshall
in Chicago." *TRANS,* vol. 1, no. 2, 1996, pp. 93–97.
Holg, Garrett. "Stuff Your Eyes with Wonder." *ARTnews,*
March 1998, pp. 154–56.
Kimmelman, Michael. "Kerry James Marshall at Jack Shain-
man." *The New York Times,* September 29, 1995, p. C18.
Marshall, Kerry James, and Katy Siegel. "Kerry James Marshall Talks
About Rhythm Master." *Artforum,* Summer 2000, pp. 148–49.
Marshall, Kerry James, Terrie Sultan, and Arthur Jafa. *Kerry
James Marshall.* New York: Harry N. Abrams, 2000.
Molesworth, Helen. "Project America." *frieze,* May 1998, pp.
72–75.
Mooney, Amy. "Kerry James Marshall: Mementos." *NKA: Jour-
nal of Contemporary African Art,* Fall/Winter 1998, pp. 24–27.
Osborne, Catherine. "Kerry James Marshall." *Parachute,*
July–September 1998, pp. 19–21.
Reid, Calvin. "Kerry James Marshall." *Bomb,* Winter 1998,
pp. 40–47.
Smith, Roberta. "Safe Among Seamless Shadows." *The New
York Times,* November 17, 1999, pp. B1, B6.
Snodgrass, Susan. "Heroes and Martyrs." *Art in America,*
November 1998, pp. 92–95.

⚡ JULIE MEHRETU

Born 1970, Addis Ababa, Ethiopia
1990–1991, University Cheik Anta Diop, Dakar, Senegal
1992, Kalamazoo College, Michigan, BA
1997, Rhode Island School of Design, Providence, MFA
Lives and works in New York

SELECTED SOLO EXHIBITIONS
2002
Julie Mehretu: Renegade Delirium, White Cube Gallery,
 London, March 7–September 28.
2001
Julie Mehretu at The Project, The Project, New York,
 November 18–December 22.
Julie Mehretu, ArtPace, San Antonio, April 5–June 17.
1999
Module, Project Row Houses, Houston, April–September.
1996
Barbara Davis Gallery, Houston.

SELECTED GROUP EXHIBITIONS
2002
Out of Site, The New Museum of Contemporary Art, New
 York, June 26–October 13. Catalogue.
The Busan Biennial, Busan, Korea.
Urgent Painting, Musée d'Art Moderne de la Ville de Paris,
 Paris, February 17–March 3. Catalogue, text by Sandra
 Antelo-Suarez.
2001
Casino 2001, Stedelijk Museum voor Actuele Kunst, Gent,
 Belgium, October 20–January 13, 2002.
Freestyle, The Studio Museum in Harlem, New York, April
 28–June 24. Traveled to Santa Monica Museum of Art,
 California, September 29–November 18. Catalogue, text by
 Thelma Golden and Hamza Walker.
Painting at the Edge of the World, Walker Arts Center, Min-
 neapolis, February 10–May 6. Catalogue, text by Douglas
 Fogel, Marcel Broodthaers, Yve-Alain Bois, Midori Matsui,
 Daniel Birnbaum, Paulo Herkenhoff, Hélio Oiticica,
 Andrew Blauvelt, Jörg Heiser, Mike Kelley, Hubert
 Damisch, Marlene Dumas, Reinaldo Laddaga, Takashi Mu-
 rakami, Frances Stark, and Rudolf Stingel.
2000
Greater New York: New Art in New York Now, P.S.1 Contempo-
 rary Art Center, Long Island City, New York, February
 27–May. Catalogue.
1999
Hot Spots: Houston, Miami and Los Angeles, Weatherspoon
 Art Gallery, Greensboro, North Carolina.
The Strokes, Exit Art, New York.

SELECTED BIBLIOGRAPHY
Berwick, Carly. "Excavating Runes." *ARTnews,* March 2002, p. 95.
Cotter, Holland. "A Full Studio Museum Show Starts with 28
 Young Artists and a Shoehorn." *The New York Times,* May
 11, 2001, p. E36.
Hoptman, Laura. "Crosstown Traffic: Laura Hoptman on Julie
 Mehretu." *frieze,* September/October 2000, pp. 104–107.
Saltz, Jerry. "Greater Expectations." *The Village Voice,* March
 7–13, 2000.
Sirmans, Franklin. "Mapping a New and Urgent History of
 the World." *The New York Times,* December 9, 2001.
Yablonksy, Linda. "The New New York: Harlem's New Renais-
 sance." *ARTnews,* April 2002, pp. 105–108.

✗ TAKASHI MURAKAMI

Born 1962, Tokyo
1986, Tokyo National University of Fine Arts and Music, BFA,
 Japanese Traditional Painting (Nihon-ga)
1988, Tokyo National University of Fine Arts and Music, MA
1993, Tokyo National University of Fine Arts and Music, PhD
Lives and works in Tokyo and New York

SELECTED SOLO EXHIBITIONS
2002
Takashi Murakami, Fondation Cartier pour l'Art Contempo-
 rain, Paris, June 27–October 27.
2001
Summon Monsters? Open the Door? Heal or Die?, Museum of
 Contemporary Art, Tokyo, August 25–November 4.
Takashi Murakami: Made in Japan, Museum of Fine Arts,
 Boston, April 25–September 3. Catalogue.
1999
*Takashi Murakami: The Meaning of the Nonsense of the Mean-
 ing,* Bard Center for Curatorial Studies, Annandale-on-
 Hudson, New York, June 27–September 12. Catalogue, text
 by Amada Cruz, Midori Matsui, and Dana Friis-Hansen.
1997
Takashi Murakami, Center for the Arts, State University of New
 York at Buffalo, April 10–July 13. Brochure, text by Tom Folland.
Takashi Murakami, Emmanuel Perrotin, Paris.
1996
Takashi Murakami, Gallery Koto, Okayama, Japan.
1995
Crazy Z, SCAI, The Bathhouse, Shiraishi Contemporary Art
 Inc., Tokyo, October 24–November 18.
1994
Which Is Tomorrow?—Fall in Love—, The Bathhouse, Shiraishi
 Contemporary Art Inc., Tokyo, June 17–July 16. Catalogue.
1993
A Very Merry Unbirthday!, Hiroshima City Museum of Contem-
 porary Art, Hiroshima, Japan, June 19–July 18. Catalogue.
1991
It's That I'm Against Acceptance of It, Hosomi Gallery Contempo-
 rary, Tokyo, December 3–21. Brochure, text by Minami Yusuke.

SELECTED GROUP EXHIBITIONS
2001
Public Offerings, Los Angeles Museum of Art and Geffen
 Contemporary, April 1–July 29. Catalogue, text by Yilmaz
 Dziewior, Midori Matsui, Lane Relyea, Paul Schimmel,
 Katy Siegel, Howard Singerman, and Jon Thompson.
Painting at the Edge of the World, Walker Art Center, Min-
 neapolis, February 10–May 6. Catalogue, text by Douglas
 Fogel, Marcel Broodthaers, Yve-Alain Bois, Midori Matsui,
 Daniel Birnbaum, Paulo Herkenhoff, Hélio Oiticica, An-
 drew Blauvelt, Jörg Heiser, Mike Kelley, Hubert Damisch,
 Marlene Dumas, Reinaldo Laddaga, Takashi Murakami,
 Frances Stark, and Rudolf Stingel.
*My Reality: Contemporary Art and the Culture of Japanese
 Animation,* Des Moines Art Center, Iowa. Traveled to seven
 venues. Catalogue, text by Jeff Fleming, Susan Lubowsky
 Talbott, and Takashi Murakami.
2000
Au-dela du Spectacle, Centre Georges Pompidou, Musée Na-
 tional d'Art Moderne, Paris, November 22–January 8, 2001.
Continental Shift: A Journey Between Cultures, Ludwig Forum
 für Internationale Kunst, Aachen, Germany, May 21–
 September 10. Traveled to Bonnefantenmuseum, Maas-
 tricht, The Netherlands; Stadtsgalerij Heerlen, The Nether-
 lands; Musée d'Art Moderne, Liege, Belgium.
Super Flat, Parco Gallery, Tokyo, through May 29. Traveled to
 Museum of Contemporary Art, Los Angeles, January
 14–May 27, 2001. Catalogue, text by Takashi Murakami
 and Hiroki Azuma.

Let's Entertain, Walker Art Center, Minneapolis, February 12–April 30. Traveled to Portland Art Museum, Oregon, July 7–September 17; Centre Georges Pompidou, Musée National d'Art Moderne, Paris, November 15–December 18; Miami Art Museum, September 14–November 25. Catalogue, text by Peter Ritter.

On View, P.S.1 Contemporary Art Center, Long Island City, New York.

1998

Abstract Painting, Once Removed, Contemporary Arts Museum, Houston, October 3–December 6. Traveled to Kemper Museum of Contemporary Art, Kansas City, April 23–July 18, 1999. Catalogue, text by Dana Friis-Hansen, David Pagel, Raphael Rubinstein, and Peter Schjeldahl.

So what? Exhibition of Contemporary Japanese Art, Ecole Nationale Superleure des Beaux-Arts, Paris.

1997

Japanese Contemporary Art Exhibition, The National Museum of Contemporary Art, Seoul.

1996

The Second Asia-Pacific Triennial of Contemporary Art, Queensland Art Gallery, South Brisbane, Australia, September 27–January 19, 1997. Catalogue, text by Midori Matsui.

Romper Room, Thread Waxing Space, New York. Traveled to DiverseWorks Art Space, Houston, September 19–October 11, 1997. Catalogue, text by Danielle Chang.

Tokyo Pop, The Hiratsuka Museum of Art, Kanagawa, Japan. Catalogue.

1995

46th esposizione internazionale d'arte, La Biennale di Venezia, Venice, June 11–September 4, organized by The Japan Foundation and Fukutake Science and Culture Foundation. Traveled to Naoshima Museum of Contemporary Art, Okayma, Japan. Catalogue, text by Fumio Nanjo and Dana Friis-Hansen.

Japan Today, Louisiana Museum of Modern Art, Humlebaek, Denmark. Traveled to four venues. Catalogue, text by Tone O. Nielsen.

1993

Art Today '93 New Japanology, Sezon Museum of Modern Art, Karuizawa, Nagano, Japan.

Beyond "Nihon-ga"—An Aspect of Contemporary Japanese Painting, Tokyo Metropolitan Art Museum, Tokyo.

1992

Nakamura and Murakami, Space Ozone, Seoul, July 4–25. Traveled to Project Room, Shiraishi Contemporary Art Inc., Tokyo, August 28–September 19. Catalogue, text by Min Nishihara.

SELECTED BIBLIOGRAPHY

Bauman, Zigmunt, Liam Gillick, Elisabeth Grosz, Boris Groys, Jackie Kay, Hanif Kureishi, Valerey Podoroga, Douglas Rushkoff, Carlos Varela, and Marina Warner, *Fresh Cream: Contemporary Art in Culture.* London: Phaidon, 2000.

Bellars, Peter. "If you can't beat 'em." *Asahi Evening News,* July 17, 1994.

Friis-Hansen, Dana. "Empire of Goods: Young Japanese Artists and Commodity Culture." *Flash Art,* March/April 1992, pp. 78–81.

_____. "Takashi Murakami." *Grand Street,* Summer 1998, p. 221.

Higa, Karen. "Some Thoughts on National and Cultural Identity: Art by Contemporary Japanese and Japanese American Artists." *Art Journal,* Fall 1996, pp. 6–13.

Matsui, Midori. "Tokyo Pop." *Flash Art,* November/December 1997, p. 110.

Molinari, Guido. "Art Review." *Los Angeles Times,* July 3, 1998, p. 26.

Pagel, David. "Paintings in the Midst of Generational Conflict." *Los Angeles Times,* August 1, 1997, p. F28.

Sawaragi, Noi. "Takashi Murakami." *World Art,* Summer 1997, p. 76.

Sawaragi, Noi, and Fumio Nano. "Dangerously Cute." *Flash Art,* March/April 1992, pp. 75–81.

🎨 ELIZABETH MURRAY

Born 1940, Chicago
1962, The School of the Art Institute of Chicago, BFA
1967, Mills College, Oakland, California, MFA
Lives and works in New York

SELECTED SOLO EXHIBITIONS

1999

Elizabeth Murray, Recent Paintings, PaceWildenstein, New York, February 12–March 13. Catalogue.

1992

Project 1: Elizabeth Murray, The Newark Museum, New Jersey, September 25–October 22.

1988

Elizabeth Murray, New Work, San Francisco Museum of Modern Art, May 4–June 4.

1987

Elizabeth Murray: Paintings and Drawings, Dallas Museum of Art, March 1–April 19. Traveled to six venues. Catalogue, text by Roberta Smith, Sue Graze, and Kathy Halbreich.

1984

Currents: Elizabeth Murray, The Institute of Contemporary Art, Boston, April 10–May 6. Catalogue.

1982

Elizabeth Murray: Recent Paintings and Drawings, Portland Center for the Visual Arts, Oregon, October 21–November 27. Catalogue.

1976

Elizabeth Murray: Recent Paintings, Paula Cooper Gallery, New York, November 2–27.

SELECTED GROUP EXHIBITIONS

1995

It's Only Rock and Roll: Rock and Roll Currents in Contemporary Art, Contemporary Arts Center, Cincinnati, November 17–January 21, 1996. Traveled to eight venues. Catalogue.

1992

Dürer to Diebenkorn: Recent Acquisitions of Art of Paper, National Gallery of Art, Washington, D.C., May 10–September 7. Catalogue.

1991

1991 Biennial Exhibition, Whitney Museum of American Art, New York, April 19–June 16. Catalogue, text by Richard Armstrong, John G. Hanhardt, Richard Marshall, and Lisa Phillips.

1990

High and Low, Modern Art and Popular Culture, The Museum of Modern Art, New York, October 3–January 15, 1991. Traveled to The Art Institute of Chicago, February 20–May 12, 1991; Museum of Contemporary Art, Los Angeles, June 1–September 15, 1991. Catalogue, text by Kirk Varnedoe and Adam Gopnik.

1988

20th Century Drawings from the Whitney Museum of American Art, Whitney Museum of American Art, New York, November 18–January 18, 1989.

1987

40th Biennial of American Contemporary Painting, Corcoran Gallery of Art, Washington, D.C., April 11–June 21. Catalogue.

1985

1985 Biennial Exhibition, Whitney Museum of American Art, New York, March 21–June 2. Catalogue.

1984

An International Survey of Recent Painting and Sculpture, The Museum of Modern Art, New York, May 17–August 19. Catalogue, edited by Kynaston McShine.

1983

Directions 1983, Hirshhorn Museum and Sculpture Garden, Smithsonian Institution, Washington, D.C., March 10–May 15. Catalogue, text by Phyllis D. Rosenzweig.

1982

74th American Exhibition, The Art Institute of Chicago, June 12–August 1. Catalogue.

Abstract Drawings, 1911–1981, Whitney Museum of American Art, New York, May 5–July 11. Catalogue.

A Private Vision: Contemporary Art from Graham Gund Collection, Museum of Fine Arts, Boston, February 9–April 4. Catalogue.

1981

Amerikanische Malerei, 1930–1980, Haus der Kunst, Munich, November 14–January 31, 1982. Catalogue.

1981 Biennial Exhibition, Whitney Museum of American Art, New York, January 20–April 19. Catalogue.

1980

American Drawing in Black and White: 1970–1980, Brooklyn Museum of Art, New York, November 22–January 18, 1981. Catalogue.

1979

1979 Biennial Exhibition, Whitney Museum of American Art, New York, February 6–April 8. Catalogue.

1978

Thick Paint, The Renaissance Society at the University of Chicago, October 1–November 8. Catalogue.

1977

Early Work by Five Contemporary Artists, The New Museum of Contemporary Art, New York, November 11–December 30. Catalogue, text by Marcia Tucker, S. Logan, and A. Schwartzman.

Nine Artists: Theodoron Awards, Solomon R. Guggenheim Museum, New York, March 4–April 7. Catalogue.

1977 Biennial Exhibition, Whitney Museum of American Art, New York, February 15–April 3. Catalogue.

1973

1973 Biennial Exhibition, Whitney Museum of American Art, New York, January 10–March 18. Catalogue.

SELECTED BIBLIOGRAPHY

Ashbery, John. "The Perennial Biennial." *New York Magazine*, March 19, 1979, pp. 28–31.

Auping, Michael, L. Cooke, Hilton Kramer, and Robert Rosenblum. *Art of Our Time, The Saatchi Collection*. Vol. 4. London: Lund Humphries, 1984.

Fineberg, Jonathan. *Art Since 1940: Strategies of Being*. New York: Abrams, 1996.

Frankel, David. "Ifs, Ands, and Buts." *Artforum*, March 1998, pp. 70–75.

Hagedorn, Jessica. "Elizabeth Murray." Interview. *Bomb*, Winter 1998, pp. 56–63.

Hughes, Robert. *Nothing If Not Critical*. London: Harvill, 1999.

Kimmelman, Michael. "Contrapuntal Paintings from Elizabeth Murray." *The New York Times*, April 10, 1992, p. C22.

Kuspit, Donald B. "Elizabeth Murray's Dandyish Abstraction." *Artforum*, February 1978, pp. 28–31.

Lingeman, Susanne. "Sieben starke Frauen in New York." *Das Kunstmagazin*, December 1994, pp. 16–34, 37.

Plagens, Peter. "Nine Biennial Notes." *Art in America*, July 1985, pp. 114–19.

Ratcliff, Carter. "The Paint Thickens." *Artforum*, June 1976, pp. 43–47.

Rosenthal, Mark. "The Structured Subject in Contemporary Art: Reflections on Works in the Twentieth Century Galleries." *Philadelphia Museum of Art Bulletin*, Fall 1983.

Sandler, Irving. *Art of the Postmodern Era, From the Late 1960s to the Early 1990s*. New York: Harper Collins, 1996.

Seliger, Jonathan, and John Zinsser. "Elizabeth Murray." Interview. *Journal of Contemporary Art*, Fall/Winter 1988, pp. 31–37.

Storr, Robert. "Shape Shifter." *Art in America*, April 1989, pp. 210–21.

☻ YOSHIMOTO NARA

Born 1959, Aomori Prefecture, Japan

1985, Aichi Prefectural University of Fine Arts and Music, BFA

1987 Aichi Prefectural University of Fine Arts and Music, MFA

Lives and works in Tokyo

SELECTED SOLO EXHIBITIONS

2001

I Don't Mind, If You Forget Me, Yokohama Museum of Art, Yokohama, Japan. Traveled in Japan to Hiroshima Museum of Contemporary Art; Ashiya City Museum of Art; Asahikawa Prefectural Museum of Art, Hokkaido; Aomori Museum of Art. Catalogue.

2000

Walk On, Museum of Contemporary Art, Chicago, March 18–June 25. Brochure, text by Staci Boris.

Lullaby Supermarket, Santa Monica Museum of Art, California.

1999

Somebody, Whispers in Nurnberg, Institut für Moderne Kunst Nurnberg, Germany. Catalogue.

Walking Alone, The Ginza Art Space, Tokyo. Catalogue.

1998

Institute of Visual Arts, University of Wisconsin, Milwaukee, September 11–November 22. Catalogue, text by Marilu Knode.

1995

In the Deepest Puddle, SCAI, The Bathhouse, Shiraishi Contemporary Art Inc., Tokyo, March 10–April 8. Catalogue, text by Eriko Osaka.

Cup Kids, The Museum of Contemporary Art, Nagoya, Japan.

Pacific Babies, Blum and Poe, Santa Monica, California.

Project for Gunma, Gunma Prefectural Museum of Modern Art, Takasaki, Japan.

1994

lonesome babies, Hakutosha, Nagoya, Japan.

1992

Drawings, Galerie d'Eendt, Amsterdam.

1988

Goethe Institut, Dusseldorf, Germany.

1984

Wonder Room, Gallery Space to Space, Nagoya, Japan.

It's a Little Wonderful House, Love Collection Gallery, Nagoya, Japan.

SELECTED GROUP EXHIBITIONS

2001

Public Offerings, Museum of Contemporary Art, Los Angeles and Geffen Contemporary, Los Angeles, April 1–July 29. Catalogue, text by Yilmaz Dziewior, Midori Matsui, Lane Relyea, Paul Schimmel, Katy Siegel, Howard Singerman, and Jon Thompson.

My Reality: Contemporary Art and the Culture of Japanese Animation, Des Moines Art Center, Iowa. Traveled to seven venues. Catalogue, text by Jeff Fleming, Susan Lubowsky Talbott, and Takashi Murakami.

2000

Super Flat, Parco Gallery, Tokyo, through May 29. Traveled to Museum of Contemporary Art, Los Angeles, January 14–May 27, 2001. Catalogue, text by Takashi Murakami and Hiroki Azuma.

The Darker Side of Playland: Childhood Imagery from the Logan Collection, San Francisco Museum of Art, San Francisco. Catalogue.

1999

Almost Warm and Fuzzy: Childhood and Contemporary Art, Des Moines Art Center, Iowa. Traveled to seven venues. Catalogue.

1998

The Manga Age, Museum of Contemporary Art, Tokyo. Catalogue.

1997

Japanese Contemporary Art Exhibition, The National Museum of Contemporary Art, Seoul.

VOCA, The Royal Museum of Art, Tokyo.

1996

Ironic Fantasy: Another World by Five Contemporary Artists, The Miyagi Museum of Art, Japan, July 27–September 1. Catalogue, text by Midori Matsui.

Tokyo Pop, The Hiratsuka Museum of Art, Kanagawa, Japan. Catalogue.

1995

Endless Happiness, SCAI, The Bathhouse, Shiraishi Contemporary Art Inc., Tokyo.

POSITIV, Museum am Ostwall, Dortmund, Germany.

1994

Gunma Biennale, Gunma Prefectural Museum of Modern Art, Takasaki, Japan.

SELECTED BIBLIOGRAPHY

Darling, Michael. "Yoshimoto Nara." *Art Issues,* September/October 1995, p. 41.

_____. "Yoshimoto Nara." *frieze,* September/October 1997, p. 85.

Joynes, Les. "Yoshimoto Nara at Ginza Art Space." *Art in America,* July 1999, p. 106.

Matsui, Midori. "Japanese Innovators: Fruitful Transformations of the Modernist Aesthetic." *Flash Art,* January/February 2000, pp. 90–91.

_____. "Tokyo Pop." *Flash Art,* November/December 1997, p. 110.

_____. "Yoshimoto Nara with Midori Matsui." *Index Magazine,* February/March 2001.

Nagoya, Satoru. "Overture: Yoshimoto Nara." *Flash Art,* May/June 1998, p. 91.

Pagel, David. "'Lullaby': Just the Right Cup of Tea." *Los Angeles Times,* pp. F1, F10.

_____. "Prizing an Animated Approach to Life." *Los Angeles Times,* May 23, 1997, p. F22.

_____. Review. *Los Angeles Times,* March 12, 1999, p. F32.

Sander, Mark, Fumiya Sawa, and Yoshimoto Nara. "Toy Stories." *Dazed and Confused,* April 1998, pp. 98–101.

Smith, Roberta. "Yoshimoto Nara." *The New York Times,* November 5, 1999, p. B39.

RAYMOND PETTIBON

Born 1957, Tucson

1977, University of California at Los Angeles, BA

Lives and works in Hermosa Beach, California

SELECTED SOLO EXHIBITIONS

2002

Tramas Entrecruzdas, Museu d'Art Contemporani de Barcelona, February 11–April.

Raymond Pettibon, Museum Ludwig, Cologne, February.

2001

Whitechapel Art Gallery, London, September 6–October 21.

1998

The Renaissance Society at the University of Chicago, Chicago, September 13–November 8. Traveled to The Drawing Center, New York, February 21–April 4, 1999; Philadelphia Museum of Art, Philadelphia, May–June 1999; Museum of Contemporary Art, Los Angeles, September 26, 1999–January 2, 2000. Catalogue, text by Susanne Ghez, Anne d'Harnoncourt, Ann Temkin, and Hamza Walker.

1994

Saint Louis Art Museum.

1993

University of California Berkeley Art Museum and Pacific Film Archive.

1992

Galerie Metropol, Vienna. Catalogue.

1990

A Long Parenthesis, Richard/Bennett Gallery, Los Angeles.

1986

Semaphore Gallery, New York.

SELECTED GROUP EXHIBITIONS

2002

Documenta 11, Kassel, Germany, June 8–September 15. Catalogue, text by Okwui Enwezor, Carlos Basualdo, Ute Meta Bauer, Suzanne Ghez, Sarat Maharaj, Mark Nash, and Octavio Zaya.

2001

The Inward Eye, Transcendence in Contemporary Arts, Contemporary Arts Museum, Houston, December 8–February 17, 2002. Catalogue, text by Lynn M. Herbert, Peter Schjeldahl, and Klauss Ottmann.

The LP Show, Exit Art, New York, June 9–August. Traveled to Experience Music Project, Seattle; The Andy Warhol Museum, Pittsburgh, June 23–August 18, 2002.

Art > Music, Museum of Contemporary Art, Sydney, March 21–June.

2000

Made in California: Art, Image and Identity 1900–2000, Los Angeles County Museum of Art, October 22–February 25, 2001. Catalogue, text by Stephanie Barron, Sheri Bernstein, and Ilene Susan Fort.

L.A. –ex, Museum Villa Stuck, Munich, April 12–June.

1999

The American Century: Art and Culture, 1900–2000, Part II, 1950–2000, Whitney Museum of American Art, New York, November 26–February 13, 2000. Catalogue, text by Lisa Phillips.

L.A., Monika Spruth and Philomene Magers, Cologne.

Mirror's Edge, BildMuseet, Umeå, Sweden. Traveled to Vancouver Art Gallery, Vancouver; Castello di Rivoli, Turin, Italy; Tramway, Glasgow, March 2–April 15, 2001.

Stop the Violence: Posters by Artists, Academy of Fine Arts, Vienna. Catalogue, text by Peter Noever and Carl Pruscha.

1998

L.A. Current: Looking at the Light: 3 Generations of L.A. Artists, UCLA Hammer Museum, Los Angeles.

1997

Sunshine and Noir: Art in L.A. 1960–1997, Louisiana Museum of Modern Art, Humlebaek, Denmark, May 16–September 7. Traveled to Kunstmuseum Wolfsburg, Germany, November 15–February 1, 1998; Castello di Rivoli, Turin, Italy; UCLA Hammer Museum, Los Angeles, October 7, 1998–January 3, 1999. Catalogue, text by Lars Nittve and Helle Crenzien.

1997 Biennial Exhibition, Whitney Museum of American Art, New York, March 20–June 1. Catalogue, text by Louise Neri and Lisa Phillips.

Angel, Angel, Kunsthalle, Vienna. Traveled to Rudolfinum, Prague. Catalogue, text by Cathrin Pichler.

Heart, Mind, Body, Soul: American Art in the 1990s, Whitney Museum of American Art, New York.

Heaven: Public View, Private View, P.S.1 Contemporary Art Center, Long Island City, New York.

1996

NowHere: Work in Progress, Louisiana Museum of Art, Humlebaek, Denmark, May 5–September 8. Catalogue, text by Iwona Blazwick, Lars Nittbe, Laura Cottingham, Bruce W. Ferguson, Anneli Fuchs, and Ute Meta Bauer.

Acquiring Minds: Contemporary Arts in Santa Barbara, Contemporary Arts Forum, California.

Sex and Crime: On Human Relationships, Sprengel Museum, Hannover, Germany. Catalogue, text by Dietmar Elger.

1995

It's Only Rock and Roll: Rock and Roll Currents in Contemporary Art, Contemporary Arts Center, Cincinnati, November 17–January 21, 1996. Traveled to eight venues. Catalogue.

1994

Mapping, The Museum of Modern Art, New York, October 6–December. Catalogue, text by Robert Storr.

It's a Tough World Out There: Drawings by Mike Kelley, Joyce Pensato, and Raymond Pettibon. Saint Louis Museum of Art, Missouri, Spring.

Can You Always Believe Your Eyes: Recent American Drawings, Museum of Contemporary Art DeBeyrd, Breda, The Netherlands.

Don't Look Now, Thread Waxing Space, New York. Catalogue, text by Joshua Decter.

1993

1993 Biennial Exhibition, Whitney Museum of American Art, New York, March 4–June 20. Catalogue, text by Elizabeth Sussman, Thelma Golden, John G. Hanhardt, and Lisa Phillips.

Live in Your Head, Heligenkreuzerhof, Vienna, January 9–February. Catalogue, text by Robert Nickas.

Mongrel, Muse/Works on Paper, Kunstmuseum, Silkeborg, Denmark. Catalogue, text by Troels Andersen.

1992

Helter Skelter: L.A. Art in the 1990s, Museum of Contemporary Art, Los Angeles, January 26–April 26. Catalogue, text by Paul Schimmel, Catherine Gudis, Norman Klein, and Lane Relyea.

Connections: Explorations in the Getty Center Collections, The Getty Center for the History of Art and the Humanities, Santa Monica, California.

Dirty Data: Sammlung Schurman, Ludwig Forum fur internationale Kunst, Aachen, Germany. Catalogue, text by Ann Goldstein.

Drawn in the Nineties, Katonah Museum of Art, New York. Catalogue, text by Joshua Smith.

L.A. Art and the Art of the Nineties, Galerie Ursula Krinzinger, Vienna.

True Stories, Institute of Contemporary Arts, London. Catalogue, text by Iwona Blazwick and Emma Dexter.

1991

AIDS Timeline, Whitney Museum of American Art, New York.

Louder, Gallery 400, Chicago.

No Man's Time, Villa Arson, Nice, France. Catalogue, text by Christian Bernard, Nicolas Bourriaud, Jean-Yves Joannais, and Eric Troncy.

1990

Drinking and Driving: The Progressive Corporation's 1989 Annual Report, Cleveland Center for Contemporary Art, Cleveland. Traveled to Gallery of Art and Design, North Carolina State University, Raleigh, 1992.

Just Pathetic, Rosamund Felsen Gallery, Los Angeles. Catalogue, text by Ralph Rugoff.

1986

Social Distortion, Los Angeles Contemporary Exhibitions, Los Angeles.

SELECTED BIBLIOGRAPHY

Artner, Alan. "The Subject Is Sex and the Style Is Cerebral." *Chicago Tribune,* August 6, 1987.

Astrid, Wege. *Art at the Turn of the Millennium.* Cologne: Taschen, 1999.

Bonami, Francesco. "U.S. Pain." *Flash Art,* May/June 1992, pp. 100–102.

Buchloh, Benjamin H. D. "Raymond Pettibon: Return to Disorder and Disfiguration." *October,* Spring 2000, pp. 36–51.

Coley, Byron. "Dreams Not Sprung from the Bush of Madonna: An Interview with Raymond Pettibon." *Forced Exposure,* Winter 1988.

Deitcher, David, and Rhonda Lieberman. "The Library in Your Good Hands." *Artforum,* October 1992, pp. 74–79.

Grady, Turner. "Raymond Pettibon." Interview. *Bomb,* Fall 1999, pp. 40–47.

Groys, Boris. "The Drawing Rescues Poetry." *Parkett,* September 1996, pp. 70–77.

Lewis, Jim. "A Conversation with Raymond Pettibon." *Parkett,* September 1996, pp. 56-69.

Loock, Ulrich. "Raymond Pettibon: 'Das musikalische Element in meiner Arbeit hat nichts mit Rock-Musik zu tun.'" *Kunstforum International,* May–September 1996, pp. 206–12.

"Raymond Pettibon: Plattencover, Plakate, Flayer au den 80er Jahren." *Jahresring,* no. 45, 1998, pp. 205–12.

Rollig, Stella. "Heldensagen der Subkulture uber den Amerikanischen Kunstler Raymond Pettibon." *Kunstpresse,* June 1992.

Smith, Roberta, "Art in Review." *The New York Times,* July 5, 1991.

Storr, Robert, Dennis Cooper, Ulrich Loock, and Raymond Pettibon. *Raymond Pettibon.* London: Phaidon, 2001.

Volkart, Yvonne. "Raymond Pettibon." *Flash Art,* Summer 1995, p. 122.

SIGMAR POLKE

Born 1941, Oels, Germany
1968, Düsseldorf Kunstakademie, Germany
Lives and works in Cologne

SELECTED SOLO EXHIBITIONS

2002

Sigmar Polke: Recent Paintings and Drawings, Dallas Museum of Art, November 15–March 23, 2003. Catalogue.

2001

Sigmar Polke, alchemist, Louisiana Museum of Modern Art, Humlebaek, Denmark, March 30–July 29. Catalogue, text by Jutta Nestgard, Jon-Ove Steihaug, and Poul Erik Tøjner.

1999

Sigmar Polke: Works on Paper 1963–1974, The Museum of Modern Art, New York, April 1–June 16. Traveled to Hamburger Kunsthalle, Hamburg, July 15–October 17. Catalogue, text by Margit Rowell, Michael Semff, and Bice Curiger.

1997

Sigmar Polke: Die Drei Lügen der Malerei, Kunst und Austellungshalle der Bundesrepublik, Bonn, Germany, October 30–February 15, 1998. Traveled to Nationalgalerie im Hamburger Bahnhof, Hamburg; Museum für Gegenwart, Berlin; Nationalgalerie, Berlin, Staatliche Museen Preussischer Kulturbesitz, Berlin. Catalogue, text by Marin Hentschel.

1995

Sigmar Polke: Illumination, Walker Art Center, Minneapolis, May 6–September 17. Catalogue, text by Richard Flood.

Sigmar Polke: Join the Dots, Tate Gallery, Liverpool, January 21–April 17. Catalogue, edited by David Thistlewood.

1990

Sigmar Polke, San Francisco Museum of Modern Art, November 15–January 13, 1991. Traveled through January 1992. Catalogue.

Sigmar Polke, Stedelijk Museum of Modern Art, Amsterdam, September 25–November 29. Catalogue.

1988

Sigmar Polke, Musée d'Art Moderne de la Ville de Paris, Paris, October 20–December 31. Catalogue.

1983

Sigmar Polke, Museum Boymans van Beuningen, Rotterdam, December 18–January 29, 1984. Catalogue.

1966

Galerie René Block, Berlin, May. Catalogue, text by Joseph Beuys.

SELECTED GROUP EXHIBITIONS

2002

Cher Peintre: Peintures Figuratives depuis l'Ultime Picabia, Centre Georges Pompidou, Musée National d'Art Moderne, Paris, June 12–September 2.

1999

48th esposizione internazionale d'arte, La Biennale di Venezia, Venice, June 13–November 7. Catalogue.

1996

Sammlung Frieder Burda: Gerhard Richter, Sigmar Polke, Arnulf Rainer, Staatliche Kunsthalle, Baden Baden, Germany, September 14–November 3. Catalogue, text by Jochen Poetter.

1992

Allegories of Modernism: Contemporary Drawings, The Museum of Modern Art, New York, February 16–May 5. Catalogue, text by Bernice Rose.

1989

Pop Art, Royal Academy of Arts, London, September 13–December 15. Traveled to Museum Ludwig Kunsthalle, Cologne, January 22–April 20, 1992; Museo Nacional Centro de Arte Reina Sofia, Madrid; Musée des Beaux-Arts, Montreal, October 23–January 24, 1993. Catalogue, text by Marco Livingstone and Dan Cameron.

Drawing as Itself, The National Museum of Art, Osaka, Japan.

1987

Warhol/Beuys/Polke, Milwaukee Art Museum, Milwaukee, June 19–August 16. Traveled to Contemporary Arts Museum, Houston, September 12–November 15. Catalogue, text by Russell Bowman, Linda L. Cathcart, Donald B. Kuspit, and Lisa Liebman.

1975

13th Bienal de São Paulo, São Paulo, Brazil, October–December. Catalogue.

1972

Documenta 5: Befragung der Realität: Bildwelten Heute, Museum Fridericianum, Neue Galerie, Kassel, Germany, June 30–October 8. Catalogue.

SELECTED BIBLIOGRAPHY

Becker, Jörgen, Claus von der Osten, and Martin Hentschel. *Sigmar Polke: The Editioned Works 1963–2000: catalogue raisonnée.* Ostfildern–Ruit, Germany: Hatje Cantz, 2000.

Erfle, Anne. *Sigmar Polke: Der Traum des Menelaos.* Cologne: DuMont Buchverlag, 1997.

Foster, Hal. "Archives of Modern Art." *October,* Winter 2002, pp. 81–95.

Gachnang, Johannes. *Sigmar Polke: The Early Drawings 1963–1969.* Translated by Catherine Schelbert. Bern and Berlin: Verlag Gachnang and Springer, 1991.

_____. *Sigmar Polke: Zeichnungen 1963–1969.* Bern and Berlin: Verlag Gachnang and Springer, 1987.

Gintz, Claude. "Polke's Slow Dissolve." *Art in America,* December 1985, pp. 102–109.

Jappe, Georg. "Young Artists in Germany." *Studio International,* February 1972, pp. 65–73.

Kuspit, Donald B. "At the Tomb of the Unknown Picture." *Artscribe International,* March/April 1988, pp. 38–45.

Pohlen, Annelie. "The Beautiful and the Ugly Pictures: Some Aspects of German Art." *Art and Text,* nos. 12–13, 1984, pp. 60–73.

Polke, Sigmar, Bice Curiger, et al. "Collaboration Sigmar Polke." *Parkett,* July 1984.

Power, Kevin. "Sigmar Polke." *frieze,* April/May 1992, pp. 24–33.

Schulz–Hoffmann, Carla, and Ulrich Bischoff. *Sigmar Polke: Schleifenbilder.* Stuttgart: Edition Cantz, 1992.

Spagnesi, Licia. "Le Grande Anarchia Polke." *Arte,* April 2001, pp. 108–13.

✦ ROBERT PRUITT

Born 1975, Houston

2000, Texas Southern University, Houston, BFA
2003, University of Texas at Austin, MFA
Lives and works in Austin

SELECTED GROUP EXHIBITIONS

2002

The Big Show, Lawndale Art Center, Houston.

Soul Sonic Lustre-Silk, Houston Community College Art Gallery, Houston.

22 to Watch, Austin Museum of Art, Austin.

2001

Umfrumnat tre', The New Gallery, University of Texas at Austin.

2000

Love Letters, Commerce Street Warehouse, Houston.

1999

Huh Whut ?!, Senior Exhibition, Texas Southern University Library Art Gallery, Houston.

Strange Fruit, DiverseWorks Art Space, Houston.

1998

Fresh Beginnings, African American Museum, Dallas.

Preventions, Project Row Houses, Houston.

⚡ MEL RAMOS

Born 1935, Sacramento

1957, Sacramento State College, California, BA
1958, Sacramento State College, California, MA
Lives and works in Hayward, California

SELECTED SOLO EXHIBITIONS

1994

Mel Ramos–Retrospective, Kunstverein Lingen, Lingen, Germany. Traveled to Manheimer Kunstverein, Manheimer, Germany; Kunsthalle zu Kiel, Kiel, Germany; (under title *Mel Ramos: Pop Art Images*) Hochschule für Angewandte Kunst, Vienna.

1985

Art in the San Francisco Bay Area, 1945–1980: An Illustrated History, Oakland Museum, June 15–August 18. Catalogue, text by Thomas Albright.

1980

Mel Ramos: A Twenty-Year Survey, Rose Art Museum, Brandeis, University, Waltham, Massachusetts, April 13–May 16. Catalogue, text by Carl Belz.

1977

Mel Ramos: Paintings 1959–1977, Oakland Museum, California, September 20–November 14. Catalogue, text by Harvey Jones.

1967

San Francisco Museum of Art, San Francisco.

SELECTED GROUP EXHIBITIONS

2001

Les Anées Pop, Centre Georges Pompidou, Musée National d'Art Moderne, Paris, March 15–July 2. Catalogue.

Pop Art: U.S./U.K. Connections, 1956–1966, The Menil Collection, Houston, January 26–May 13. Catalogue, text by David E. Brauer, Jim Edwards, Christopher French, and Walter Hopps.

2000

Protest and Survive, Whitechapel Art Gallery, London, September 15–November 12.

1998

Amerikanische Pop Art, Hamburger Kunsthalle, February. Catalogue, text by Marina Schneede and Uwe M. Schneede.

1991

Pop Art, Royal Academy of Art, London, September 13–December 15. Traveled to Museum Ludwig Kunsthalle, Cologne, January 22–April 20, 1992; Museo Nacional Centro de Arte Reina Sofia, Madrid; Musée des Beaux-Arts, Montreal, October 23–January 24, 1993. Catalogue, text by Marco Livingstone and Dan Cameron.

1983

Modern Nude Paintings, 1880–1980, National Museum of Art, Osaka, Japan.

1976

Painting and Sculpture in California: The Modern Era, San Francisco Museum of Modern Art, September 23–November 21. Traveled to National Museum of American Art, Smithsonian Institution, Washington, D.C., May 20–September 11, 1977. Catalogue, text by Henry Hopkins and Walter Hopps.

1974

Pop Art, Whitney Museum of American Art, New York.

1970

Festival of Contemporary Art, Municipal Art Museum of Yokahama, Yokahama, Japan.

1963

Pop Goes the Easel, Contemporary Arts Museum, Houston. April 4–30. Catalogue, text by Douglas MacAgy.

SELECTED BIBLIOGRAPHY

Arnason, H. H. *History of Modern Art.* Third ed. New York: Harry N. Abrams, 1986.

Claridge, E. *Mel Ramos.* London: Mathews Miller Dunbar, 1975.

Etulain, Richard. *Re-imagining the Modern American West: A Century of Fiction, History and Art.* Tucson: University of Arizona Press, 1996.

Grünewald, Dietrich. "Kunst-Comic-Kunst." *Kunst und Unterricht,* August 1993, pp. 18–21.

Lippard, Lucy R., Lawrence Alloway, Nancy Marmer, and Nicolas Calas. *Pop Art.* New York: Praeger, 1966.

Lucie-Smith, Edward. *Art Today.* London: Phaidon, 1995.

Moos, David. "What You Can Do for Pop to What Pop Can Do for You." *Art and Text,* January 1994.

Perrella, Cristiana. "Mel Ramos: l'invasione degli ultracorpi." *Arte,* February 1999, pp. 114–19.

Ramos, Mel. *Mel Ramos: Watercolors.* Berkeley: Lancaster-Miller Publishers, 1980.

Rose, Barbara. "Dada Then and Now." *Artforum,* September 1963, pp. 13–14.

Rosenblum, Robert, and Mel Ramos. *Mel Ramos: Pop Art Images.* Cologne: Benedikt Taschen, 1994.

Weiermair, Peter, ed. *Ideal and Reality: The Image of the Body in Twentieth Century Art from Bonnard to Warhol.* Zurich: Edition Stemmle, 1999.

✐ DAVID SANDLIN

Born 1956, Belfast, Northern Ireland

1979, University of Alabama at Birmingham, BA

Lives and works in New York

SELECTED SOLO EXHIBITIONS

2001

Road to No . . . Where, Gallery of the School of Art and Design, Lucerne, Switzerland.

1998

Pur-Ton-O-Fun-Co, Gracie Mansion Gallery with installation at Gramercy International, New York, May 9–11.

1996

A Sinner's Progress: The David Sandlin Story, White Columns, White Room, New York.

Welcome to Sinland, Un Regard Moderne, Paris.

1992

Burning Ring of Fire, SMASH Gallery of Modern Art, Vancouver.

1990

Voyage to Sinland, Carl Hammer Gallery, Chicago, September 7–October 10.

1985

Historical, Religious and Mythological Art for the New Right, Gracie Mansion Gallery, New York, March 28–April 21.

1984

Backyard of Earthy Delights, Gracie Mansion Gallery, New York May 3–May 27.

SELECTED GROUP EXHIBITIONS

2002

Raw, Boiled and Cooked, Yerba Buena Center for the Arts, San Francisco.

2001

Print 2001, Brooklyn Museum of Art, New York.

2000

The End: An Independent Vision of Contemporary Culture 1982–2000, Exit Art, New York.

1999

Comics by David Sandlin, Chris Ware, Simon Grennan and Christopher Sperandio, The Museum of Modern Art Library, New York.

1997

Art and Provocation: Images from Rebels, Boulder Museum of Contemporary Art, Colorado.

Auto Portrait: The Calligraphy of Power, Exit Art, New York.

Kunst Comics und Komics, Kunsthaus, Langenthal, Switzerland.

1995

Imaginary Being, Exit Art, New York.

On Beyond the Book, Forum for Contemporary Art, St. Louis.

1993

Artist Select, Part I, Artists Space, New York.

Cadavre Exquis, The Drawing Center, New York.

1992

Reframing Cartoons, Wexner Center for the Arts, Ohio State University, Columbus, June 27–September 13.

1991

Misfit Lit, COCA Center for Contemporary Art, Seattle. Traveled to SMASH Gallery of Modern Art, Vancouver; Los Angeles Contemporary Exhibitions. Catalogue.

1986

Painting and Sculpture Today, Indianapolis Museum of Art, Indianapolis.

1985

New York–East Village Art Situation '85, Accademia Di Belle Arti, Museo di Arte Moderna di Catanzaro, Italy.

SELECTED BIBLIOGRAPHY

Bulka, Michael. "David Sandlin." *The New Art Examiner,* December 1995, pp. 29–30.

Cameron, Dan. "Shifting Tastes." *Art and Auction,* September 1991, pp. 78–81.

Cohen, Ronny H. "Prints About Art." *Print Collector's Newsletter,* November/December 1985, pp. 164–68.

Hawkins, Margaret. "Comical Artist Sandlin Descends into Sinland." *Chicago Sun Times,* December 4, 1992, pp. 31, 33.

Iwayoshi, Takahisa. "The Fine Artist Ridiculing Modern Society: David Sandlin." *Idea,* July 1997, pp. 42–47.

Johnson, Ken. "Art in Review: David Sandlin." *The New York Times,* November 14, 1997, p. E45.

Moufarrege, Nicolas A. "The Year After." *Flash Art,* Summer 1984, pp. 51–55.

Princenthal, Nancy. "Artist's Book Beat." *Art on Paper,* January/February 2000, pp. 88–89.

Smith, Roberta. "Seven Year Itch." *The New York Times,* April 21, 1989.

✂ PETER SAUL

Born 1934, San Francisco
Washington University, BFA
Lives and works in New York

SELECTED SOLO EXHIBITIONS
1996
Peter Saul: Art World Portraits, The David and Alfred Smart
 Art Museum, University of Chicago, Chicago.
'Crime and Punishment' and Other New Paintings, Texas
 Gallery, Houston, April 16–May 18.
1990
Peter Saul: Political Paintings, Frumkin/Adams Gallery, New
 York. Traveled to Krannert Art Museum, Champaign, Illinois;
 Washington University Gallery of Art, St. Louis. Catalogue.
1989
Peter Saul: Retrospective, Aspen Art Museum, Colorado, June 1–
 July 4. Traveled to Museum of Contemporary Art, Chicago;
 Austin Museum of Art/Laguna Gloria; Contemporary Arts
 Center, New Orleans. Catalogue, text by Robert Storr.
1976
Musée d'Art et Industrie, St. Etienne, France.
1961
Allan Frumkin Gallery, Chicago.

SELECTED GROUP EXHIBITIONS
2001
*Eye Infection: Robert Crumb, Mike Kelley, Jim Nutt, Peter Saul,
 H. C. Westermann,* Stedelijk Museum of Modern Art,
 Amsterdam, November 3–January 20, 2002. Catalogue,
 text by Robert Storr, edited by Christian Braun.
Les Anées Pop, Centre Georges Pompidou, Musée National
 d'Art Moderne, Paris, March 15–July 2. Catalogue.
2000
Made in California: Art, Image and Identity 1900–2000, Los
 Angeles County Museum of Art, October 22–February 25,
 2001. Catalogue, text by Stephanie Barron, Sheri Bernstein,
 and Ilene Susan Fort.
The Lighter Side of Bay Area Figuration, Kemper Museum of
 Contemporary Art, Kansas City, April 7–June 18. Traveled
 to San Jose Museum of Art, San Jose, California. Catalogue.
1999
*Faster than a Speeding Bullet: Superheroes in Contemporary
 Art,* Cleveland Center for Contemporary Art.
1997
Art in Chicago 1945–1995, Museum of Contemporary Art,
 Chicago, November 16–March 23. Catalogue, text by Lynne
 Warren and Jeff Abell.
1995
Grotesque, The Museum of Modern Art, New York.
1995 Biennial Exhibition, Whitney Museum of American Art,
 New York. Catalogue, text by Klaus Kertess and John Ahsbery
1992
Hand-Painted Pop: American Art in Transition, 1955–1962,
 Museum of Contemporary Art, Los Angeles, December
 6–March 7, 1993. Traveled to Museum of Contemporary
 Art, Chicago, April 3–June 20, 1993; Whitney Museum of
 American Art, New York, July 16–October 3, 1993.
 Catalogue, text by Donna de Salvo, Paul Schimmel, Russell
 Ferguson, and David Deitcher.
1990
Word as Image: American Art 1960–1990, Milwaukee Art
 Museum, Wisconsin, June 15–August 26. Traveled to Okla-
 homa City Art Museum, November 17– February 2, 1991;
 Contemporary Arts Museum, Houston, February 23–May
 12, 1991. Catalogue, text by Dean Sobel.
1988
Different Drummers, Hirshhorn Museum and Sculpture Garden,
 Smithsonian Institution, Washington, D.C., May 12– August
 14. Catalogue, text by Frank Gettings and Anna Brooke.

*Committed to Print: An Exhibition of Recent American Printed Art
 with Social and Political Themes,* The Museum of Modern Art,
 New York, January 31–April 19. Catalogue, text by Deborah Wye.
1978
Art about Art, Whitney Museum of American Art, New York,
 July 19–September 24. Catalogue, text by John Lipman and
 Richard Marshall.
1976
Painting and Sculpture in California: The Modern Era, San
 Francisco Museum of Modern Art, September 23–Novem-
 ber 21. Traveled to National Museum of American Art,
 Smithsonian Institution, Washington, D.C., May 20–
 September 11, 1977. Catalogue, text by Henry Hopkins
 and Walter Hopps.
1969
Spirit of the Comics, Institute of Contemporary Art, Univer-
 sity of Pennsylvania, Philadelphia, October 1–November 9.
 Catalogue, text by Joan C. Siegfried.
1968
Social Comment in America, The Museum of Modern Art,
 New York.
1963
New Directions, San Francisco Museum of Modern Art.

SELECTED BIBLIOGRAPHY
Abbe, R. "Peter Saul." *Arts Magazine,* January 1978, p. 15.
Cameron, Dan. "The Trials of Peter Saul." *Arts Magazine,*
 January 1990, pp. 71–75.
Gregor, Katherine. "Peter Saul." Interview. *Artspace,* Fall 1985,
 pp. 26–28.
Lieberman, Rhonda, and Carry S. Leibowitz. "It's Been Nice
 Gnawing at You." *Artforum,* December 1993, pp. 40–44, 97.
Madoff, Steven Henry, ed. *Pop Art: A Critical History.*
 Berkeley, Calif.: University of California Press, 1997.
McCarthy, David. "Peter Saul: 13–14 November 1995." *Art
 Papers,* March/April 1996, pp. 12–15.
Perrot, Raymond. "Peter Saul." *Artension,* May 1991, pp.
 34–36.
Pradel, J. L. "Peter Saul: Une Luxuriante Insolence." *Opus
 International,* Autumn 1979, pp. 30–32.
Storr, Robert. "Obscured Visions." *Artforum,* March 2002,
 pp. 114–19.

✦ KENNY SCHARF

Born 1958, Los Angeles
1980, School of Visual Arts, New York, BFA
Lives and works in Los Angeles

SELECTED SOLO EXHIBITIONS
1997
Kenny Scharf: Pop-Surrealist, Salvador Dalí Museum,
 St. Petersburg, Florida.
1996
Museo de Arte Contemporáneo de Monterrey, Mexico.
1995
Scharf-O-Rama Vision 1978–1995, Museum of Art, Fort
 Lauderdale, Florida.
1985
Galeri Bruno Bischofberger, Zurich.
1979
Celebration of the Space Age, Club 7, New York.

SELECTED GROUP EXHIBITIONS
2001
Animations, P.S.1. Center for Contemporary Art, Long Island
 City, New York, October 14–January 13, 2002.
1998
Pop Surrealism, The Aldrich Museum of Contemporary Art,
 Ridgefield, Connecticut.

1997
American Graffiti, Museo di Castelnuovo Santa Barbara, Naples. Traveled to Chiostro del Bramante, Rome.
1993
Extravagant: The Economy of Elegance, Russiches Kulturzentrum, Berlin, May 7–June 27.
1992
1492, Museo de Arte Contemporáneo de Monterrey, Monterrey, Mexico.
1991
The 1980s, Whitney Museum of American Art, New York.
1988
Figure as Subject: Revival of Figuration since 1975, Whitney Museum of American Art, New York.
1987
Comic Iconoclasm, Institute of Contemporary Arts, London, June–September. Traveled to Douglas Hyde Gallery, Trinity College, Dublin, October–November; Cornerhouse, Manchester, England, January–February 1988. Catalogue, text by Sheena Wagstaff and Iwona Blazwick.
1985
1985 Biennial Exhibition, Whitney Museum of American Art, New York, March 21–June 2. Catalogue.
1984
Arte di Frontiera: New York Graffiti, Galeria d'Arte Moderna, Bologna, Italy, June–August. Catalogue, text by Tony Shafrazi and F. Alinovi.
41st esposizione internazionale d'arte, La Biennale di Venezia, Venice, June–August.
Via New York, Musée d'Art Contemporain de Montréal, Montreal, May 8–June 24. Catalogue, text by André Ménard, Robert Pincus-Witten, and Phillippe Evans-Clark.
1983
The Comic Art Show, Whitney Museum of American Art, New York, July 18–August 23.
Bienal de São Paulo, São Paulo, Brazil.
1981
The Times Square Show, Times Square, New York.

SELECTED BIBLIOGRAPHY

Albertazzi, Liliana. "Graffiti, post–graffiti." *Arte en Colombia,* February 1985, pp. 60–63.
Cameron, Dan. "Saint Kenny and the Cultural Dragon." *Arts Magazine,* January 1984, pp. 93–95.
_____. "Transparencies." *Art Criticism,* vol. 4, no. 1, 1986, pp. 1–10.
Camnitzer, Luis. "Absolut Relativity." *Third Text,* Spring 1997, pp. 86–91.
Haring, Keith. "Kenny Scharf." Interview. *Flash Art,* January 1985, pp. 14–17.
Hullenkremer, M., and A. Nemeczek. "Graffiti: Fvon der U–Bahn ins Museum." *Art: Das Kunstmagazin,* February 1984, pp. 40–57.
Jock, Heinz–Norbert. "Das amerikanische Lachen–ider vom Nutzen und Nachteil der Komik für das Leben." *Kunstforum International,* no. 121, 1992, pp. 64–121.
Marschall, E. "Post Graffiti." *Sztuka,* vol. 10, no. 4, 1985, pp. 46–48.
McKenzie, Michael. "Post–Warhol no artists tachi." *Mizue,* Spring 1989, pp. 78–105.
O'Connor, John, Benjamin Liu, and Glenn O'Brien. *Unseen Warhol,* New York: Rizzoli, 1996.
Renard, D. "Kenny Scharf: 'Pop–Surrealism.'" *Art Press,* May 1984, p. 13.
Timarco, A. "Il New Surrealism." *Op.Cit.,* May 1985, pp. 38–44.
Verzotti, Giorgio. "Portrait of the Artist as an Infant." *Flash Art,* May/June 1986, pp. 42–45.
Westfall, S. "Surrealist Modes Among Contemporary New York Painters." *Art Journal,* Winter 1985, pp. 315–18.

✳ ROGER SHIMOMURA

Born 1939, Seattle
1961, University of Washington, Seattle, BFA
1964, Cornish School of Allied Arts, Seattle
1967, Stanford University, Palo Alto, California
1968, Cornell University, Ithaca, New York
1969, Syracuse University, New York, MFA
Lives and works in Lawrence, Kansas

SELECTED SOLO EXHIBITIONS
1996
Roger Shimomura Delayed Reactions: A Retrospective Exhibition, Spencer Museum of Art, University of Kansas, Lawrence, April 4–June 20. Traveled to Weatherspoon Art Gallery, Greensboro, North Carolina, May 9–July 28; Western Gallery, Western Washington University, Bellingham, September 30–December 7; Newcomb Art Gallery, New Orleans. Catalogue, text by Lucy Lippard and Kazuko Nakane.
1992
Eastern Washington State Historical Society, Cheney Cowles Museum, Spokane, Washington. Traveled to Yellowstone Art Museum, Billings, Montana. Catalogue, text by William Lew.
1986
Center for Contemporary Arts, Santa Fe.
1982
Roger Shimomura: Diary Series, Birmingham Museum of Art, Alabama, April 17–May 30. Catalogue, text by John H. Seto.
1979
Minidoka Series, Spencer Museum of Art, University of Kansas, Lawrence, March 20–25. Traveled to four venues.
1969
Handwerker Gallery of Art, Ithaca, New York.

SELECTED GROUP EXHIBITIONS
1997
American Stories: Amidst Displacement and Transformation, Setagaya Art Museum, Tokyo, August 30–October 19. Traveled in Japan to Chiba Municipal Museum of Art, Chiba, November 1–December 23; Fukui Fine Arts Museum; Kurashiki City Art Museum; Akita Prefectural Integrated Life Cultural Hall, August 7–September 6, 1998. Catalogue.
1996
American Kaleidoscope: Art at the Close of This Century, National Museum of American Art, Smithsonian Institution, Washington, D.C.
1994
Memories of Childhood…so we're not the Cleavers or the Brady Bunch, Steinbaum Krauss Gallery, New York, December 3–January 7, 1995. Catalogue, text by Bernice Steinbaum.
Elvis and Marilyn 2 x Immortal, The Institute of Contemporary Art, Boston, November 2–January 8, 1995. Traveled to nine venues. Catalogue, text by Geri Defaoli, Wendy McDaris, et al.
Japanese Art after 1945: Scream Against the Sky, Yokohama Museum of Art, Yokohama, Japan. Traveled to Solomon R. Guggenheim Museum, New York; San Francisco Museum of Modern Art. Catalogue, text by Alexandra Munroe.
1992
Relocations and Revisions: The Japanese-American Internment Reconsidered, Long Beach Museum of Art, California.
1991
Syncretism: The Art of the XXI Century, Alternative Museum, New York.
1989
Tools as Art, National Building Museum, Washington, D.C.
1988
Alice and Look Who Else Through the Looking Glass, Bernice Steinbaum Gallery, New York, December 10–January 7, 1989.

SELECTED BIBLIOGRAPHY

Addiss, Steve, and Patricia Fister. *Katachi: Form and Spirit in Japanese Art*. Albuquerque: Albuquerque Museum, 1980.

Chattopadhyay, Collette. "From Zen to Pop Culture." *Art Asia Pacific*, no. 28, 2000, pp. 24–25.

Failing, Patricia. "Seizing the Moment." *ARTnews*, March 2002, pp. 76, 78–79.

Kimmelman, Michael. "Roger Shimomura." *The New York Times*, February 10, 1989, p. C1.

Lucie-Smith, Edward. *American Art Now*. New York: William Morrow, 1985.

Mayo, James M. *War Memorial as Political Landscape*. New York: Praeger, 1988.

Mura, David. "Cultural Claims and Appropriations (e.g., who owns the internment camps?)." *Art Papers*, March/April 1997, pp. 6–11.

Purdom, Judy. "Mapping Difference." *Third Text*, Autumn 1995, pp. 19–32.

Rupp, James. *Art in Seattle's Public Places: An Illustrated Guide*. Seattle: University of Washington Press, 1992.

Tsutakawa, Mayumi. *Turning Shadows into Light: Art and Culture of the Northwest's Early Asian/Pacific Community*. Seattle: Young Pine Press, 1982.

☞ DAVID SHRIGLEY

Born 1968, Macclesfield, Scotland
1991, Glasgow School of Art, BA
Lives and works in Glasgow

SELECTED SOLO EXHIBITIONS
2002
David Shrigley, UCLA Hammer Museum, Los Angeles, February 9–May 5.
2001
Center for Curatorial Studies, Bard College, Annandale-on-Hudson, New York.
1997
Stephen Friedman Gallery, London.

SELECTED GROUP EXHIBITIONS
2002
Gags and Slapstick in Contemporary Art, CCAC Institute for Exhibitions and Public Programs, San Francisco, January 19–March 9. Traveled to Collection Lambert, Avignon, France.
Open Country, Contemporary Scottish Artists, Le Musée Cantonal des Beaux-Arts de Lausanne, Lausanne, Switzerland.
2001
Here and Now: Scottish Art 1990–2001, Aberdeen Art Gallery and Peacock Printmakers, Aberdeen, Scotland, Dundee Contemporary Arts, McManus Galleries, and Generator Projects, Dundee, Scotland, September 15–November 4.
2000
The British Show 5, various locations, Edinburgh, April 8–January 28, 2001. Traveled in England to Southampton, Cardiff, and Birmingham. Catalogue.
Becks Futures, Institute of Contemporary Arts, London, March 17–May 17. Traveled to Cornerhouse, Manchester, England, May 26–July 2; Centre for Contemporary Arts, Glasgow, Fall.
1999
Common People, British Art Between Phenomenon and Reality, Fondzione Sandretto re Rebaudengo per L'Art, Turin, Italy.
1998
Surfacing–Contemporary Drawing, Institute of Contemporary Arts, London.
1996
Appetizer, Free Parking, Toronto, March–March 1997.
The Unbelievable Truth, Stedelijk Museum Bureau, Amsterdam. Traveled to Tramway, Glasgow.

White Hysteria, Contemporary Art Centre of South Australia, Adelaide.
1995
Scottish Autumn, Bartok 32 Galeria and Ludwig Muzeum, Budapest, September 28–November 12.

Artist's Book Project
1996
Catalyst Arts, Belfast, May 10–31. Artist's book, *Drawings Done Whilst on Phone to Idiot* (Glasgow: Arm Pit, 1996).

SELECTED BIBLIOGRAPHY

Bauman, Zigmunt, Liam Gillick, Elisabeth Grosz, Boris Groys, Jackie Kay, Hanif Kureishi, Valerey Podoroga, Douglas Rushkoff, Carlos Varela, and Marina Warner. *Fresh Cream: Contemporary Art in Culture*. London: Phaidon, 2000.

Bracewell, Michael. "Jesus Doesn't Want Me for a Sunbeam." *frieze*, November/December 1995, pp. 50–51.

"David Shrigley." *tate: the art magazine*, Winter 1997, pp. 59–64.

Falconer, Morgan. "As Good as Your Word." *Art Review*, March 2002, pp. 33–39.

Garcia-Anton, Katya. "Histe(o)rias del Arte Reciente." *Lapiz*, January/February 2001, pp. 128–35.

Lillington, David. "Comic Art." *Art Monthly*, May 1998, pp. 1–6.

Morley, Simon. "What Is British Art?" *Art Review*, October 2000, p. 70.

Musgrave, David. "Multiples Multiplicities." *Art Monthly*, July/August 1999, pp. 52–53.

Shrigley, David. "Insert: David Shrigley." *Parkett*, no. 53, 1998, pp. 153–68.

_____. *The Beast Is Near*. London: Redstone, 1999.

☀ ANDY WARHOL

Born, 1928, Pittsburgh
1949, Carnegie Mellon University, Pittsburgh
Died 1987, New York

SELECTED SOLO EXHIBITIONS
2001
Andy Warhol: Retrospective, Neue Nationalgalerie, Berlin, October 2–January 6, 2002. Traveled to Tate Modern, London, February 4–March 31, 2002. Catalogue, text by Heiner Bastian and Kirk Varnedoe.
2000
Andy Warhol: Social Observer, Pennsylvania Academy of the Fine Arts, Philadelphia, June 17–September 21. Traveled to Corcoran Gallery of Art, Washington, D.C., December 22–March 12, 2001. Catalogue, text by Jonathan P. Binstock, Maurice Berger, and Trevor Fairbrother.
1999
About Face: Andy Warhol Portraits, Wadsworth Atheneum, Hartford, Connecticut, September 23–January 30, 2000. Traveled to Miami Art Museum, March 24–June 4, 2000. Catalogue, text by Nicholas Baume, Douglas Crimp, and Richard Meyer.
1997
After the Party: Andy Warhol Works, 1956–1986, Irish Museum of Modern Art, Dublin. Catalogue, text by Declan McGonagle, Thomas Crow, and G. R. Swenson.
1996
Andy Warhol's Factory Photos, Parco Gallery, Tokyo, April 25–May 28. Catalogue, text by Dave Hickey and Collier Schorr.
1993
Andy Warhol, Kunsthalle Basel, Basel, Switzerland, September 19–November 14. Traveled to four other European venues, through November 27, 1994. Catalogue, text by Thomas Kellein and Callie Angell.

1989

Andy Warhol, a Retrospective, The Museum of Modern Art, New York, February 6–May 2. Traveled to Centre Georges Pompidou, Musée National d'Art Moderne, Paris, June 21–September 10, 1990. Catalogue, text by Kynaston McShine, et al.

1988

Andy Warhol: Death and Disasters, The Menil Collection, Houston, October 21–January 8, 1989. Catalogue, text by Walter Hopps.

1979

Andy Warhol, Portraits of the 70s, Whitney Museum of American Art, New York, November 20–January 27, 1980. Catalogue, text by Robert Rosenblum.

1975

Andy Warhol: Paintings, 1962–1975, Baltimore Museum of Art, Baltimore, July 22–September 14. Catalogue.

1970

Andy Warhol, Pasadena Art Museum, California, May 11–June 21. Traveled to five venues. Catalogue, text by Richard Morphet.

1968

Andy Warhol, Moderna Museet, Stockholm. Catalogue.

SELECTED GROUP EXHIBITIONS

2002

Warhol, Basquiat, Clemente: Obras en Colaboración, Museo Nacional Centro de Arte Reina Sofia, Madrid, February 5–April 29. Catalogue.

2001

Pop Art: U.S./U.K. Connections, 1956–1966, The Menil Collection, Houston, January 26–May 13. Catalogue, text by David E. Brauer, Jim Edwards, Christopher Finch, and Walter Hopps.

1999

Made in USA: Between Art and Life, 1940–1970—de l'expressionisme abstracte al pop, Fundació la Caixa, Barcelona, January 28–March 28. Traveled to Schirn Kunsthalle, Frankfurt, April 30–July 10. Catalogue.

1995

Views from Abroad: European Perspectives on American Art One, Whitney Museum of American Art, New York, June 29–October 1. Traveled to Stedelijk Museum of Modern Art, Amsterdam, November 17–January 28, 1996. Catalogue, text by Seamus Heaney, Robert Lowell, Rudi H. Fuchs, Adam D. Weinberg, and Hayden Herrera.

Public Information: Desire, Disaster, Document, San Francisco Museum of Modern Art, January 18–April 30. Catalogue, text by Gary Garrels.

1993

American Art in the 20th Century: Paintings and Sculpture, 1913–1993, Martin-Gropius-Bau, Berlin, May 8–July 25. Traveled to Royal Academy of Arts and Saatchi Gallery, London, September 16–December 12. Catalogue, text by Christos Joachimides, Donald B. Kuspit, Arthur C. Danto, et al.

1988

Made in the Sixties, Whitney Museum of American Art at Federal Reserve Plaza, New York, April 18–July 13. Catalogue, text by Karl Willers.

1987

Warhol/Beuys/Polke, Milwaukee Art Museum, Wisconsin, June 19–August 16. Traveled to Contemporary Arts Museum, Houston, September 12–November 15. Catalogue, text by Russell Bowman, Linda L. Cathcart, Donald B. Kuspit, and Lisa Liebman.

1985

Pop Art, 1955–1970, Art Gallery of New South Wales, Sydney, February 27–April 14. Traveled to Queensland Art Gallery, Brisbane, Australia, May 1–June 2; National Gallery of Victoria, Melbourne, June 26–August 11. Catalogue, text by Henry Geldzahler.

1984

Artistic Collaboration in the Twentieth Century, Hirshhorn Museum and Sculpture Garden, Smithsonian Institution, Washington, D.C., June 9–August 19. Traveled to Milwaukee Art Museum, Milwaukee, November 18–January 15, 1985; The Speed Art Museum, Louisville, Kentucky, February 21–April 21, 1985. Catalogue, text by C. J. McCabe, D. Shapiro, and R. C. Hobbs.

1983

Photography in Contemporary Art, National Museum of Modern Art, Tokyo, October 7–December 4. Traveled to National Museum of Modern Art, Kyoto, December 13–January 22, 1984. Catalogue, text by H. Fujii, Y. Kondo, and T. Matsumoto.

1982

Joseph Beuys, Robert Rauschenberg, Cy Twombly, Andy Warhol: Sammlung Marx, Nationalgalerie Berlin, Staatliche Museen Preussischer Kulturbesitz, Berlin, March 2–April 12. Traveled to Städtisches Museum Abteiberg, Mönchengladbach, Germany, May 6–September 30.

1974

American Pop Art, Whitney Museum of American Art, New York, April 6–June 6. Catalogue, text by L. Alloway.

SELECTED BIBLIOGRAPHY

Bianchi, Paolo. "Andy Warhol's Factory." *Kunstforum International,* October–December 1998, pp. 62–71.

Bourdon, David. *Warhol.* New York: Harry N. Abrams, 1989.

Coplans, John. *Andy Warhol.* New York: Graphic Society, 1970.

Danto, Arthur C. "Andy Warhol: Brillo Box." *Artforum,* September 1993, pp. 128–29.

———. "Andy Warhol: Drawings." *Artforum,* November 1998, pp. 108–109.

———. "Who Was Warhol?" *ARTnews,* May 1987, pp. 128–32.

De Duve, Thierry. "Andy Warhol, or the Machine Perfected." *October,* Spring 1989, pp. 3–14.

Dillenberger, Jane. *The Religious Art of Andy Warhol.* New York: Continuum, 1988.

Doyle, Jennifer, Jonathan Flatley, and José Esteban Muñoz, eds. *Pop out: Queer Warhol.* Durham, N.C.: Duke University Press, 1996.

Feldman, Frayda. *Andy Warhol Prints: A Catalogue Raisonné, 1962–1987.* 3rd ed. New York: R. Feldman Fine Arts; Munich and New York: Editions Schellmann; New York: Abbeville, 1997.

Frei, Georg, ed. *The Andy Warhol Catalogue Raisonné.* London and New York: Phaidon, 2002.

Gidal, Peter. *Andy Warhol: Films and Paintings.* London: Studio Vista; New York: Dutton Pictureback, 1971.

Koestenbaum, Wayne. *Andy Warhol.* New York: Viking, 2001.

Malanga, Gerard. *Archiving Warhol: An Illustrated History.* London: Creation Books, 2002.

Michelson, Annette, ed. *Andy Warhol.* Cambridge, Mass.: MIT Press, 2001.

Ratcliff, Carter. *Andy Warhol.* New York: Abbeville, 1983.

Smith, John W. "Saving Time; Andy Warhol's Time Capsules." *Art Documentation,* Spring 2001, pp. 8–10.

Smith, Patrick S. *Andy Warhol's Art and Films.* Ann Arbor, Mich.: University of Michigan Press, 1986.

Stuckey, C. F. "Warhol: Backwards and Forwards." *Flash Art,* January/February 1981, pp. 10–18.

Theweleit, Klaus. "Production Principles of the Andy Warhol Factory." *Paletten,* vol. 57, nos. 2–3, 1996, pp. 118–31.

Tully, Judd. "Fifteen Minutes Later: Warhol Now." *ARTnews,* March 1992, pp. 114–21.

Vartanian, Ivan. *Andy Warhol: Drawing and Illustrations of the 1950's.* New York: Distributed Art Publishers, 2000.

Warhol, Andy. *The Andy Warhol Diaries.* Edited by Pat Hackett. New York: Warner Books, 1989.

———. *Andy Warhol's Index.* New York: Random House, 1967.

———. *The Philosophy of Andy Warhol: From A to B and Back Again.* London: Cassell, 1975.

❤ JENNIFER ZACKIN

Born 1970, Waterbury, Connecticut
1992, Parsons School of Design, New York, BFA
1997, The School of the Art Institute of Chicago, MA
1998, Skowhegan School of Painting and Sculpture, Maine
1999, The School of the Art Institute of Chicago, MFA
Lives and works in New York and Waterbury, Connecticut

SELECTED GROUP EXHIBITIONS

2002
2002 Emerging Artists Fellowship Exhibition, Socrates Sculpture
Park, Long Island City, New York, opened September 22.
2002 Biennial Exhibition, Whitney Museum of American Art,
New York, March 7–May 26. Catalogue, text by Lawrence
R. Rinder, Chrissie Isles, Christiane Paul, and Debra Singer.
Fourth Annual Video Marathon, Art in General, New York.
2001
Freestyle, The Studio Museum in Harlem, New York, April
28–June 24. Traveled to Santa Monica Museum of Art,
California, September 29–November 18. Catalogue, text
by Thelma Golden and Hamza Walker.
AIM 21, The Bronx Museum of the Arts, New York. Catalogue.
Not Quite Myself Today, Arizona State University Art
Museum, Tempe.
2001 Biennial Exhibition, Portland Museum of Art, Maine.
Catalogue.
2000
Culture of Class, The Maryland Institute College of Art,
Baltimore.
TRANSPOSE, Indigo Gallery, Katmandu, Nepal.

1999
1999 MFA Exhibition, The School of the Art Institute of
Chicago.
1998
Inaugural Exhibition 1998: New Artists in Chicago, Terra
Museum of American Art, Chicago.
New Talent, Contemporary Art Workshop, Chicago.

SELECTED BIBLIOGRAPHY

Budick, Ariella. "Post Black and White." *Newsday,* June 1,
2001, p. B27.
Cotter, Holland. "Art in Review: Rumors of War." *The New
York Times,* January 4, 2001, p. E42.
_____. "A Full Studio Museum Show Starts with 28 Young
Artists and a Shoehorn." *The New York Times,* May 11,
2001, p. E36.
Gopnick, Blake. "As American as Jambalaya." *The Washington
Post,* March 7, 2002, p. C1.
Nickas, Bob. "Multiple Voices." *Artforum,* May 2002, p. 164.
Plagens, Peter. "This Man Will Decide What Art Is."
Newsweek, March 4, 2002, p. 54.
Rooks, Michael. "New Artists in Chicago." *Dialogue,*
September/October 1998, p. 10.
Rubenstein, Raphael. "Report from Arizona: Not a Mirage."
Art in America, December 2002, p. 46.
Stevens, Mark. "In Brief: ART." *New York Magazine,* May 21,
2001, p. 82.

Photography

Laylah Ali and 303 Gallery, New York: pl. 23

American Folk Art Museum, New York, © Kiyoko Lerner; photography, James Prinz: pls. 25A & 25B

Austin Museum of Art, Austin: pl. 9

Blum and Poe Gallery, Santa Monica, California: pls. 32, 33

Brent Sikkema, New York: pl. 10

Cat Chow; photography, James Prinz: pl. 11

Catherine Clark Gallery, San Francisco: pl. 17

Renee Cox and Robert Miller Gallery, New York; photography © Renee Cox: pl. 30

Jason Dunda: pl. 19

Dunn and Brown Contemporary, Dallas, and James Cohan Gallery, New York: pl. 40

EAI, New York: pl. 5

Estate of Keith Haring, New York: pl. 26

Gagosian Gallery, New York; © 2003 Artists Rights Society (ARS), New York/ADAGP, Paris: pl. 28

Michael Galbincea; photography, Christine Duke: pl. 20

Galerie Chantal Crousel, Paris: pl. 14

Galerie Hans Mayer, Dusseldorf: pl. 21

George Adams Gallery, New York: pls. 3, 7

Greg Kucera Gallery, Seattle: pl. 31

Jack Shainman Gallery, New York: pls. 22, 36

Luhring Augustine, New York: pl. 38

Mattel, Inc.: pl. 6

Mitchell-Innes & Nash, New York: pl. 37

PaceWildenstein Gallery, New York; photography, Ellen Page Wilson: pl. 24

Phyllis Kind Gallery, New York: pl. 16

The Project, New York: pl. 18

Robert Pruitt: pl. 39

Mel Ramos: pl. 1

Rena Bransten Gallery, San Francisco: pl. 8

Ronald Feldman Fine Arts, New York; © 2003 Andy Warhol Foundation for the Visual Arts/ARS, New York: pl. 2, and photography, Jennifer Kotter: pl. 15

Rose Art Museum, Brandeis University, and the Estate of Roy Lichtenstein, New York: pl. 13

David Sandlin and Carl Hammer Gallery, Chicago: pl. 4

Stephen Friedman Gallery, London: pl. 35

Texas Gallery, Houston: pls. 29, 34

Tony Shafrazi Gallery, New York: pl. 27

Jennifer Zackin; photography, David Ottenstein: pl. 12

Cartoon and Comics Copyrights

Catalogue

Publication Coordinator: Valerie Cassel

Editor: Polly Koch

Biography and bibliography research: Clare Elliott and Julie Firth

Design: Don Quaintance, Public Address Design, Houston

Design/production assistant: Emma Elizabeth Frizzell and additional research and editing for A Cartoon Timeline

Cover illustration: Sonny Windstrup

Typography: Public Address Design; composed in Minion (text); Comicraft (CC) That's All Folks, CC Thrills, CC Spills, and CC Zoinks; and Font Bureau Showcard Moderne (display)

Color separations: C+S Repro, Filderstadt-Plattenhardt, Germany

Printing: Cantz Druckerei, Ostfildern-Ruit, Germany

page 128:
Jason Dunda
Pair (Fists), 2000
Oil on canvas
6 x 6 x 3 inches
Collection of Dr. Nitin Dilawri, Toronto, Canada